Publisher's Acknowledgements
Special thanks to **Isao Takakura**, Yayoi Kusama Studio, Tokyo and **Reiko Tomii**, New York. We would also like to thank the following authors and publishers for their kind permission to reprint texts: **Jud Yalkut**, Dayton, Ohio; **Damien Hirst**, London ; and the following for lending reproductions: **Galerie Neher**, Essen; **The Andy Warhol Foundation**, New York. We also thank for their assistance with this publication: **Takako Fujibayashi** and **Yoko Miyazaki** at Yayoi Kusama Studio, and **Sachie Gocho**, Tokyo; **Paula Cooper Gallery**, New York; **Lisa Graziose Corrin** and **Julia Peyton-Jones**, Serpentine Gallery, London; **Ota Fine Arts**, Tokyo; **Henk Peeters**, Hall, The Netherlands; **Robert Miller Gallery**, New York; **Victoria Miro** and **Glenn Scott-Wright**, Victoria Miro Gallery, London; **The Whitney Museum of American Art**, New York. Photographers: Shigeo Anzai; Nobuyoshi Araki; Bill Baron; Michael Benedikt; Rudolph Burckhardt; Carl Doerner; Stan Goldstein; Eikoh Hosoe; Ted Howard; Lock Huey; Francis Keaveny; Aoki Minoru; Peter Moore; K.A. Morais; Tetsushi Namura; Hal Reiff; Bob Sabin; Eiichiro Sakata; John D. Schiff; Van Sikle; Norihiro Ueno; J. Wollach.

Artist's Acknowledgements
Firstly my sincere gratitude to Phaidon Press for publishing this monograph on my work. My special thanks to Gilda Williams, Ian Farr, John Stack, Clare Manchester and Veronica Price of Phaidon Press for their work in editing the book from an enormous volume of archival materials. I would also like to thank Akira Tatehata, Laura Hoptman and Udo Kultermann for their contributions. My thanks also go to the museums, galleries and photographers involved in the project.

All works are in private collections unless otherwise stated.

Phaidon Press Limited
Regent's Wharf
All Saints Street
London N1 9PA

Phaidon Press Inc.
180 Varick Street
New York, NY 10014

www.phaidon.com

First published 2000
Reprinted 2001
© 2000 Phaidon Press Limited
All works of Yayoi Kusama are
© Yayoi Kusama

ISBN 0 7148 3920 5

A CIP catalogue record of this book is available from the British Library.

All rights reserved. No part of this publication may be reproduced, stored in a retrieval system or transmitted in any form or by any means, electronic, mechanical, photocopying, recording or otherwise, without the written permission of Phaidon Press.

Designed by SMITH
Printed in Hong Kong

cover, **Core of Flower**
1991
Acrylic on canvas
73 × 60.5 cm

page 4, Installation, 'Between Heaven and Earth', Fuji Television Gallery, Tokyo, 1991
foreground, **A Boat Carrying My Soul** (detail)
1989
Sewn stuffed fabric, wood
80 × 340 × 160 cm
centre, **Heaven and Earth** (detail)
1991
Sewn stuffed fabric, wood
h. 130 cm
background, right, **Stamens in the Sun**
1989
Sewn stuffed fabric, wood, paint
240 × 561 × 19 cm
Collection, The Museum of Modern Art, Toyama, Japan

page 6, **Yayoi Kusama**, Studio, New York, *c.* 1963–64

page 32, **Accretions** and **Compulsion Furniture**
c. 1962–63
Sewn stuffed fabric, furniture, household objects, paint
Works in progress, the artist's studio, New York, *c.* 1962–63

page 84, **Driving Image** (detail)
1959–64
Sewn stuffed fabric, wood, canvas, mannequins, household objects, paint, macaroni carpet, soundtrack
Installation, 'Driving Image Show', Galerie M.E. Thelen, Essen, Germany, 1966

page 94, **No. T.W.3**
1961
Oil on canvas
174 × 126.5 cm

page 144, **Yayoi Kusama**, Tokyo, 1998. Polaroid portrait by Nobuyoshi Araki

Laura Hoptman Akira Tatehata Udo Kultermann

Yayoi Kusama

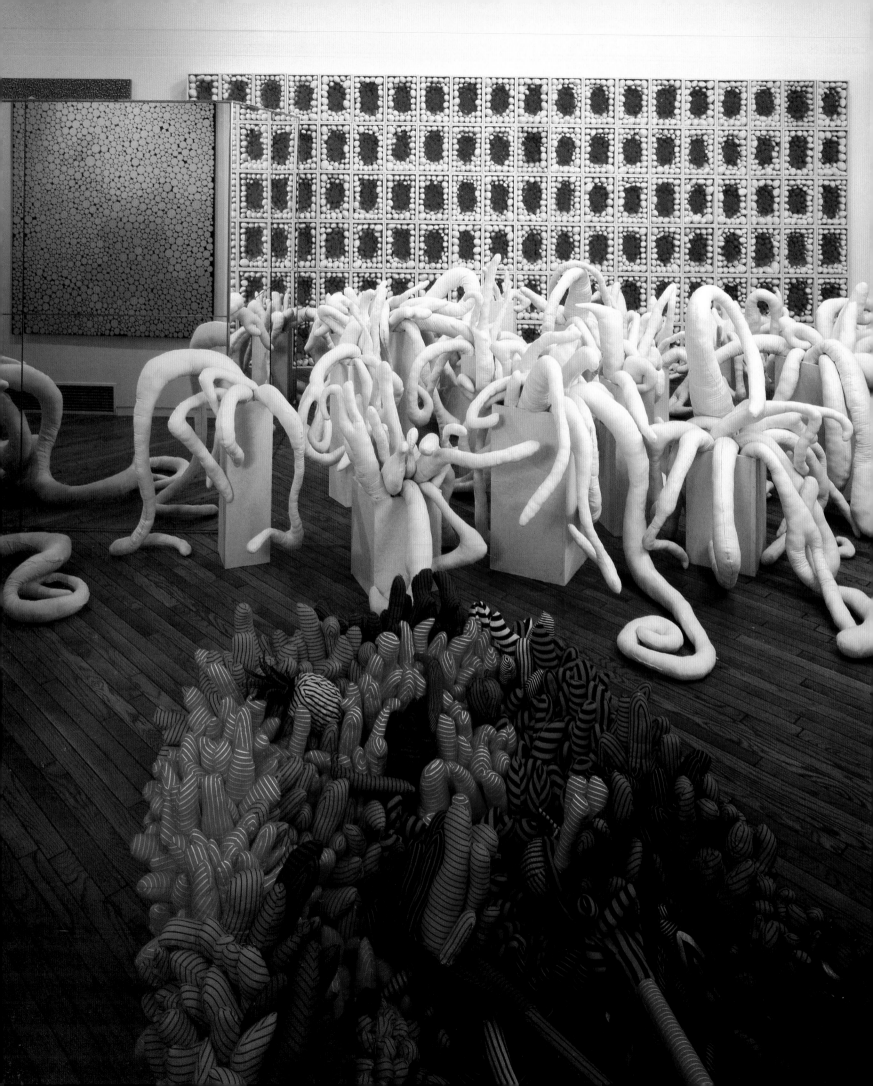

Contents

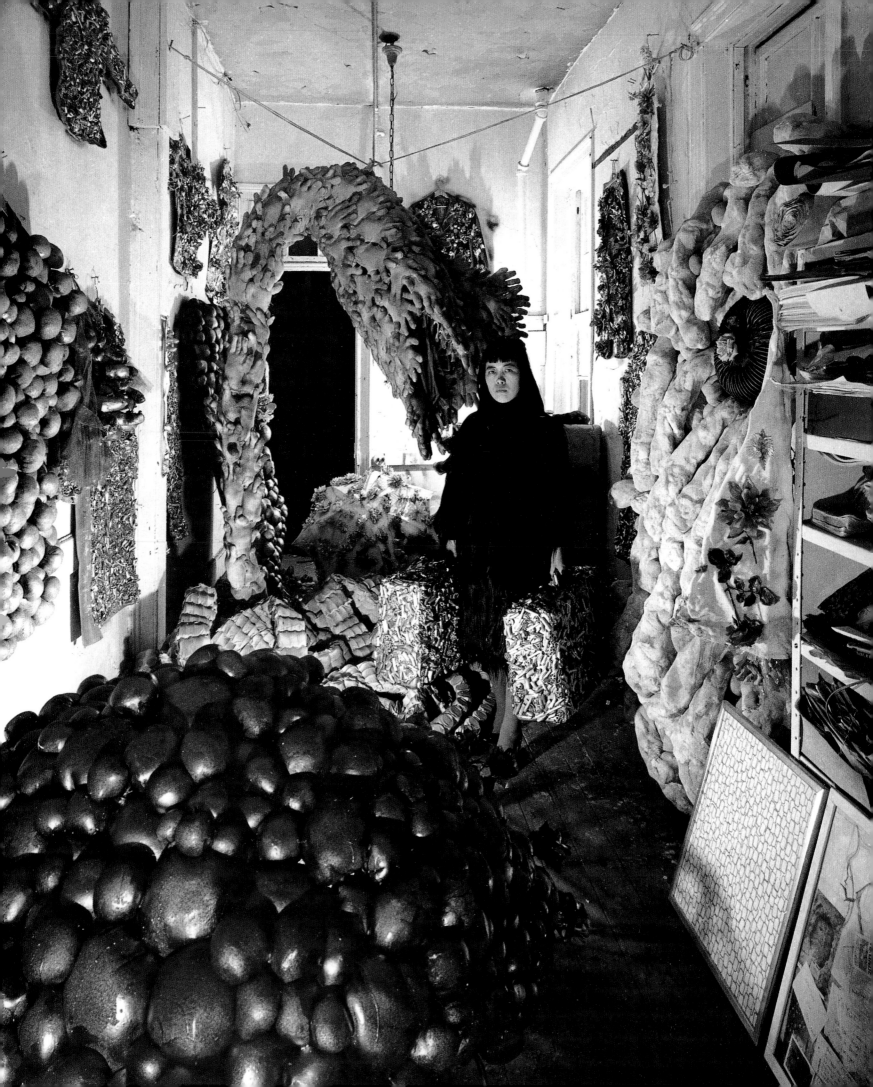

Contents

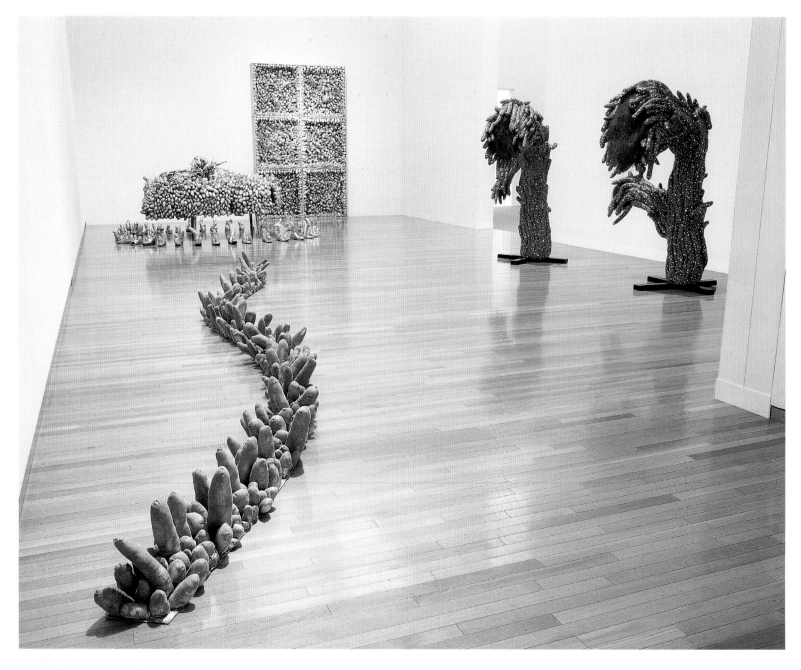

Akira Tatehata Ms Kusama, after many years of being viewed as a kind of
heretic, you are finally gaining a central status in the history of postwar art.
You are a magnificent outsider yet you played a crucial, pioneering role at a time
when vital changes and innovations were taking place in the field of art.

 During 1998–99 a major retrospective exhibition of your early work ('Love
Forever: Yayoi Kusama, 1958–1968') toured major museums in the United
States and Japan. How did you feel when you looked at your past works again?

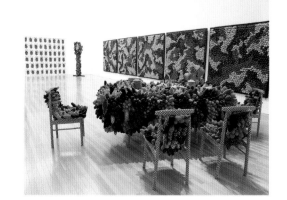

Yayoi Kusama **Well … if I were not Kusama, I would say she is a good artist.
I'd think she is outstanding.**

Tatehata However, you had to fight one difficult battle after another before
you came to this point.

Kusama **Yes, it was hard. But I kept at it and I am now at an age that I never
imagined I would reach. I think my time, that is the time remaining before I**

**pass away, won't be long. Then, what shall I leave to posterity? I have
to do my very best, because I made many detours at various junctures.**

Tatehata Detours? You may have experienced hardships, but I don't think
you wasted your time. You have never stopped working.

Kusama **I have never thought of that.**

Tatehata And each one of your battles that you fought at each stage of your life
was inevitable. In fact, you yourself jumped into them.

Kusama **Yes, like the Happenings I staged in New York.**

Tatehata First of all, I would like to ask you about the period when you were in
Japan before going to the US. You went to New York at twenty-seven. By then,
you must have already developed your own world as a painter.

Kusama **Yes.**

Tatehata Your self-formation was grounded in Japan. Still, you did not flaunt
your identity as a *Japanese* artist.

Kusama **I was never conscious of it. The art world in Japan ostracized me for
my mental illness. That is why I decided to leave Japan and fight in New York.**

Tatehata In any case, while in Japan you had already produced numerous
works, most of which were drawings. It is true that in your encounter with New

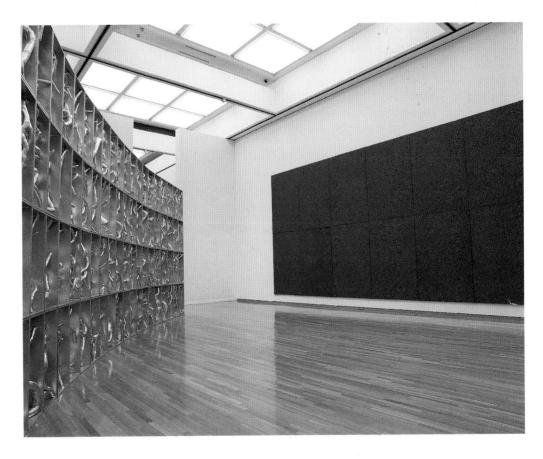

York's atmosphere your work flourished, beginning with the spectacular large-scale canvases such as your *Infinity Net* paintings of the late 1950s and early 1960s. Still, the nets and dots that dominate your early New York works are clearly prefigured in the small drawings you made before your move to America. These nets and dots are predicated on a technique of simple, mechanical repetition; yet, in a sense, they also epitomize hallucinatory visions. At that time, were you interested in Surrealism?

Kusama **I had nothing to do with Surrealism. I painted only as I wished.**

Tatehata I once wrote that Kusama was an 'autonomous' Surrealist; which is to say that without you having had any direct knowledge of the Surrealist movement, the outbursts from your singular, fantastic world characteristically appeared to converge with the world of the Surrealists. To put it another way, André Breton and his colleagues began this movement by methodologically legitimizing the world of those who possessed unusual visions such as yours.

Kusama **Nowadays, some people in New York call me a 'Surrealist-Pop' artist. I do not care for this kind of labelling. At one time, I was considered to share the sensibility of the monochrome painters of the early 1960s; at another time I was regarded as a Surrealist. People are confused and don't know how to understand me. Regardless, some want to call me a Surrealist, trying to pull me to their side, others want me in the camp of Minimal Art, pushing me in the other direction. For example, Henk Peeters, an ex-member of the European Zero group, came to the opening reception of my exhibition at The Museum of Modern Art, New York in 1998. He phoned his former Zero Group colleagues all over the world and told them to come and see my show; but I had no special relationship with Zero. All I did was do what I liked.**

Tatehata You haven't thought much about 'isms', have you?

Kusama **Nil.**

Tatehata Yet people try to attach these labels to you.

The artist in her studio,
Matsumoto, Japan, *c.* 1953

Kusama **Since I rely on my own interior imagination, I am not concerned with whatever they want to say about me.**

Tatehata Another question I have is: why did you go to America in 1958, particularly after you had gained admission to the Académie de la Grande Chaumière in Paris?

Kusama **I chose America because of my connections. Besides, I believed the future lay in New York. However, I had a hard time due to the restrictions imposed on foreign exchange by the Japanese government. I even sold my *furisode* [long-sleeved kimonos with sumptuous designs]. Georgia O'Keeffe, with whom I had corresponded since before my arrival in the US, was so worried that she invited me to come to her place, offering to take care of me. But I remained in New York, in a studio with broken windows at the junction of Broadway and 12th Street.**

Tatehata Did the various art scenes in New York excite you?

Kusama **The first thing I did in New York was to climb up the Empire State Building and survey the city. I aspired to grab everything that went on in the city and become a star.**

At the time, New York was inhabited by some 3,000 adherents of action painting. I paid no attention to them, because it was no use doing the same thing. As you said, I am in my heart an outsider.

Tatehata Are you self-conscious at being an outsider?

Kusama **Yes, I am.**

Tatehata To you, 'outsider' must be a word of pride; to me, you are no mere outsider. It feels odd to say this in front of the artist herself, but Kusama can be considered as an artist who, seriously engaged with the art of her time, has been situated at the centre of the unfolding of art history, like Van Gogh. Mere outsiders could not change history.

Kusama **I had no time to dwell on which school or group I belonged to. Van Gogh would have thought little of schools when he was painting. I cannot imagine how I will be classified after my death. It feels good to be an outsider.**

Tatehata Still, you had certain exchanges with other artists.

Kusama **Yes. Lucio Fontana, for example, in Europe. I made some of my works at his place and he helped me with my exhibitions. Our contact lasted until his death in 1968. I borrowed $600 from him to have the mirror balls (*Narcissus Garden*) fabricated for the Venice Biennale in 1966. He died before I could pay him back. He spoke highly of my work; he was very kind to me. He was like that, encouraging the development of younger artists. His work is also wonderful, both his painting and sculpture.**

Tatehata And in New York?

Kusama **I was close to Joseph Cornell for ten years. He developed an obsession for me. When I first visited him he was dressed in a ripped sweater. I was very scared, I thought I was seeing a ghost. He had such an extraordinary appearance, and he lived like a hermit. He was unusual as an artist. He, too, was an outsider.**

Tatehata How about Donald Judd?

Kusama **My first boyfriend. I met him in the early 1960s, when he was very poor. He was studying at Columbia University and had just begun writing criticism for *Art News* and *Arts Magazine*.**

Tatehata He made a very accurate observation of your work. As a formalist, he keenly discerned the spatial essence of your *Infinity Net* paintings – their stratified structure and oscillating sensation.

left to right, from top l., **Untitled**
1954
Ink, watercolour, pastel on paper
25 × 17.5 cm

Untitled
1952
Ink, watercolour, pastel on paper
25 × 17.5 cm

Phosphorescence in the Day
c. 1952–53
Ink, watercolour, pastel on paper
25 × 18 cm

Untitled
1952
Ink, watercolour, pastel on paper
27 × 19 cm

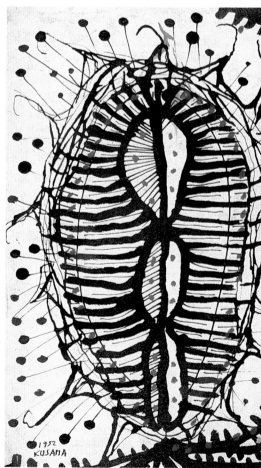

God of the Wind
1955
Oil on canvas
51.5 × 64 cm

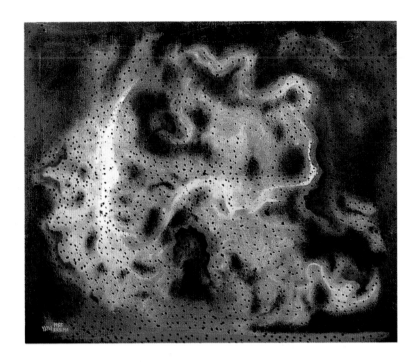

Kusama Judd was a theorist. Simply put, he could not make an ordinary kind of work. In a sense, half of his work at that time was my making. He once griped, 'What shall I do now? I am at a loss.' I responded, 'This, this is it', kicking a square box that we had picked up somewhere and turned into our table. That gave him a hint for his box pieces. We were both extremely poor. As I recall, an armchair that became one of my *Accumulation* pieces was also scavenged from somewhere by him. He helped me make the stuffed phalluses from bed linen.

Later I moved to a larger studio, separated from Judd. Larry Rivers and John Chamberlain lived upstairs; On Kawara was across the hall from Chamberlain. One day I was struck by fear while I was standing in the building. I cried out: 'I'm scared. Somebody, please come.' There came Mr Kawara: 'Don't worry. No need to be scared, I am with you.' He lay down with me. There was no sex but we held each other naked. He helped calm down my attack. My attacks became so severe that an ambulance came every night. At the hospital they recommended I see a psychoanalyst.

Tatehata What was your problem?

Kusama Depersonalization. Everything I looked at became utterly remote.

Tatehata Did you have the same problem while in Japan?

Kusama Yes. When I was a child, my mother did not know I was sick. So she hit me, smacked me, for she thought I was saying crazy things. She abused me so badly – nowadays, she would be put in jail. She would lock me in a storehouse, without any meals, for as long as half a day. She had no knowledge of children's mental illness.

Tatehata How long did your hallucinations persist?

Kusama I still have them.

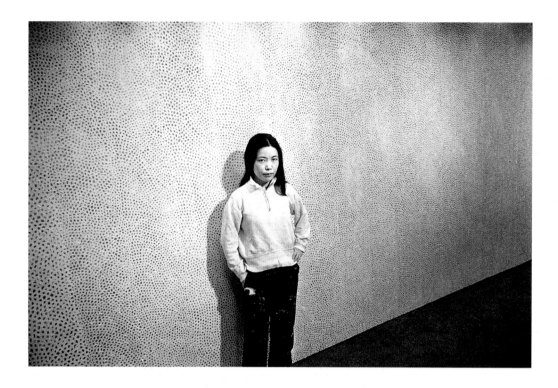

left, The artist with **Infinity Net**
painting, Stephen Radich Gallery,
New York, 1961

opposite, **No. F.C.H.**
1960
Oil on canvas
76.5 × 66 cm

Tatehata Is your work a kind of art therapy?

Kusama **It's a self-therapy.**

Tatehata Is it fair to say that you make your work in order to gain spiritual
stability and release yourself from psychosomatic anxiety?

Kusama **Yes. That is why I am not concerned with Surrealism, Pop Art,
Minimal Art, or whatever. I am so absorbed in living my life.**

Tatehata I interpret your dot motifs as representing a hallucinatory vision.
In your experience, just as attacks of depersonalization bring you a vision of
fear, so do these dots. Proliferating dots append themselves to scenes around
you. You attempt to flee from psychic obsession by choosing to paint the very
vision of fear, from which one would ordinarily avert one's eyes …

Kusama **I paint them in quantity; in doing so, I try to escape.**

Tatehata You have also described this process as a 'self-obliteration' into
a world suffused with dots. Salvation through self-obliteration.

Kusama **I was so desperate that I made my art during hallucinations. When
I was studying *Nihonga* ('Japanese-style painting' that employs traditional
glue-based mineral pigments) in Kyoto, I would go out in the rain to practise
Zen, wearing only a T-shirt. I would meditate in the mud in a heavy down-
pour, go home when the sun came out, and pour icy water over my head.
I could not work otherwise.**
In some ways, my New York years were no different.

Tatehata Is the imagery of phallus-covered furniture related to your
hallucinations?

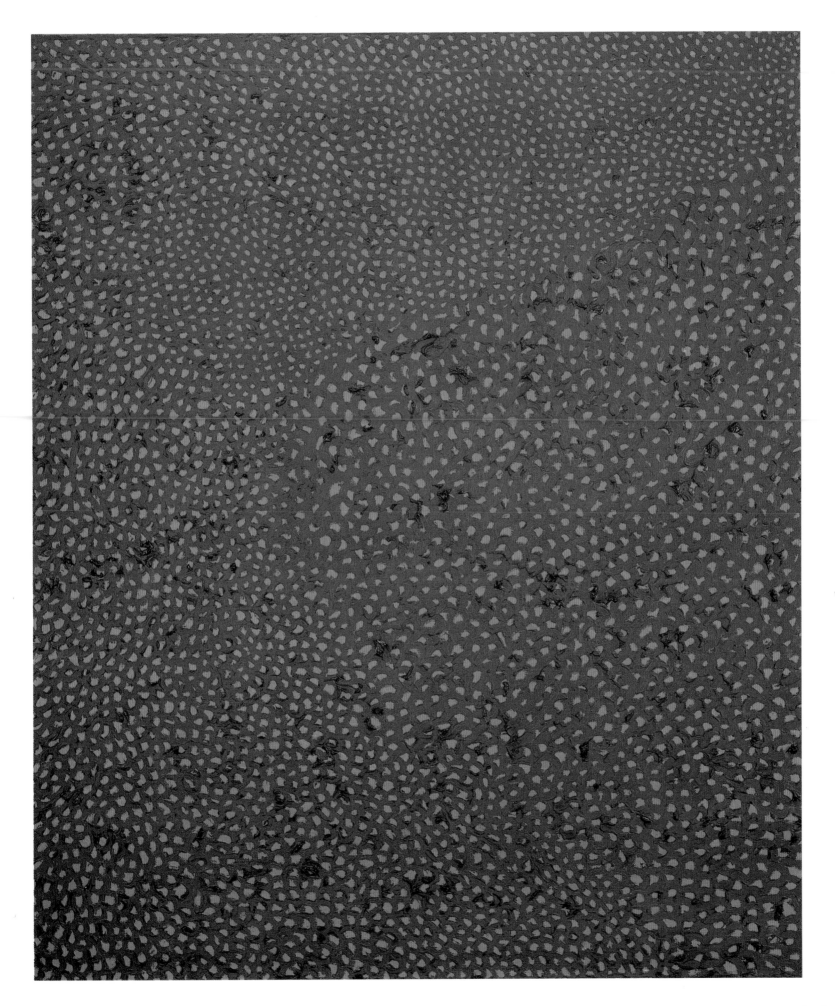

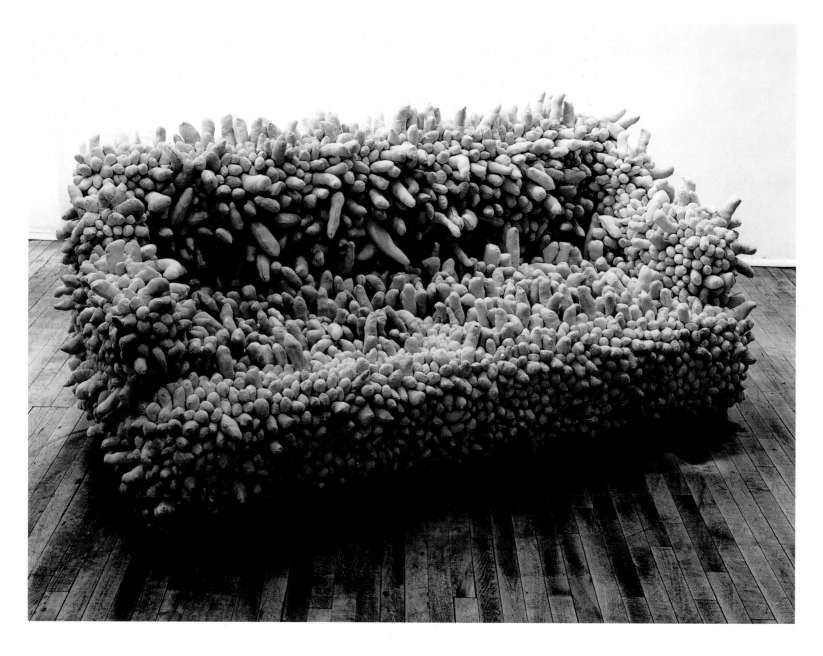

Kusama **It is not my hallucinations but my will.**

Tatehata Your will to cover the space of your life with phalluses?

Kusama **Yes, because I am afraid of them. It's a 'sex obsession'.**

Tatehata Still, these works motivated by your interior necessity are considered to be precursors of Minimal and Pop Art. Although what people say may be of no concern to you, it is a fact in terms of chronology. Art historically, your work of the late 1950s and early 1960s was contemporary with that of the Zero and Nul Groups and what became known as the New Tendency in Europe, with its emphasis on monochrome works.

Kusama **In 1960 one of my *Infinity Net* paintings, *Composition* (1959), was included in Udo Kultermann's exhibition 'Monochrome Malerei' at the Städtisches Museum in Leverkusen, Germany. Mark Rothko and myself were the only two artists from America invited to participate. I made an inquiry as**

opposite, **Accumulation No. 2**
1962
Sewn stuffed fabric, paint, sofa
frame
89 × 223.5 × 102 cm
Installation, artist's studio, New
York
Collection, Hood Museum of Art,
Dartmouth College

right, **Accumulation** furniture and
shoes, the artist's studio, New
York, *c.* 1961–62

Suitcase and shoes, the artist's
studio, New York, *c.* 1963

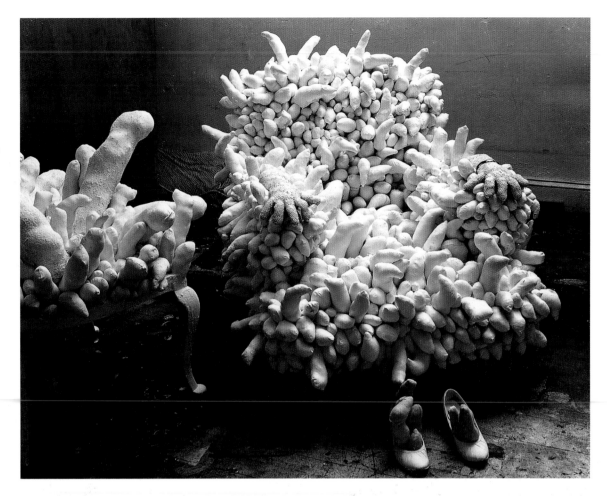

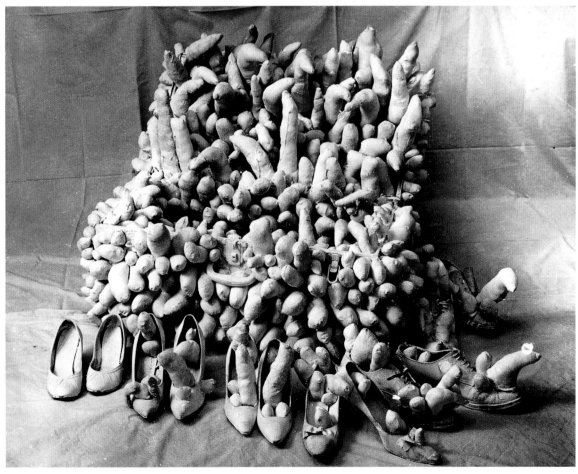

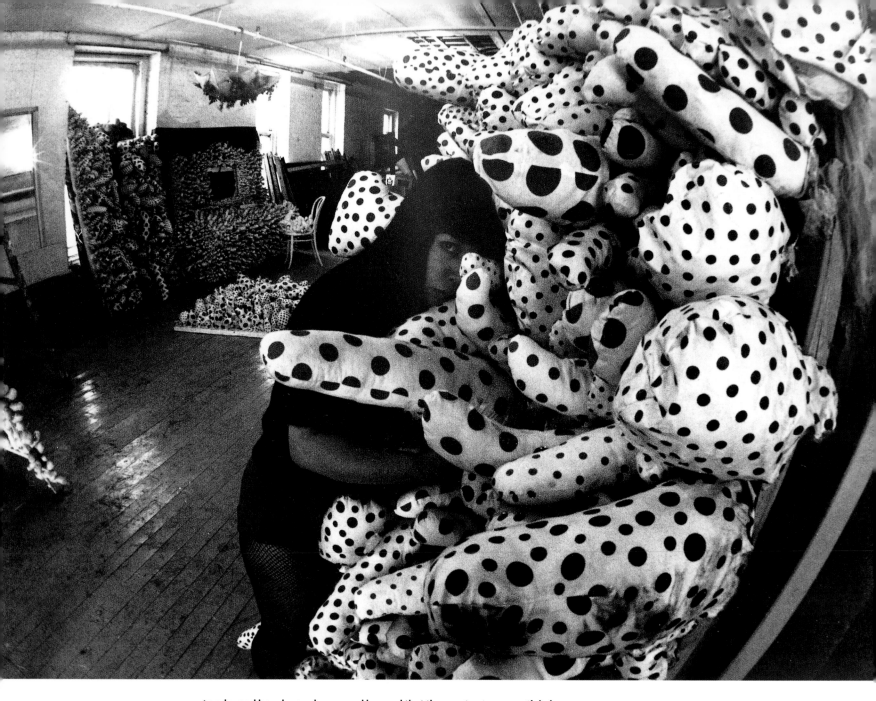

to why and how I was chosen and learned that the curator saw an article in *Arts Magazine* that discussed my work as black-and-white painting. It was on this basis that Kultermann initially contacted me.

Tatehata You yourself did not think that you were making monochrome works?

Kusama **No. People made it up after the fact. My** *Infinity Net* **paintings and** *Accumulation* **works had different origins from the European monochrome works. They were about an obsession: infinite repetition. In the 1960s, I said:** *'I feel as if I were driving on the highways or carried on a conveyor belt without ending until my death. This is like continuing to drink thousands of cups of coffee or eating thousands of feet of macaroni … I am deeply terrified by the obsessions crawling over my body, whether they come from within me or from outside. I fluctuate between feelings of reality and unreality.'*[1]

Tatehata Your obsession with repetition signals both desire, and the need to escape. However, you also added: *'In the gap between people and the strange jungle of civilized society lie many psychosomatic problems. I am deeply*

Accumulation No. 2
1962
Sewn stuffed fabric, paint, sofa frame
89 × 223.5 × 102 cm
The artist's studio, New York

Accumulation pieces, the artist's
studio, New York, c. 1963–64

*interested in the background of problems involved in the relationship of people
and society. My artistic expressions always grow from the aggregation of these.'*[2]

Kusama **Yes.**

Tatehata When I say you are no mere outsider, this is not an unfounded opinion
that I made up. All the more because you are an actual person who breathes the
same air as we do, you were able to exert a tremendous influence.

Kusama …

Tatehata For example, you challenged the authorities of the time, as in your
guerrilla event at the Venice Biennale in 1963.

Kusama **Yes, what was most important about *Narcissus Garden* at Venice
was my action of selling the mirror balls on the site, as if I were selling hot
dogs or ice cream cones. I sold the balls from *Narcissus Garden* at $2 each.
This action was done in the same spirit as my nude Happenings.**

Tatehata So, in an explicit challenge to the authorities, you not only exhibited
but also put your work on sale outside the Italian Pavilion – until the organizers
of the Biennale stopped you. I have to confess, however, that I was mesmerized
by the installation itself of *Narcissus Garden,* which was re-created for your
retrospective in 1998–99, especially when it was displayed outdoors at the
Los Angeles County Museum of Art. It radiated a beautiful, almost sanctuary-
like, light.
 The Rockefeller Garden at the Museum of Modern Art in New York, where
you staged one of your later guerrilla nude Happenings (*Grand Orgy to Awaken
the Dead*, 1969), was at the very centre of all the American art institutions.
You chose your sites very pointedly.

Kusama **In the Rockefeller Garden I did body painting while my models
fucked a bronze sculpture by Maillol.**

Tatehata Although many of your Happenings bore social messages, people
tended to see them as scandals. Sacred scandals, I would say in retrospect. Did
you from the beginning plan to incite a scandal or was it an unexpected result?

Kusama **It was not intentional. Whatever I did tended to become a scandal
or a piece of gossip.**

Tatehata When we think about it, these scandalous Happenings differ a great
deal from your lonely toil in the studio. Whereas in your Happenings you were
the leader of many participating people, in your studio you spent endless time
alone, painting the *Infinity Net* works. It was a monotonous, solitary act.
What inspired you to change your *modus operandi*, from the interiorized self-
salvation of your early New York days to an anti-establishment, anti-
institutional provocation that directly engaged society?

Kusama **Since people in New York were so conservative, so narrow-minded
about sex, I wanted to overturn the conventions through my**

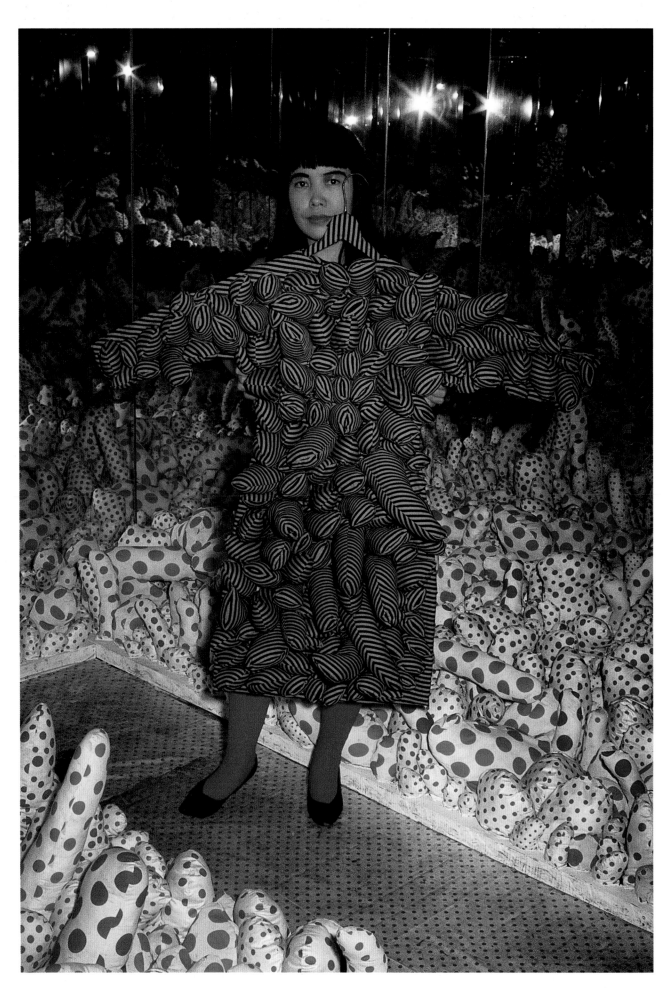

Infinity Mirror Room (Phalli's Field)
1965
Sewn stuffed fabric, mirrors
360 × 360 × 324 cm
Installation, 'Floor Show',
Castellane Gallery, New York

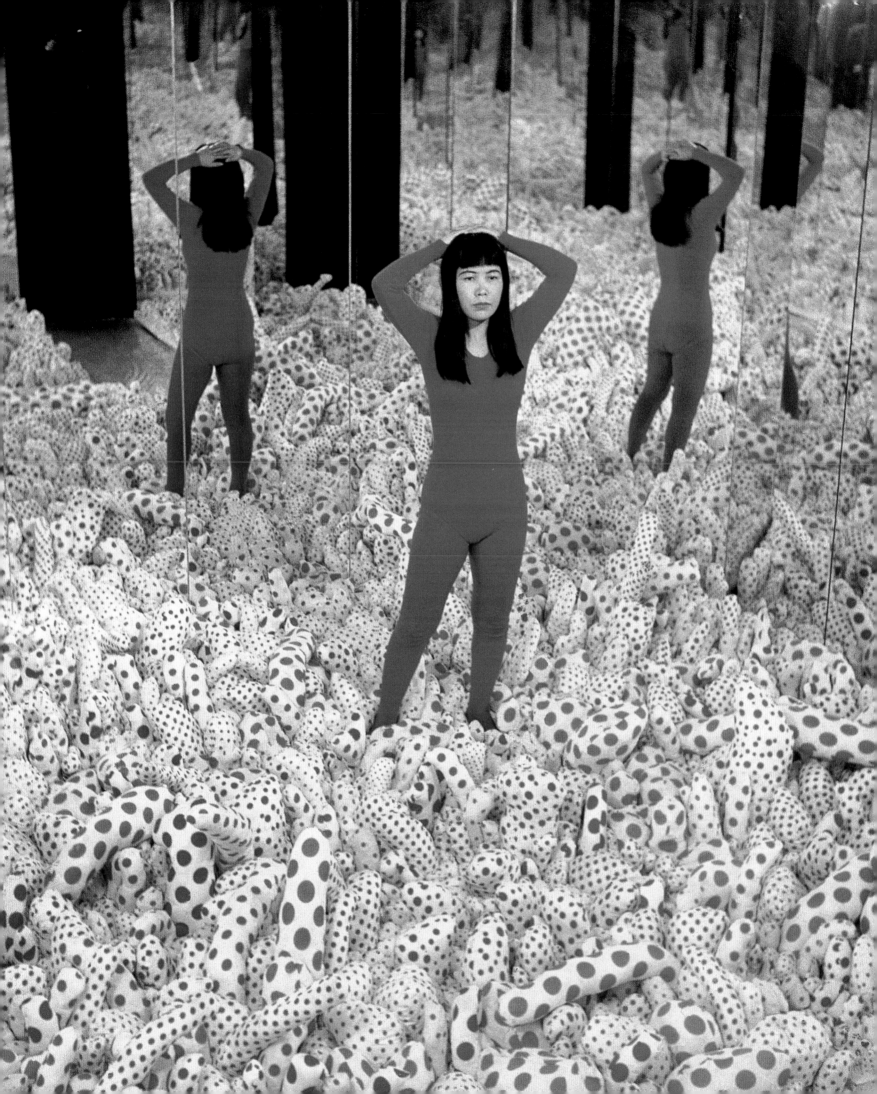

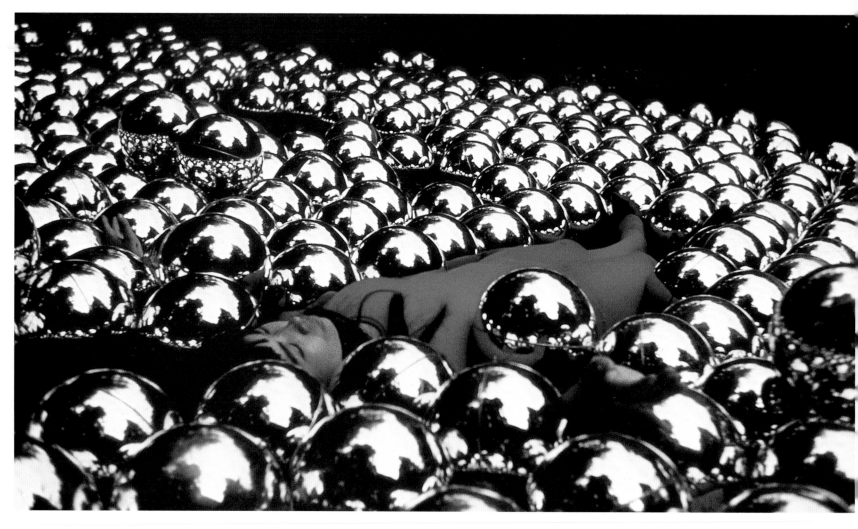

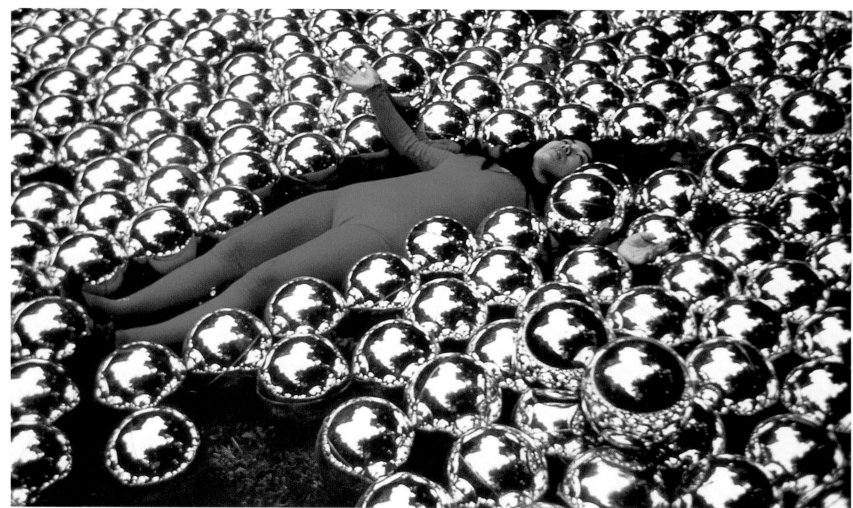

Narcissus Garden
1966
Plastic mirror balls
1,500 balls, ø 20 cm each
Installation, XXXIII Venice
Biennale

demonstrations. I organized several political Happenings involving national flags. One Happening was staged in front of the United Nations building in 1968 when the Soviet troops invaded Czechoslovakia. I washed a Soviet flag with soap, because the Soviet Union was dirty.

Tatehata Among your oeuvre, politically and socially oriented works were concentrated in the brief period of the late 1960s. You did little work of this kind before or after this period.

Kusama **At the end of the 1960s I did think of continuing, somehow, in this direction. I was planning a Broadway musical entitled *Tokyo Lee Story*. The protagonist, Tokyo Lee, was me. Rocky Aoki and I attempted to set up a fund-raising company. We lined up the actors and stagehands, but then, in late 1969, I became sick again. So I saw a doctor, who said that it was nothing. The psychiatrists I saw were in my opinion a mess, with their heads muddied and brainwashed by Freud. For me, they were useless clinically. I frequented them, but my illness remained as debilitating as ever. It was a waste of time. They were antiquated Freudians. All I needed from them was a piece of information about how to cure myself, which they never gave me. As they asked, I recounted to them, 'My mother did this to me, did that to me.' The more I talked, the more haunting the original impression became.**

Tatehata They didn't save you but prompted your memory to recover?

Kusama **My memory became clearer and clearer, larger and larger, and I felt worse and worse.**

Tatehata Towards the end of the 1960s you also founded a fashion company, which marketed radically avant-garde clothes. It was a part of your art project.

Kusama **Walking on the streets, I noticed many people who wore clothes which were very similar to my designs. After some investigation I identified a company called Marcstrate Fashions, Inc., which manufactured them. I met with the company's President, showed him a trunkful of my designs, and told him that his products were all imitations of my ideas. He said, 'Oh, you are ahead of me, I didn't realize.' Then he and I decided to make a company that specialized in my line. It was an officially incorporated company. He was Vice President and I was President.**

Tatehata What was it called?

Kusama **Yayoi Kusama Fashion Company. The mass media reported about us big time. We did fashion shows and had a Kusama corner at department stores. Buyers from big department stores came and selected 100 of this, 200 of that, although they only bought the more conservative styles. The radical vanguard items that I poured my energy into sold little in the end.**

Tatehata In the 1970s you returned, or rather moved your activities, to Japan.

Kusama **I came back to Japan to have surgery. I had a foot problem. A doctor in New York didn't even give me a blood test, didn't know what was wrong.**

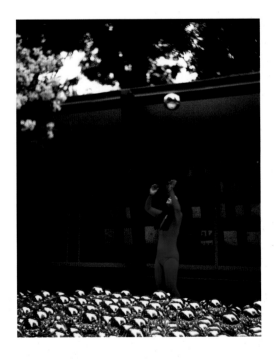

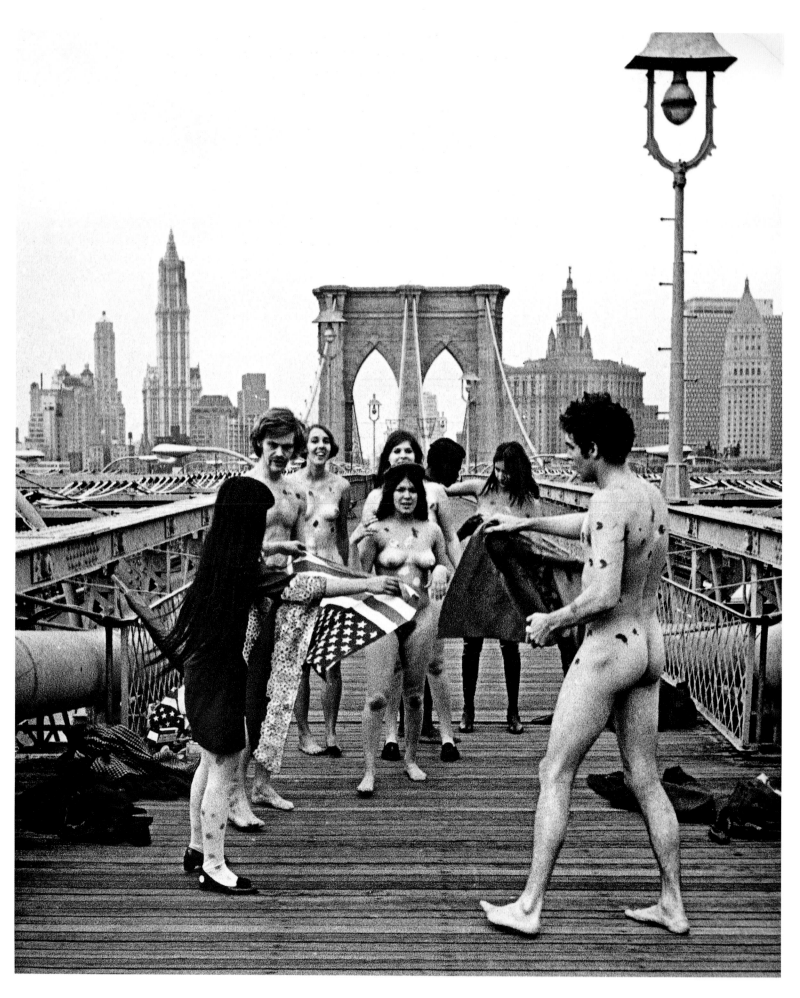

Naked Happening Orgy and Flag-
burning, Brooklyn Bridge, New
York, 1968

Tatehata The first time I saw your work was at Nishimura Gallery in Tokyo, where you showed your collages in 1975, soon after your return. I was much moved by the mysteriousness of your singular, fantastic world. The commonly held opinion in Japan was that Kusama had returned a loser from New York. That was completely blown away when I saw your work. It was then that I made it my curator's mission to have society rediscover this genius. It is humbling how long it has taken to realize this goal.

By the way, I wonder why your works made in New York and in Tokyo are so different? I don't mean to suggest that one is better or worse than the other. The same can be said of your early Japanese work before you went to America.

Kusama **Originally, I didn't have enough space in Japan to make large works.**

Tatehata In addition to the issue of scale, your New York work feels drier and more inorganic, whereas your Japanese work is – though I am concerned that my expression may be misleading – more literary. That is the kind of difference I have in my mind.

Kusama **I could not survive in New York otherwise. You cannot live there with a lyrical frame of mind.**

Tatehata When you came back to Japan the fantastic and lyrical aspect of your work that characterized the pre-New York works re-emerged. It is interesting that your work after New York grew increasingly younger. Your fantastic vision is beautiful yet macabre. Your New York works exude an awe-inspiring sense of scale, with literary qualities eradicated. Presenting an intensified vision marked by materiality, they have their virtue. However, when you came back to Japan, another aspect of your work emerged.

Silver Squid Dress
c. 1969
Silver lamé
150 × 115 cm
left, Original design worn by
model, *c.* 1969
middle, Reconstruction, 1997

far right, **Avant-garde Fashion**
c. 1969
Silver lamé
150 × 110 cm
Reconstruction, 1997

Kusama **A reverse side, so to speak.**
It is as if another person surfaces, to complement my personality. If New York is the front side, Japan is the back.

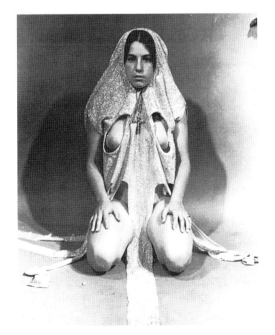
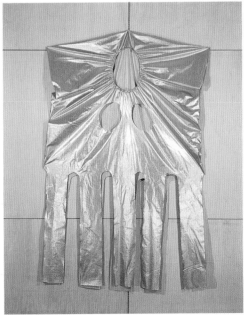
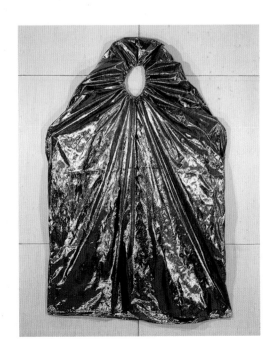

Tatehata If so, even works by an outsider artist like yourself are differently affected by their surrounding environments: New York versus Tokyo and Japan.

Kusama **It's true. In Japan, I write poetry. In New York, there was no mood for poetry; every day was a struggle with the outside world. It's hell for a woman to live alone there. For example, one day when I returned to my studio I found all my belongings had been stolen; I saw my paintings suddenly appear in junk shops.**

Tatehata You produced no literary or poetic work in New York. Certainly New York is a theme in your works of literature but these were all written in Japan. You have published fifteen volumes of novels since your return to Japan.

Kusama **I also wrote and composed songs.**

Tatehata Composition as well?

Kusama **Yes. I bought a piano.**

Tatehata Did you sing them?

Kusama **Not in public, but I sing them at home. One is called 'Song of a Manhattan Suicide Addict' (1974). It goes like this:**

Swallow antidepressants and it will be gone
Tear down the gate of hallucinations
Amidst the agony of flowers, the present never ends
At the stairs to heaven, my heart expires in their tenderness
Calling from the sky, doubtless, transparent in its shade of blue
Embraced with the shadow of illusion
Cumulonimbi arise
Sounds of tears, shed upon eating the colour of cotton rose
I become a stone
Not in time eternal
But in the present that transpires

Tatehata This is included in your anthology of poetry, *Kakunaru urei* (*Such a Sorrow*, 1989). Your word images are piercing. Your novels received high praise from the reputable novelist Kenji Nakagami and one of them won you a literary award for emerging writers.

Kusama **He was very supportive. It is truly a great loss that he died young.**

Tatehata For you, what is the relationship between art and literature? Do they share anything or are they totally different?

Kusama **Different.**

Tatehata Do you consider writing as a means of self-salvation?

Kusama **No, poetry is not about self-salvation.**

opposite, left, **Untitled**
1975
Collage, ink, watercolour, pastel
on paper
39.5 × 54.5 cm

opposite, right, **Eyes of the Night**
1975
Collage, ink, watercolour on paper
39.5 × 54.5 cm
Collection, Chiba City Museum of
Art, Japan

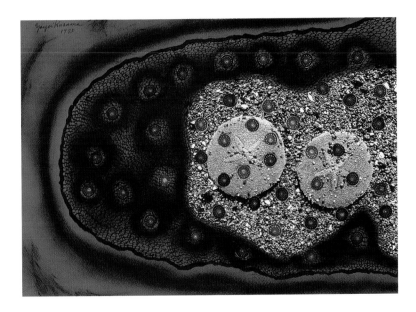

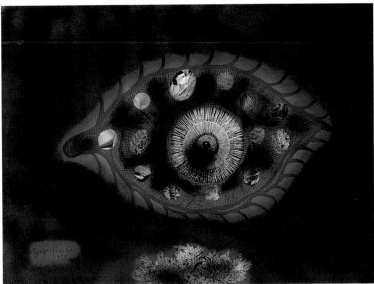

Tatehata You mean poetry is differently motivated than art?

Kusama **That is correct. When I was writing poetry in the 1970s, I was very depressed. I was on the verge of committing suicide, constantly. I consulted with a doctor in Tokyo and was advised that hospitalization was necessary.**

Tatehata I have one more question that will probably bore you.
In recent art criticism and scholarship, there is a distinct tendency to honour you as a great forerunner of feminist art, to interpret your work within the history of feminist struggles.

Kusama **I am too busy with myself to worry about a man-woman problem. Since I find a refuge in my work, I cannot be bullied by men.**

Tatehata However, would you say that those who wish are free to render a feminist interpretation of you?

Kusama **Yes. Although I have never thought of feminism. In my childhood, I experienced so much hardship, all thanks to 'feminism'. My mother wielded a tremendous amount of authority and my father was always dispirited.**

Tatehata Your family was a matriarchy, with your mother at the centre.

Kusama **She turned the entire household into her own castle. Her children had no meaning other than as existences subordinate to hers. She was smart and very strong. She was also good at painting and calligraphy. She was a valedictorian at her school. My father was dominated by her, which he disliked. He customarily went out, he was absent at home. Yet he was a very kind father.**

Tatehata Psychoanalysts would have a lot to say on the subject – citing the Electra complex among other things. However, feminist discussion of your work has produced certain interpretations that cannot be ignored. Indeed your phallus-covered high-heeled shoes, handbags and dresses are potent fetishes.

Your work also merits a formalist analysis, as articulated by Donald Judd, for example, and furthermore it has the impact, which we have discussed, of art that comes from an outsider. You are at once part of the New York scene and closely connected to the European trends of the 1960s. You are regarded as a progenitor of feminist and issue-oriented art. Your work allows all these inherently contradictory discourses, yet departs from them all. You are an artist outside the given boundaries. It may take a little more time to comprehend the whole body of your work.

Kusama **I have had so many hardships, with people saying various things about me. Time is finally turning a kind eye on me. But it barely matters, for I am dashing into the future.**

Translated from Japanese by Reiko Tomii

1 Interview Prepared for WABC radio, New York by Gordon Brown, executive editor of *Art Voices*; first published in *De nieuwe stijl/The New Style: Werk van de internationale avant-garde*, Vol. 1, De Bezige Bij, Amsterdam, 1965, pp. 163–64. Reprinted in this volume, pp. 100-105

2 Ibid., p. 164

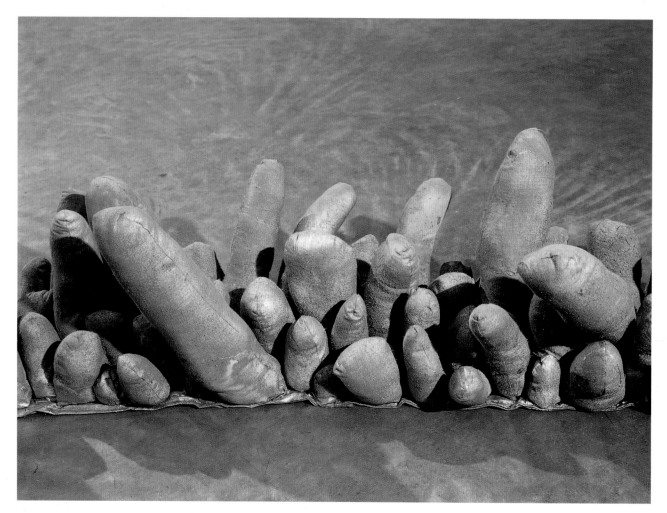

left, **A Snake**
1974
Sewn stuffed fabric, silver paint
25 × 30 × 650 cm

opposite, **Silver Shoes**
1976
Sewn stuffed fabric, shoes, silver paint
Dimensions variable

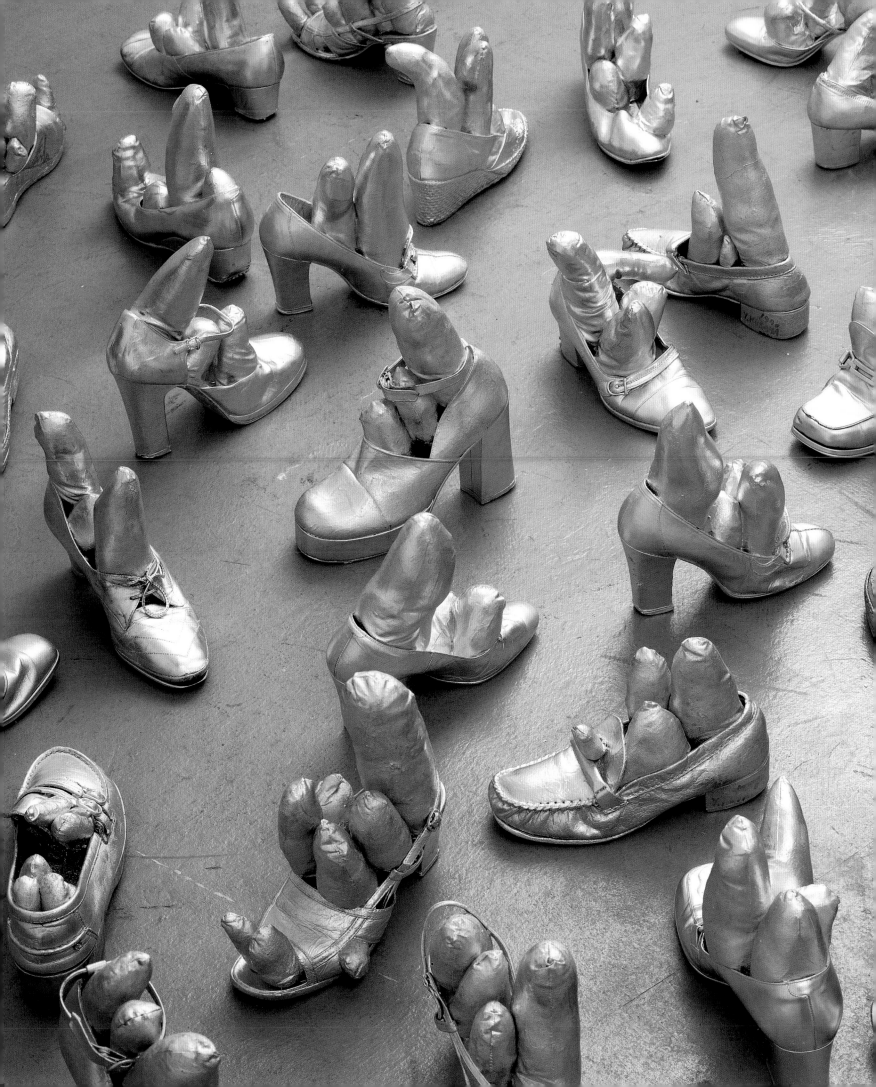

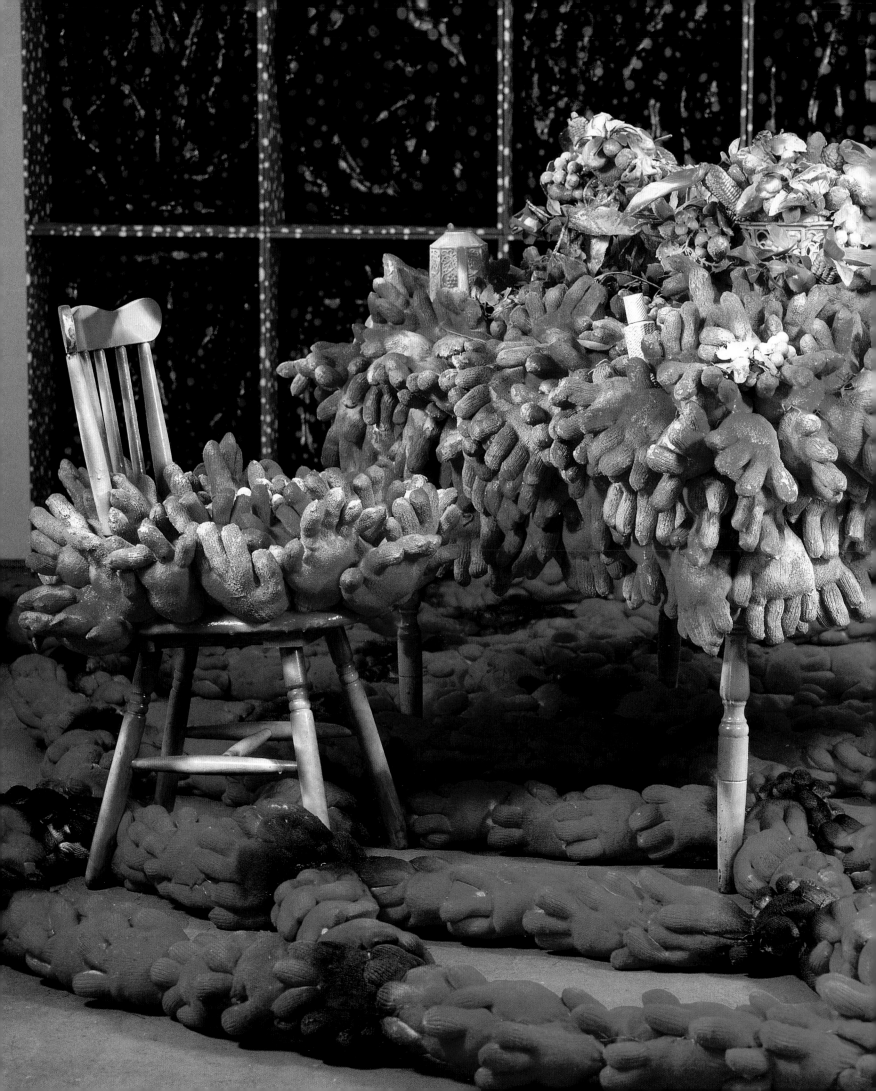

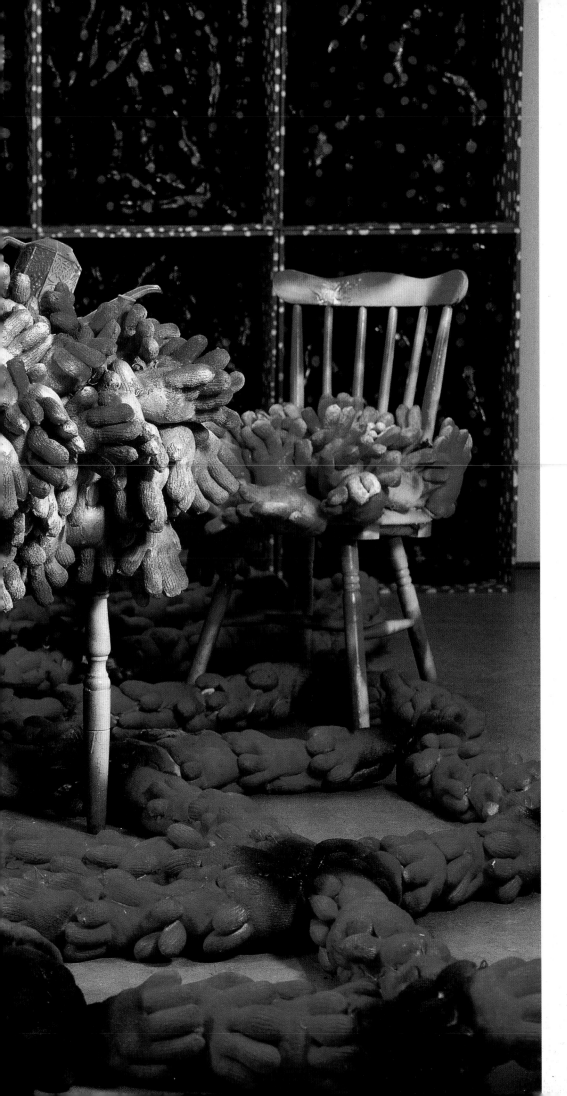

Installation, Ota Fine Arts, Tokyo, 1997
background, **Sea of the Summer**
1983
Sewn stuffed fabric, wood, paint
180 × 365 × 39.5 cm
centre, **End of Summer**
1980
Stuffed cotton work gloves, household objects, furniture, paint
136 × 235 × 175 cm
foreground, **The Red Horizon**
1980
Stuffed cotton work gloves, paint
360 × 342 × 9 cm

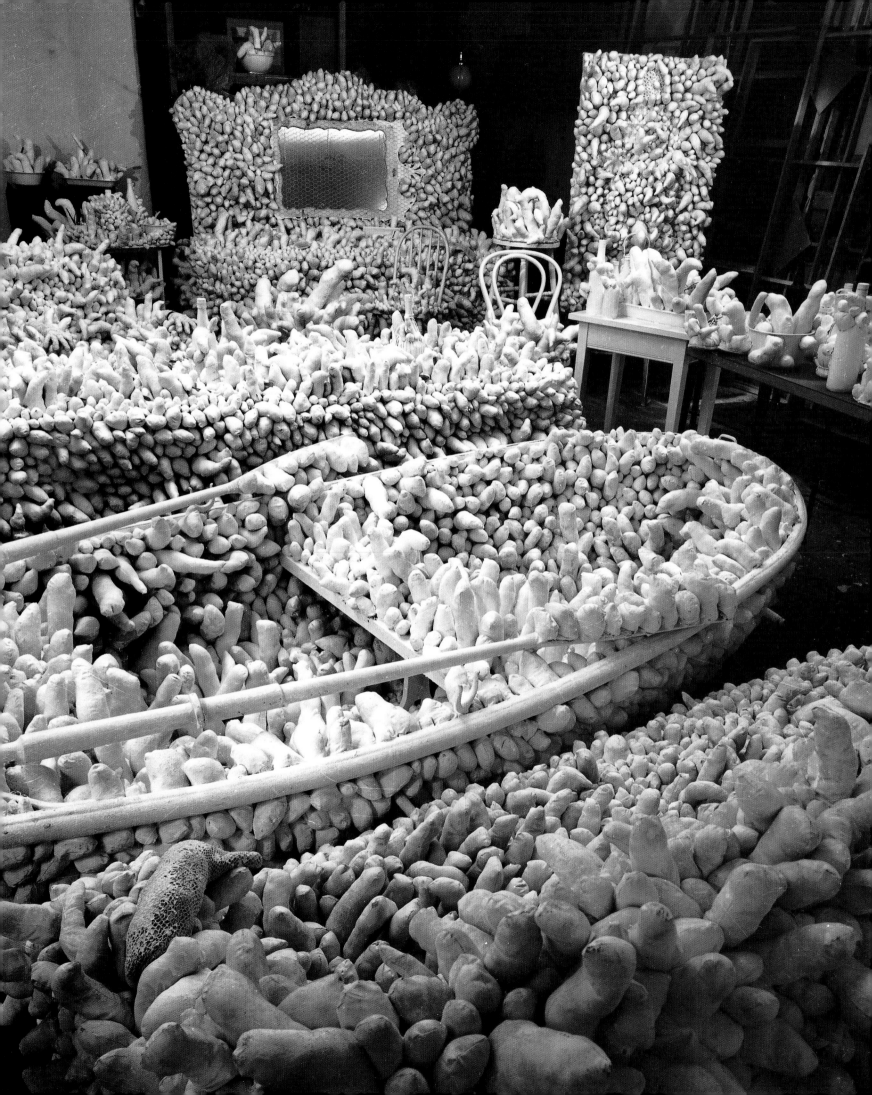

Contents

Untitled
1939
Pencil on paper
25 × 22.5 cm

I. Fame

In 1966 Yayoi Kusama wrote to one of her gallerists in Europe, 'I must ... work very hard to be internationally active in an avant-garde manner.' From the very beginning of her long and astonishingly prolific artistic career, Kusama has concentrated on the seemingly impossible goal of spreading her vision like a vast net over at least three continents. It has taken more than four decades of struggle, but she has succeeded.

It has been said of many late twentieth-century artists that their lives and their art are inseparable. This is true for Kusama, not in a figurative sense but in a concrete, visceral one. Kusama *is* the *Infinity Net* and the polka dot, two interchangeable motifs that she adopted as her alter ego, her logo, her franchise and her weapon of incursion into the world at large. The countless artworks that she has produced and that carry Kusama's nets and dots into the world, when seen as a whole, are the mere results of a rigorously disciplined and single-minded performance that has lasted for almost fifty years.

Kusama's work has spread into many media and touched many styles. As a young artist in Japan, Kusama was a painter in both traditional Japanese and European idioms. During the decade of the 1960s, when she was based in New York and exhibiting throughout Europe, she made paintings and sculpture, drawings and collages, kinetic installations, Happenings and even a film. Back in Tokyo in the early 1970s, she continued to paint and sculpt while also producing ceramics. In the second half of the 1970s she began writing novels, short stories and poetry. Most recently Kusama has

made a series of large-scale installations incorporating gigantic inflatables, and has plans for a number of monumental outdoor sculptures. All of her visual art, with very few exceptions, shares a common vocabulary of dense, repetitive patterns made from cell-like clusters she calls *Infinity Nets*: polka dots, phallic-shaped tubers, mailing stickers and even dried macaroni. Since the early 1960s Kusama has described her obsession with pattern as a means of self-annihilation. However, her unceasing restatement of the *Infinity Net* is also a re-affirmation of her persona, a defiant 'I exist'.[1] With its dizzying monotony and labour-intensive intricacy, the making of her obsessive works is, paradoxically, both an act of self-obliteration as well as one of artistic transubstantiation through which the physical self is erased only to be re-asserted in the artist's signature patterns.

Psychoanalytic theory holds that serial repetition is the return of psychic material in symbolic form, and Kusama has traced her obsessive use of the *Infinity Net* pattern and its inverse variations, the phallic accumulation and the polka dot, to 'childhood trauma'. Born 22 March 1929 in Matsumoto City, Japan, the last of four children in a prosperous and conservative family, Kusama's crucial years of early adolescence passed while the country was at war. It was during this time that the artist began to experience hallucinations that have plagued her throughout her life, among them aureoles around objects and veils of patterns before her eyes. Kusama remembers that her first drawings date from this period, and this is significant because in Kusama's

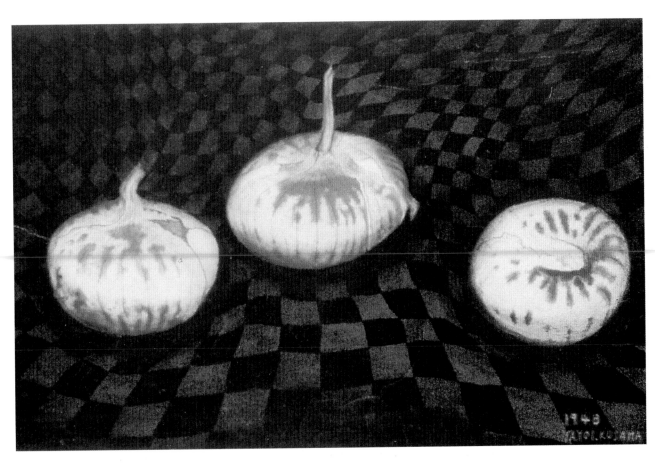

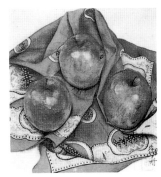

left, **Onions**
1948
Pigment on paper
39.5 × 59 cm

above, **Hayami Gyoshu**
Apples
1920
Pigment, gold leaf on silk
26.5 × 24 cm

own construction of her artistic genealogy, her mental illness is central to every aspect of her work, from her imagery to her working process. It is a testament to the amount of control that the artist had and has over shaping her own artistic person that the main elements of the mythified Kusama of today – the obsession with a signature net/dot pattern, the supernatural productive powers, the madness – were in place at the very beginning of her career as a professional artist, put there by Kusama herself.

Kusama has traced the origins of the *Infinity Net* and polka dot motifs back to a specific series of hallucinations that first struck when she was ten years old: '*One day, looking at a red flower-patterned table cloth on the table, I turned my eyes to the ceiling and saw the same red flower pattern everywhere, even on the window glass and posts. The room, my body, the entire universe was filled with it, my self was eliminated, and I had returned and been reduced to the infinity of eternal time and the absolute of space. This was not an illusion but*

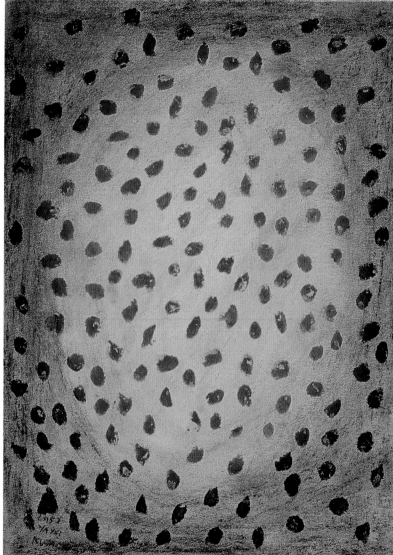

reality. I was astounded. If I did not get away from there, I would be wrapped up in the spell of the red flowers and lose my life. I ran for the stairs without thinking of anything else. Looking down, I saw the steps fall away one by one, pulling my leg and making me trip and fall from the top of the stairs. I sprained my leg. Dissolving and accumulating, proliferating and separating. A feeling of particles disintegrating and reverberations from an invisible universe ... '[2]

Crediting her use of repetitive gestures and motifs to her obsessions, she also attributes her protean production – hundreds of paintings, sculptures and objects, drawings that number in the thousands, prints, ceramics and nineteen published novellas and books of poetry – to her neurotic energy. Kusama's description of the making of her *Infinity Net* paintings offers a chilling picture of an artist physically driven by forces beyond her control. 'I felt as if I were driving on the highways or carried on an [endless] conveyor belt ... to my death', she reported, describing sessions in which she would paint as much as forty to fifty hours at an uninterrupted stretch. *'This is like continuing to drink thousands of cups of coffee or eating thousands of feet of macaroni. This is to continue to desire and to escape all sorts of feelings and visions until the end of my days whether I want to or not ... '*[3]

That the work was and is obsessive is doubtless, but hardly, the result of an ungovernable compulsion. Kusama herself has stated that, 'it is hard to say after all, whether these signature repetitions were caused by my disease ... or by my own intention'.[4] Claiming her

illness as a generative force, it is also, in her words, 'a weapon' not only to 'tide over the hardship of life' but to leave her artistic mark.[5] In her paintings as well as in her career as a whole, Kusama has never ceded control – not even to her illness. The symptoms of Kusama's disorder are helpful in our understanding of her imagery but they are not the subject of her work. They are the engine that drives it.

Kusama was trained in *Nihonga* painting, a style that combined traditional Japanese techniques and materials with nineteenth-century European naturalistic subject matter. By 1950 she had begun to experiment with more abstracted natural forms, painting them in watercolour, gouache and oil paint. Over the next two years this more Westernized work was exhibited frequently and received a measure of recognition from both the Japanese art community and the psychiatric profession, two of whose members were interested enough to present papers, not on Kusama's illness, but on the meaning of her paintings. From 1951 until her departure for the US in 1957, Kusama concentrated almost exclusively on works on paper. It was in these works – which Kusama claims number in the thousands – that the polka dot and the *Infinity Net* patterns develop from stylized motifs based on natural observation to autonomous abstractions.[6] The earliest of these muted and graceful works still bear titles that relate them to objects in nature, like *Cosmos, Heart* or *Flower,* although their motifs are spare and absolutely abstract. All-over patterns of irregular black ink dots on a background faintly tinted blue or rose, and delicate white balls veined through by

opposite, left, **The Heart**
1952
Pastel, ink on paper
38 × 30 cm

opposite, right, **Untitled**
1953
Pastel, gouache on paper
38 × 30 cm

webs of inked lines and floating balloon-like on a charcoal black background, served as Kusama's *morceau de reception* to the American art world. Three of them were chosen for inclusion in the Brooklyn Museum International Watercolour exhibition in 1955 while Kusama was still in Japan; fourteen of the works on paper were enclosed with letters that Kusama began writing to the artist Georgia O'Keeffe later that same year. That a young, unknown, non English-speaking artist who had no previous connection to the reclusive doyenne of American painting would take such an initiative is a bit out of the ordinary, but Kusama, fiercely ambitious and already determined to emigrate to the United States, was no ordinary young artist. Focused on quickly achieving the success which she felt was inevitable, Kusama seems to have carefully, almost scientifically chosen O'Keeffe because she was successful on a world scale and because she was a woman. In her letters to the older artist, Kusama spent less ink discussing her own work than in asking for concrete advice as to how to find an art dealer in Manhattan. 'I hope with all my heart that I will be able to show my paintings [to] dealers in New York', wrote Kusama, 'I am very optimistic in this regard.'[7] O'Keeffe, who expressed guarded admiration for Kusama's watercolours, counselled against Kusama's plan to go to New York. None the less, she was equally straightforward in her advice: 'Take your pictures under your arm', she wrote bluntly, 'and show them to anyone you think may be interested …' 'It seems very odd that you are so ambitious to show your paintings here', she added, 'but I wish the best for you'.[8]

II. New York

After a stopover in Seattle, Washington for an exhibition in late 1957, Kusama arrived in Manhattan in the summer of 1958 with more than one thousand drawings and very little money, determined to support herself by selling her work. Despite an initial success and momentary notoriety, it was a goal that was to elude her for the entire period she lived in New York. The decade during which she used New York City as a base for her artistic practice was one of tremendous personal hardship and professional struggle as well as enormous creative output. It was here that within eighteen months she transformed what had been small-scale motifs into a signature style, played out large in endless variation across miles of canvas, houses full of objects, clothes and even people (on film and in real time), in discos, public parks and museums, in the press and even once or twice on television. These repetitive and obsessive patterns of the *Infinity Net*, the polka dot and the stuffed phallic protrusions Kusama called *Accumulations*, as well as her artistic strategy, developed during the first months in New York, of a no-holds-barred promotion of her art/self, remain to this day the primary elements of her remarkably consistent work.

In the newly minted ruminations on Kusama's long career, it is popular to speculate upon her place in any one of the canonical movements of American and European art history of the 1960s – Abstract Expressionism, Minimalism, Pop. It is clear that her large oeuvre can be related at least tangentially to all three movements as well as kinetic art and the European Nouvelle Tendence.

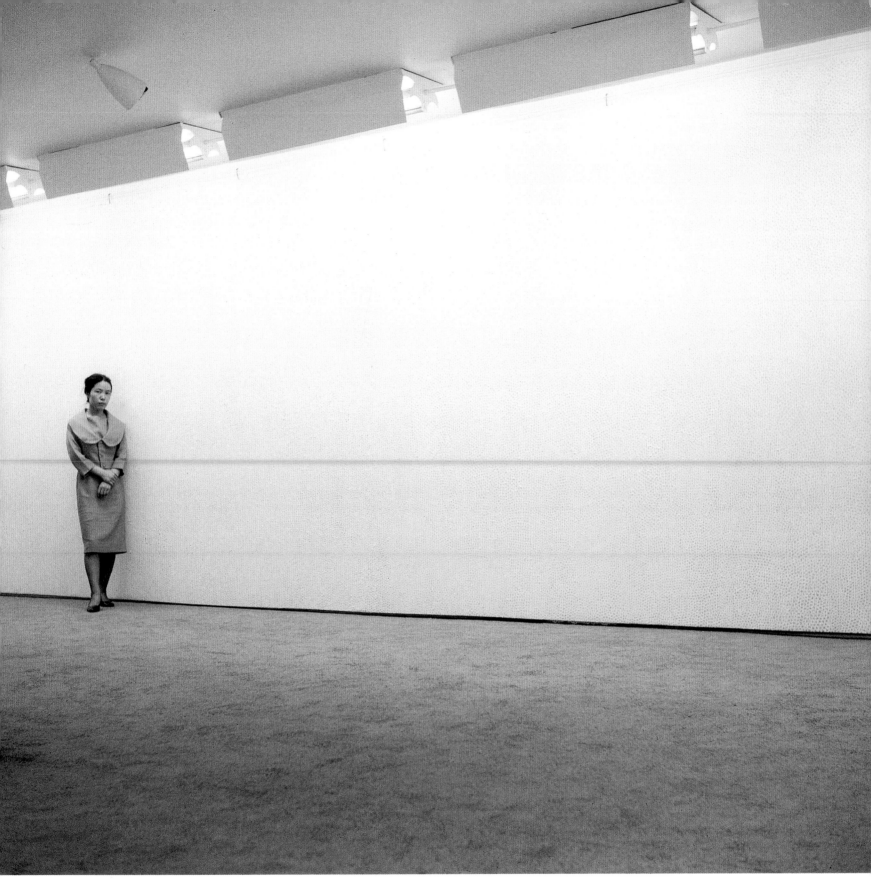

above, The artist with 10 metre
white **Infinity Net** painting, solo
exhibition, Stephen Radich
Gallery, New York, 1961

overleaf, **No. A.B.**
1959
Oil on canvas
210 × 414 cm
Collection, Toyota Municipal
Museum of Art, Japan

40

Infinity Net
1965
Oil on canvas
132 × 152 cm

However related to these movements, Kusama was never a part of them. During that crucial decade of the 1960s in New York when the contemporary art market as we now know it was born, Kusama moved within the art world with considerable skill. A member or adherent of no group of artists in particular, she knew virtually all the major figures of the time. A friendly neighbour of Claes Oldenburg, she was acquainted with many of the major figures of Abstract Expressionism and Pop, including Frank Stella, Ad Reinhardt, Barnett Newman, Marisol and Andy Warhol. Kusama had close friendships with both Joseph Cornell and Donald Judd; the former gave her his works to sell when she was most in need of cash, and the latter ecstatically reviewed her first exhibition in New York and bought a number of her works. It was this winning combination of social skills, unquestionable talent, a keen instinct for what was current in the artistic discourse, and finally, sheer nerve, that allowed her, without money, contacts or the language, to gain a foothold in the extraordinarily competitive New York art world in a surprisingly short period.

In October of 1959, eighteen months after her move to New York, Kusama had her first solo exhibition at Brata Gallery, a well-respected East 10th Street artist's co-operative known for championing second-generation Abstract Expressionists, and whose members included the sculptors Ronald Bladen and George Sugerman, among others. In this exhibition Kusama showed five mural-sized white monochrome canvases covered densely and completely with spiraling chains of tiny circular marks, called *Infinity Nets*.

Although she had employed the *Infinity Net* as a motif in her paintings and drawings created as early as 1948, the 1959 *Nets*, with their severely restricted palette and all-over repetitive pattern, were like nothing the artist had previously produced. Painted from edge to edge on enormous canvases that recalled the heroic scale of Jackson Pollock or Barnett Newman, these *Infinity Nets*, though similar in motif, lack the delicacy and the tenebrous emotion of the gouaches made in Japan. Untitled, save for a muscular numeral or letter designating the order in which they were completed, the *Infinity Nets* boldly referenced the New York School and, on its own ground, challenged its hegemony.[9] Describing the brush-strokes she employed as 'repeated exactly in monotone, like the gear of a machine'[10] Kusama remembers that the painstaking sameness of the composition was a deliberate attempt to find an antidote to the emotionalism of Abstract Expressionism.[11]

One cannot help but conclude that it was the repetitive quality of the *Nets*, as well as their non-relational composition and what was perceived as their 'profound detachment'[12] that attracted the interest of nascent Minimalists like Judd and Stella, both of whom purchased work from Kusama's earliest painting exhibitions.

As an art critic Donald Judd was an early advocate, admiring, along with other critics, the impassivity of the white monochromes, which he described as resembling slabs of 'massive, solid lace',[13] and pronouncing them 'advanced in concept'.[14] As a sculptor, Judd was inspired in his own search for a profoundly anti-rationalist but

boldly literal system of expressing pure form by Kusama's 'complex and powerful idea' of obsession-driven seriality.[15]

It was a similar reading of her work that first brought Kusama to the attention of a number of European artists experimenting with the strategies of monochromy and 'repetitive field structure'[16] in order to achieve a cool, objective art that 'approached the impartiality of graphic data in a laboratory'.[17] Marshalled together under the moniker 'Nouvelle Tendence', groups like Zero, based in Germany, and the Dutch Nul, the French Nouveau Realistes and later the kinetic consortium Groupe de Recherche d'art visuel (GRAV), the Italian Azimuth, Gruppo N and Gruppo T, exhibited together throughout Europe during the first half of the 1960s in large controversial shows designed to counter the influence of American Abstract Expressionism and its pallid European offspring, Informel.

During the decade of the 1960s, Kusama had more exhibitions in Europe than in the US, virtually always under Nouvelle Tendence auspices and much of the time as a participant in Zero, originally a troika of three German artists, Heinz Mack, Otto Piene and Günther Uecker. The artists shared an interest in exploring the material and visual properties of individual components of surface, colour and light in an attempt to create an art that was anti-metaphoric, non-relational and empty of any reference except to itself. By 1960, Group Zero had grown to become a flexible consortium of loosely allied European artists that exhibited together from 1960 to 1965.[18] With no manifesto to guide them, it was understood that

those who showed with Zero shared an involvement with the problem of representing an object in space without resorting to illusionism. To this end, they used a wide variety of strategies with a precision that recalled scientific investigation, but most deployed a single colour across the surface of their work or organized identical geometric forms or found objects within the rigorous confines of a grid.[19] Because they freed painted surfaces or objects from any relationships between their elements, monochromy and monomorphism were ideal formal strategies to strip colour and composition from their traditional descriptive and metaphorical tasks.

While it is not difficult to see why Kusama's *Infinity Nets* might have attracted the interest of American Minimalists like Judd and Stella and the European Zero artists, Kusama's work is utterly different from her Minimalist and Nouvelle Tendence counterparts in its execution and in its *mode d'emploi*. Despite her description of her brushstroke as 'mechanical', and of the paintings themselves as 'empty'[20] one does not have to believe that the *Infinity Nets* are direct transcriptions of hallucinations in order to understand them as highly personalized expressions of the artist's persona. Most obviously, however rote the specific repetitive action used in putting paint to canvas, the result is insistently handmade. Whorls of chain-linked circular forms accumulate in a kind of painterly crochet around a few central nodules strewn at random across the surface, creating an unsystematic pattern as varied as those found in nature, and as personal as

Günther Uecker
Lichtscheibe
1965
59 × 59 × 2 cm

opposite, **Airmail Stickers**
1962
Collage on canvas
181.5 × 171.5 cm
Collection, Whitney Museum of
American Art, New York

above, **Andy Warhol**
Red Airmail stamps
1962
Silkscreen on canvas
51 × 40.5 cm

right, **Accumulation No. 15 A**
1962
Collage on paper
51.5 × 65.5 cm

a signature. It was this planned chaos of the *Nets*, and later, the phallic protrusions in the *Accumulation* sculpture, that caused the critic Lucy R. Lippard in 1966 to cite Kusama's work as a refutation of the coolness of Minimalism and a precursor to a sensuous 'eccentric' abstraction, brought to fruition in the late 1960s by artists like Eva Hesse, Jackie Windsor and others.[21]

This kind of conscious revolt against the emotionless mechanics of the minimal is most evident in a series of collages from 1962 that featured brightly coloured mailing stickers arranged more or less in a raster formation. Although they might conform to the literal definition of serial repetition, they are not so in spirit. The key element – the thrum of sameness that delivers the pleasure of a repeated pattern and the chillingly *Unheimlich* possibility of an endless march of perfect simulacra, is missing.

There is insistent imperfection in all of Kusama's works, but in all the sticker *Accumulations,* with their slipped or missing stickers, gaps and ragged edges, the grid is deliberately ruptured, our pleasure interrupted

above, left, The artist with **Infinity Net** painting, double exposure photograph, early 1960s

above, right and opposite, The artist with **Infinity Net** paintings, studio, New York, *c.* 1961

in length and over 6 feet (1.85 metres) in height, the sheer acreage of canvas covered with the *Infinity Net* pattern stands as inescapable evidence of the frightening acts of endurance that it took to make them. Kusama saw the process of making the *Infinity Nets* as integral to the works themselves, and the physical and emotional energy that she poured into them as an imprint of her physical being. Within the first year of her arrival in New York, and in the direst of financial circumstances, she found the resources to hire professional photographers to document both the act of creating these paintings *cum* environments, as well as the acting out of her spiritual, emotional and almost physical association with them.

So consciously did Kusama want the viewer to make the connection between her physical self and her work that, to the annoyance of some researchers, it is difficult to find a photograph of an *Infinity Net* that does not also include the artist herself standing in front of, on, above or below it. In some instances, Kusama poses in front of her *Infinity Nets* dressed in clothes that mimic their colour or intricate pattern. Other photographs reveal her crouching amidst the paintings as if trying to physically merge with them.

In one extraordinary undated and unsigned double exposure a negative image of an *Infinity Net* is superimposed over a full-length portrait of the artist; through the grid of paint the artist's image is fractured into a thousand tiny pixel-like dots. Transformed into pattern before our eyes, the merger between artist and work of art is complete.

by the artist who reminds us of her fallible, human presence.

That Kusama's works were insistent if not flamboyant in their emphasis on the process was evident to all who followed her work, even to those who praised it for entirely different reasons. To see a show by Kusama, wrote Judd in 1964, is to see 'a result of Kusama's work, not a work itself'.[22] From her earliest exhibitions it was clear to her contemporaries that Kusama herself was 'headed … into the peculiar world of performance art'[23] well before the phrase was coined and she herself began to experiment with Happenings. With the largest *Infinity Net* measuring 33 feet (10 metres)

The artist in her studio, New York,
c. 1964, with **Travelling Life** and
macaroni jacket from **Food
Obsession** series

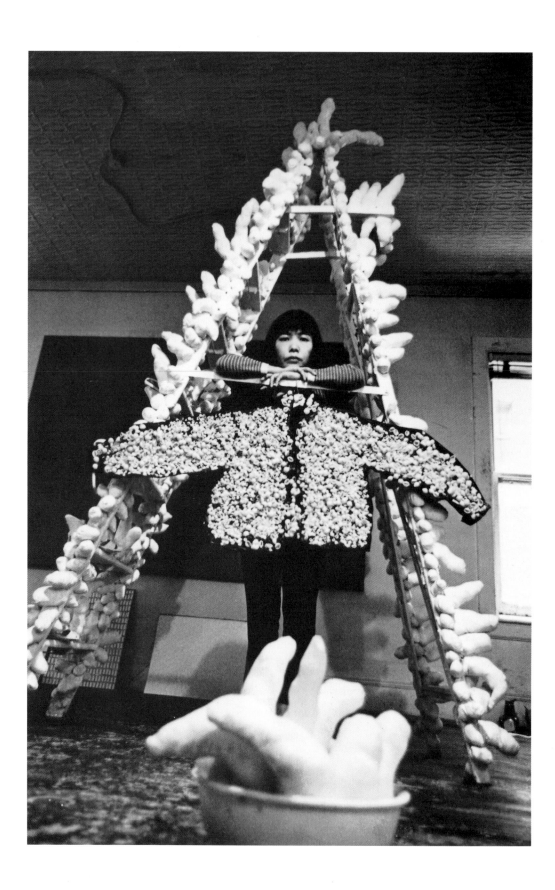

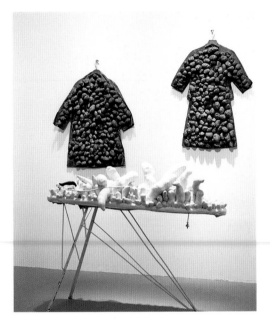 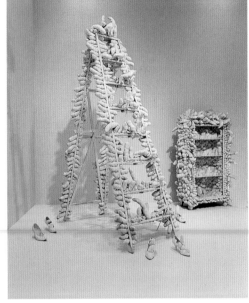 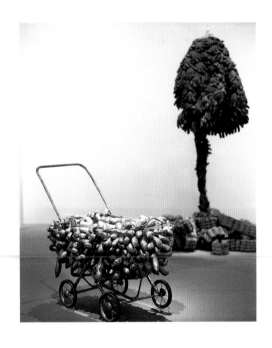

III. Sex

These photographs make clear not only Kusama's desire for her physical 'self-obliteration' by her graphic metonym, but also her desire for her signature pattern to bleed off the canvas and overrun the environment. At the same time as Kusama was completing her largest and most austere *Infinity Net* paintings, she also began to produce sculptures that consisted of household objects – from sofas to chairs to bedpans – covered with profusions of small, stuffed phallic tentacles. Called *Accumulations,* the earliest works were painted white like the first *Infinity Nets*, and can be seen, in a sense, as a psycho-sexual inversion of their dot-like voids. Humorous and frankly sexual, Kusama's phalluses, which, flaccid and erect, joyfully overrun such symbols of feminine

domesticity as irons, baking pans, kitchen tables and ladles, or peak coyly from the inside of shoes and shoulder-bags, also offer a none too subtle commentary on a world absurdly if suffocatingly dominated by the male gender. Playful, they are also angry, suffused with what were no doubt Kusama's personal frustrations as a struggling female artist and foreigner in a chauvinistic and tightly circumscribed art community. If Kusama's use of high heels stuffed with phalluses are her most unnuanced jibe at the male fetish and its quintessential double,[24] close observation of the encrusted surfaces of other works from the period reveal wickedly funny anecdotes that belie the surface impression of all-over pattern. In the 1963 *Ironing Board*, a heavy iron rests on an impudent protuberance, and in *Travelling Life*, among

Driving Image (details)
1959–64
Mannequins, furniture, household objects, macaroni, sewn stuffed fabric, paint
Dimensions variable
Installation, 'Driving Image Show', Galleria d'Arte del Naviglio, Milan, 1966

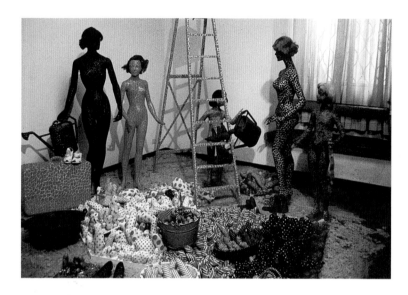

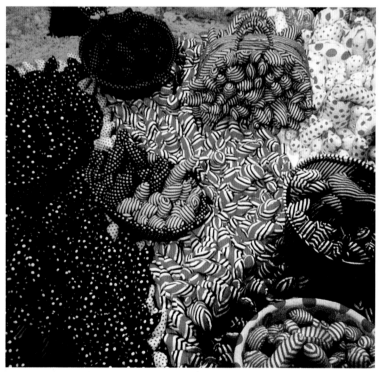

Kusama's most important works from the period, three pairs of high heels are poised in the midst of their upward scramble, crushing the stuffed phalli in their wake with careless and cruel abandon.[25]

Kusama clearly saw the *Accumulations* – and their sculptural offspring, the related phallus-covered *Sex-Obsession* objects; the *Food Obsession* series carpeted with dry macaroni; and the *Compulsion Furniture*, covered with the *Infinity Net* pattern painted in Day-Glo colours – as another addition to an ever expanding environment of pattern. Heretofore theoretical, enacted only in her studio and in photo-collages made for promotional purposes, in 1964 Kusama was able to realize her dream of a full-blown environment at the Castellane Gallery in New York. Called 'Driving Image Show', the exhibition consisted of a room full of *Accumulation* furniture set up in a living room tableau, phallus-covered clothes and mannequins overrun with dried macaroni. Dried macaroni was also scattered on the floor, and the walls were lined with *Infinity Net* paintings. As one astonished critic noted, so overwhelming was the sensory overload that the room seemed to shimmer and buzz; 'separate, distinguishable things tended to dissolve in their all-over texture'.[26] Although nothing sold, the exhibition caused a sensation, with stunned visitors ogling the thousands upon thousands of phalluses, while the macaroni crunched uncomfortably beneath their feet.

The *Driving Image* environment in New York served as a model for two subsequent installations of the same name, as well as a set for a series of performances for the camera. Photographs and

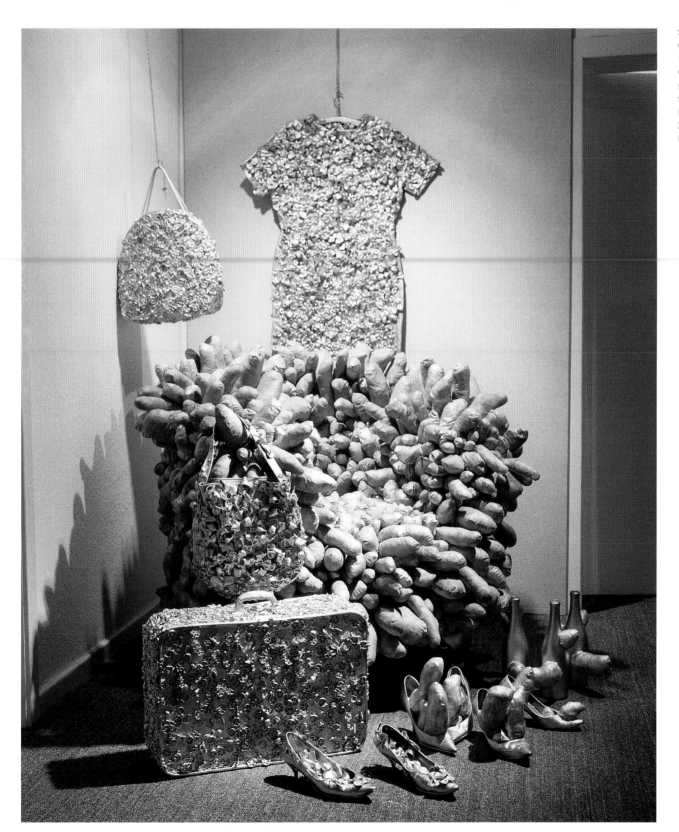

Sex Obsession and **Food
Obsession** (detail)
1962–64
Chair, dress, handbag, suitcase,
shoes, macaroni, sewn stuffed
fabric, gold paint
Dimensions variable
Installation, Galerie M.E. Thelen,
Essen, Germany, 1966

Untitled
c. 1966
Photo collage
Photograph by Hal Reif of the
artist reclining on **Accumulation
No. 2**, **Infinity Net** background,
macaroni carpet
Dimensions unknown

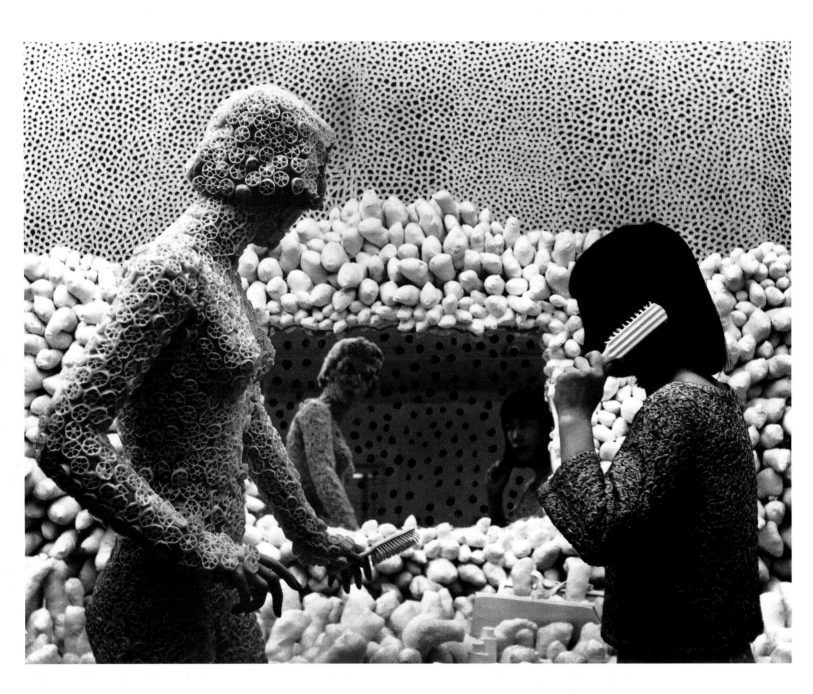

The artist with **Macaroni Girl** and
Infinity Net painting, studio, New
York, *c.* 1964
Photograph by Eikoh Hosoe

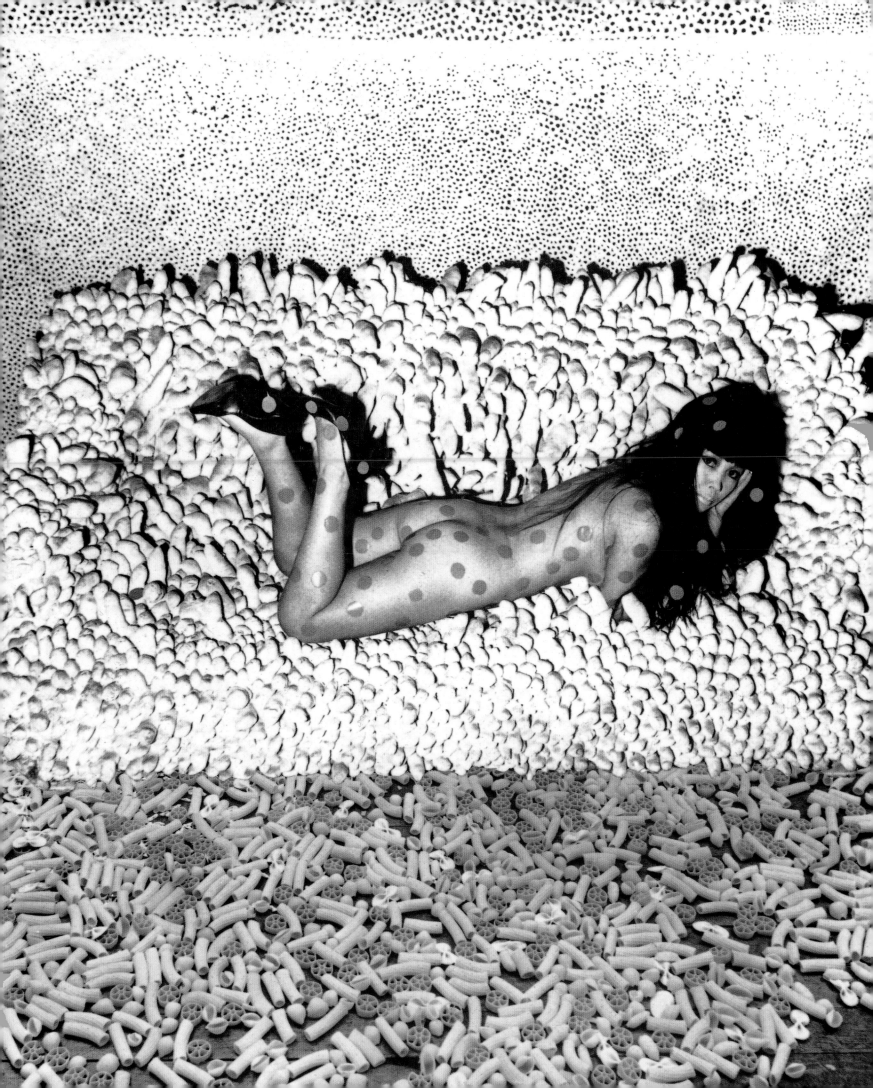

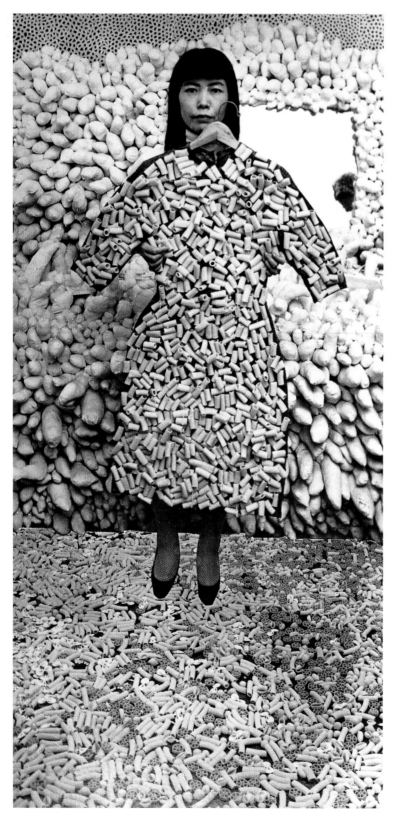

Photo collage for 'Driving Image Show' exhibition poster (detail)
c. 1963
No longer extant, dimensions unknown

photo collages of the artist cavorting on, under and amidst her two- and three-dimensional works were meant not only for publicity purposes but also as works unto themselves – stop-action performances in which artist and artwork are indistinguishable. They are also, in their way, self-portraits. In one series in particular dating from 1964, Kusama, wearing a crocheted blouse and fishnet stockings, does a credible imitation of one of her own works, standing frozen next to a similarly posed pasta-covered mannequin surrounded by *Infinity Nets* and *Accumulation Furniture*. In a photo-collage cobbled together most probably from shots from the same photo session, she gravely holds in front of her a dress stiff with macaroni. The dress obscures Kusama's body completely leaving only her expressionless face and her fishnet-clad gams dangling like the appendages of a paper doll. In perhaps the best-known photographic image of Kusama from the period, the artist, naked save for a spray of stick-on polka dots and a pair of high heels, drapes herself provocatively, centrefold style, across *Accumulation II*, a couch that bristles with erect phalli.

As has been pointed out eloquently by others,[27] with her straightforward allusions both to little girls and to pin-ups, Kusama toys with the clichés of femininity, consciously satirizing them but at the same time using them to promote her self and her work. Indeed, throughout her career Kusama has consciously assumed a series of clichéd sexual, ethnic and psychological roles that simultaneously acknowledge and send-up the stereotypes that have accrued to her. Although she

never stated it explicitly, Kusama was very aware of her position as a mentally ill, female 'non-American' artist at 'a time when American artists developed national pride ... that did not allow them to acknowledge or to recognize what people were doing in other cultures'.[28] To exaggerate and indeed to capitalize on her exotic status, Kusama, who never wore a kimono while living in Japan, habitually sported traditional Japanese dress for her own exhibition openings, and used a kimono in at least one of her early Happenings. Gleefully accepting the moniker 'Dotty', from the tabloid press in the late 1960s, more recently she has donned flowing sorcerer's robes and peeked witch's hats for performances, no doubt in ironic reference both to her age and the mental illness that has plagued her.

Much has been written recently about Kusama's bold and prescient confrontation with feminist issues before the vocabulary of feminist critique was born. Kusama's militancy, though, goes beyond essentialist feminism and into sexuality itself. What Alexandra Munroe has called Kusama's exercise of 'the glorious right to dominate back'[29] can be extended to include the glorious right to make banal what is almost sacred in its profanity, namely the phallus. In the 1990s Kusama's ferocious use of the phallus as a symbol of feminist anger against male domination has been justly celebrated for its brio, but she is also to be admired for her unflinching use of overtly sexual imagery and themes that began with the *Accumulations* and continued through her so-called 'orgy' performances, as well as her novels and poetry.

The introduction of such baldly sexual imagery into the streamlined cool of New York in 1962 might have been expected to cause a sensation, if not a scandal, but it is a measure of Kusama's ability to shock that the initial reaction of critics and spectators was to ignore the phallic content of the *Accumulations* and assimilate their form into the vocabulary of the time. Kusama herself seems to have been loath to give a specific name to her forms. When asked by the New York critic Gordon Brown in a 1964 interview for radio: 'Miss Kusama, are the stuffed sacs with which you cover all those household objects really phallic symbols?' Kusama's uncharacteristically coy response was, 'Everybody says so.'[30]

Everybody might have been talking about Kusama's phalluses but nobody was doing so in print. From the first appearance of the *Accumulations* in 1962, critics and curators had a difficult time discussing their irreverent sexuality, so mostly they avoided it – often with comic results. Referring specifically to these works, the eminent art historian Sir Herbert Read took a strictly biological tack, noting that Kusama 'with perfect consistency ... creates forms that proliferate like mycelium and seal the conscious-ness in their white integument'.[31] A critic writing in 1966 could gaze upon a room full of Kusama's bristling members and declare them – *pace* Donald Judd and the whole of the New Tendency – a prime example of 'the semantics of monosurfacing and multiplied elements'[32] while in the same year, one of the largest *Accumulations*, a six-foot rowboat now in the collection of the Stedelijk Museum in Amsterdam, could be included with Kasimir

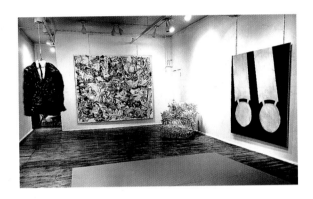

Installation, group exhibition including works by Yayoi Kusama, Robert Morris, Claes Oldenburg, James Rosenquist, George Segal, Richard Smith, Andy Warhol; Green Gallery, New York, 1962

background, right, **Accumulation No. 1**
1962
Sewn stuffed fabric, paint, chair frame
94 × 99 × 109 cm

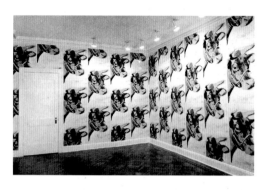

above, **Andy Warhol**
Cow Wallpaper
1966
Serigraph printed on wallpaper
115.5 × 75.5 cm

opposite, **Aggregation: One
Thousand Boats Show** (detail)
1963
Sewn stuffed fabric, wooden
rowboat, paint; 999 silkscreen
images on paper
Boat, 265 × 130 × 60 cm
Installation dimensions variable
Reconstruction of original
installation, 'Love Forever: Yayoi
Kusama, 1958–1968', The Museum
of Modern Art, New York, 1998
Collection, Stedelijk Museum,
Amsterdam

Malevich, Josef Albers and Frank Stella in an
international exhibition survey of monochromy
and seriality.[33]

As uncomfortably as Kusama's raucous
Accumulations fit with the controlled monotony of
the grid and the hard edge, they are not quite Pop
either, although an attempt was made to make
them so. *Accumulations* were included in two of the
defining exhibitions of American Pop Art in New
York at the Green Gallery in 1962 and 1963, as well
as in Lucy R. Lippard's definitive anthology *Pop Art*
published in 1966. In the same way that her
Infinity Nets hovered on the outer edge of Abstract
Expressionism and the Nouvelle Tendence, serving
in retrospect as a commentary on both, Kusama's
Accumulations have a peripheral connection to
certain elements of Pop but in fact contradict its
very essence.

Pop's object-orientation and its adoption
of techniques like silkscreen and airbrush that
mimicked the clean lines of industrial and
commercial art were for Kusama the embodiment
of what she called the increasingly 'mechanized
and standardized' environment of 'highly civilized
America'.[34] If her counter to the slick perfection of
machine production was her emphatically
handmade seriality, her critique of the ever-more
commodity-oriented milieu of the New York art
market lay in her increasing devotion to the
creation of environments.

Kusama's *Aggregation*: *One Thousand Boats
Show,* exhibited at the Gertrude Stein Gallery in
New York in 1963, had been the first publicly
exhibited installation of her career, and her
strongest statement to date against those values
that she saw embodied in Pop Art. The *Boats Show*
consisted of an eight-foot rowboat and two oars
covered completely with white phallic
accumulations and 999 black and white poster-
sized photo reproductions of the sculpture.
Visitors entered the installation through a small
dark corridor, papered floor to ceiling with the
boat image. The effect of the vast number of
repeated images in such a confined spaces was
vertiginous and oppressive. At the end of the
hallway, lit by a white spotlight and waiting like
a reward, was the original boat, beached in all its
splendour, surrounded by its pale simulacra.
Like seeing a movie star in person, the thrill of
confronting this one-thousandth boat eloquently –
if theatrically – argued for the superiority of the
original over its eminently reproducible copy.
At the same time that the installation argues
against mass (re)production of an art object,
it is also a succinct testament to the power of
advertising and promotion. This distinction,
between the commodification of the object by
outside market forces and the use of the media
for promotional purposes, for Kusama boiled down
to an issue of retaining authority over one's own
production. 'Anything mass-produced', she told
a reporter in 1968, 'robs us of our freedom.
We, not the machine, should be in control.'[35]

Perhaps because of her prescient use of
wallpaper in the *Boats Show*, or the 1962 collages
incorporating airmail stickers and labels, the Pop
artist most often compared to Kusama is Andy
Warhol. Although never close, the two artists knew
one another and travelled in the same downtown
circles.[36] Their interaction, it seems, was minimal.

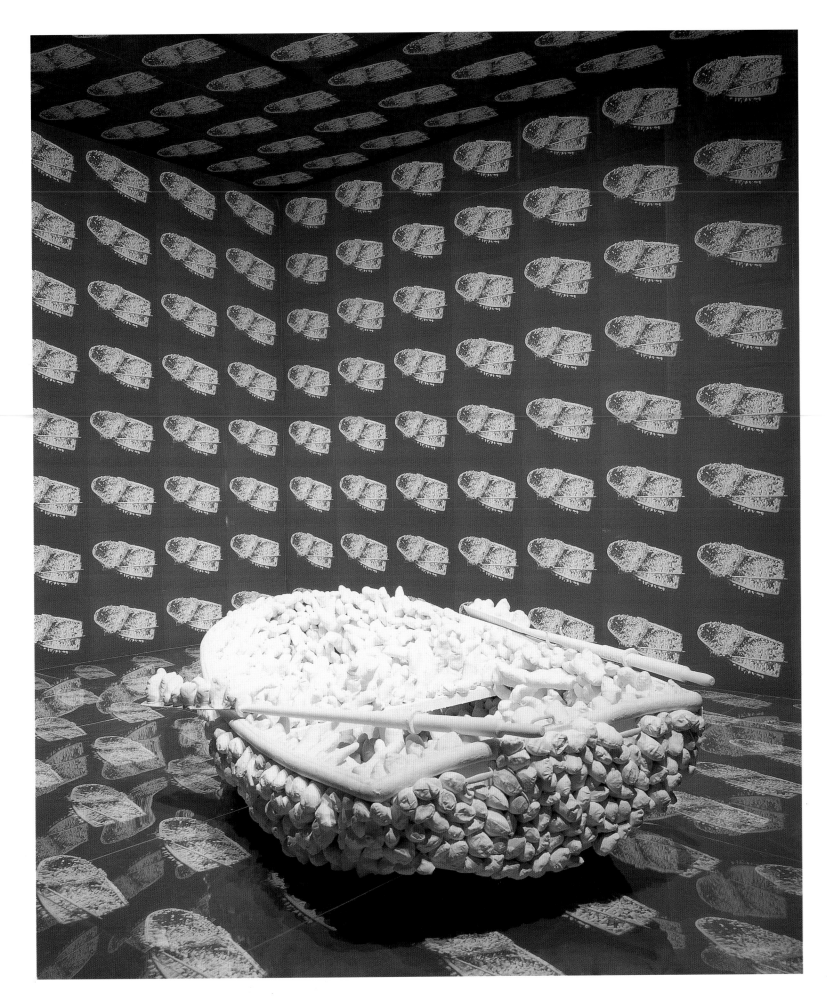

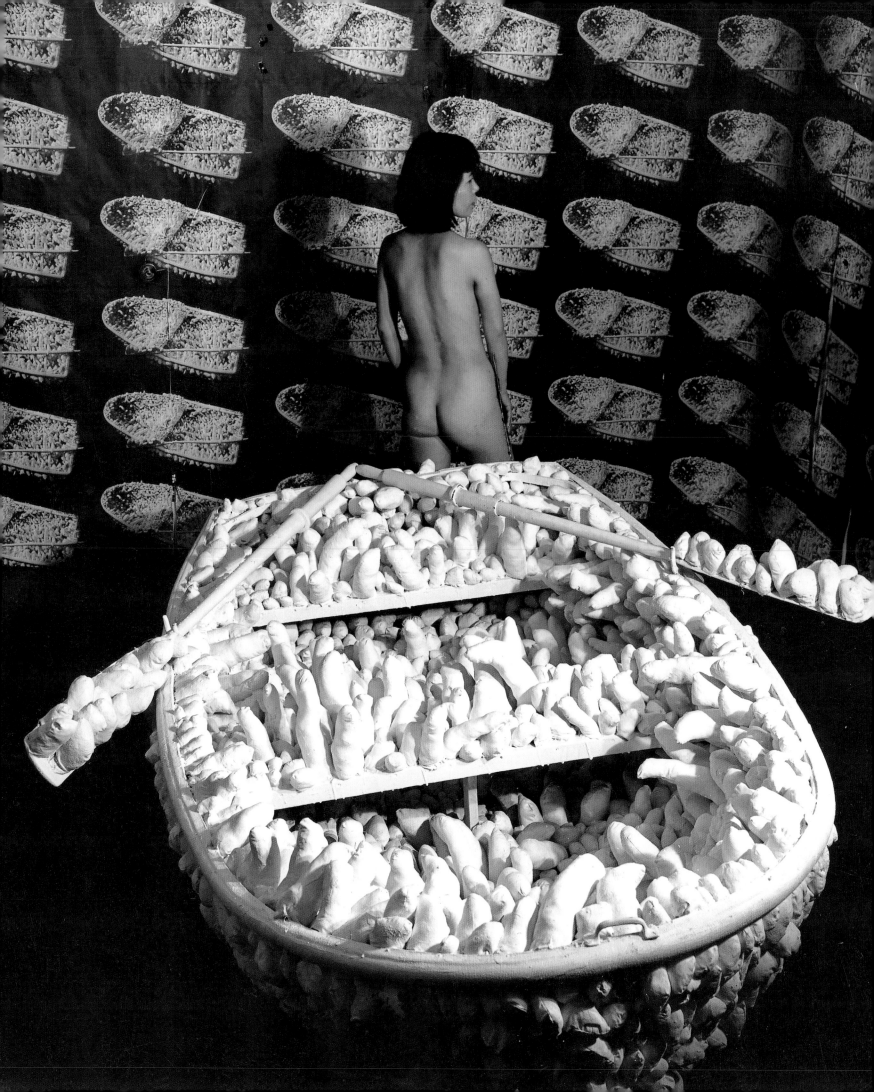

'We were like two mountains', noted Kusama recently.[37] Warhol's entire oeuvre, exemplified by the cool remove of the medium of silkscreen, exhibits what the art historian Robert Rosenblum has called 'a shoulder-shrugging indifference to direct and unique experience',[38] as well as a celebration of the annihilation of the authorial hand. Environments like Kusama's *Boats Show* offer an argument against anonymous, industrial seriality and champion process over object, experience over consumption. This neat privileging of the original over its endlessly reproducible simulation runs counter to the very idea of Warhol's Factory, where industrial production and mass marketing merged seamlessly and sensationally with contemporary art.

IV. Fame

What Kusama did share with Warhol was a fascination with the mass media and an appreciation for the possibilities it presented for promotion and distribution of her ideas. As it did with Warhol, celebrity crops up as a theme in a number of her works in various media beginning in the mid 1960s. Two years after the *Boats Show*, in which the theme of publicity is only obliquely referenced, Kusama experimented with the visual seduction of kinetic art to promote the aphrodisiacal qualities of fame in an environment called *Peep Show* or alternatively *Endless Love Show*. A mirrored hexagonal room with coloured lights that flashed in time to piped-in rock and roll, *Peep Show*, like its bawdy namesake, was experienced by viewers through slots located at eye level.[39] In an onanistic twist, rather than ogling an anonymous 'star' on the *Peep Show*'s stage, the only image one saw was one's own – reflected *ad infinitum* in the mirrored walls, surrounded by blinking lights, for all the world like a kinetic marquee.

Mention has already been made of the well-known 1966 photo-collage that features a nude Kusama sprawled on phallic sculpture, but it is important to reiterate that this kind of work was not only a self-portrait, or a stop-action performance, but an important part of a publicity package that, along with promotional materials like artist's statements, critics' testimonials and press releases, accompanied all of Kusama's projects, beginning with the earliest *Infinity Net* paintings and continuing today.[40] This archive of still photography, film and video, press releases and newspaper clippings, documents the ongoing performance that encompasses all of Kusama's voluminous body of work as well as the artist's very life. More importantly perhaps, this material was used to advertise that life, as art, to an audience outside the confines of the contemporary art community. By the later half of the 1960s, Kusama's ongoing project had burst the tight confines of the art magazines and, with the artist's encouragement, spread to the general press – so successfully that by 1967, Kusama could claim that she had more newspaper clippings than Warhol himself. As with Warhol, Kusama's engagement with popular media proved unpopular with an art world which, after the advent of Pop Art, was particularly sensitive to the encroachment of mass culture into the realm of high art.[41] Complaints concerning Kusama's excessive self-promotion and 'lust for publicity' began at this

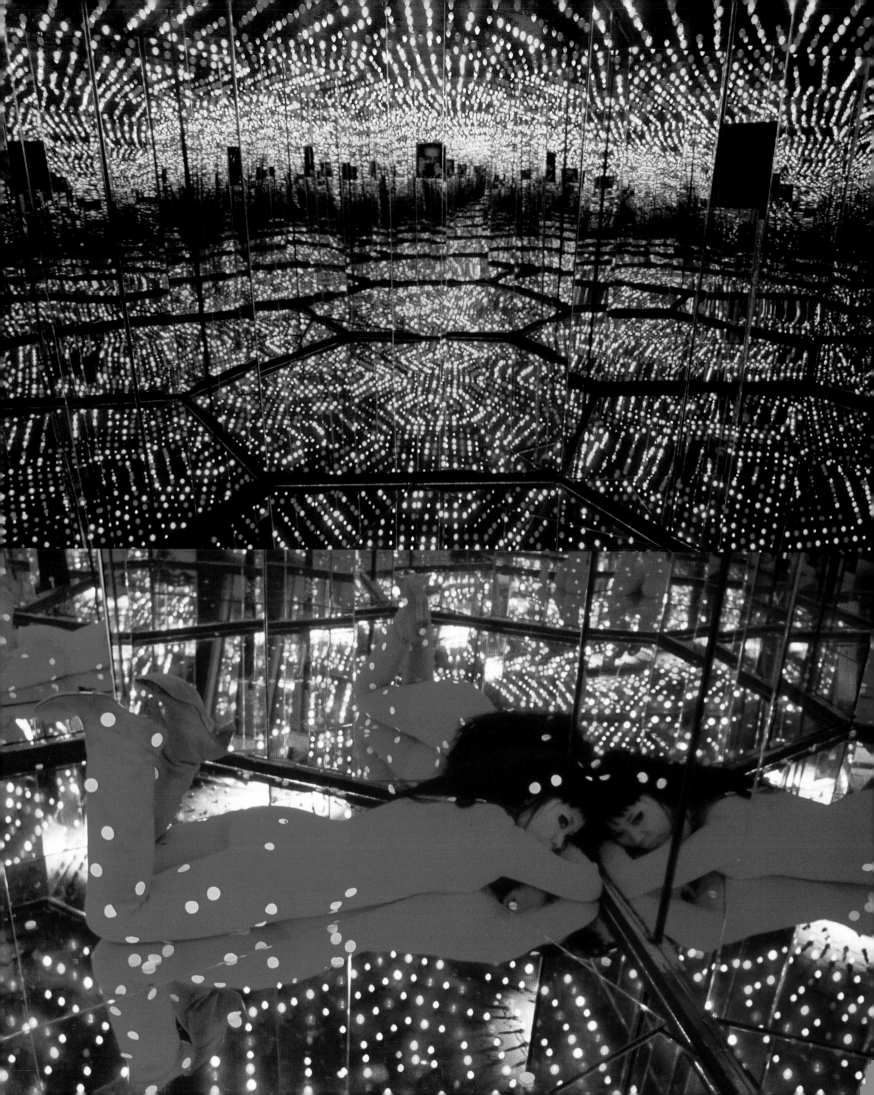

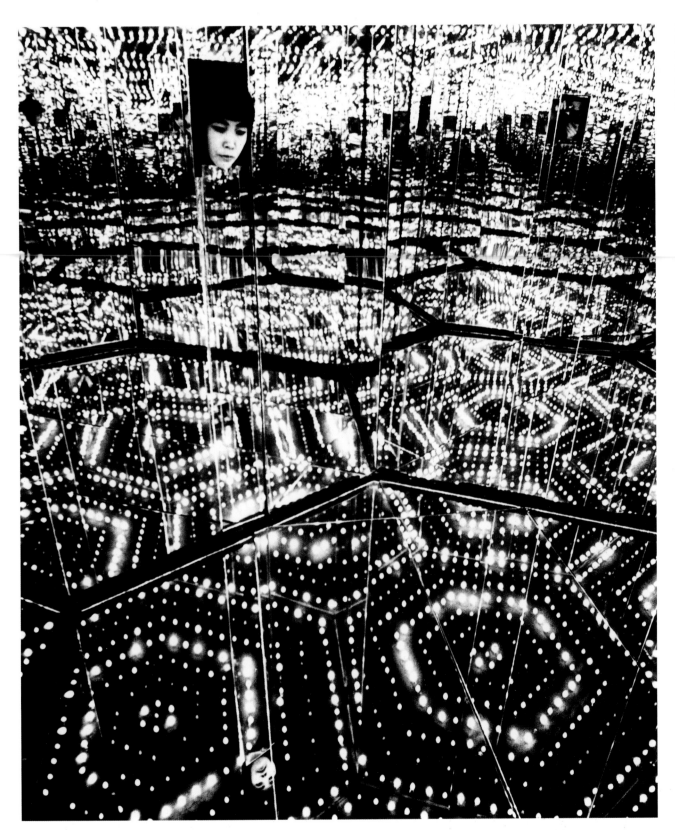

Kusama's Peep Show or **Endless Love Show**
1966
Mirrors, coloured lights
210 × 240 × 205 cm
Installation, Castellane Gallery,
New York

The artist in her studio, New York,
c. 1964–65
background, l. to r., **Accumulation
No. 2**, 1962, **Travelling Life**,
1964, **Accumulation No. 1**, 1962
foreground, **My Flower Bed**
1962
Stuffed cotton gloves, bedsprings,
paint
250 × 250 × 250 cm
Collection, Musée national d'art
moderne, Centre Georges
Pompidou, Paris

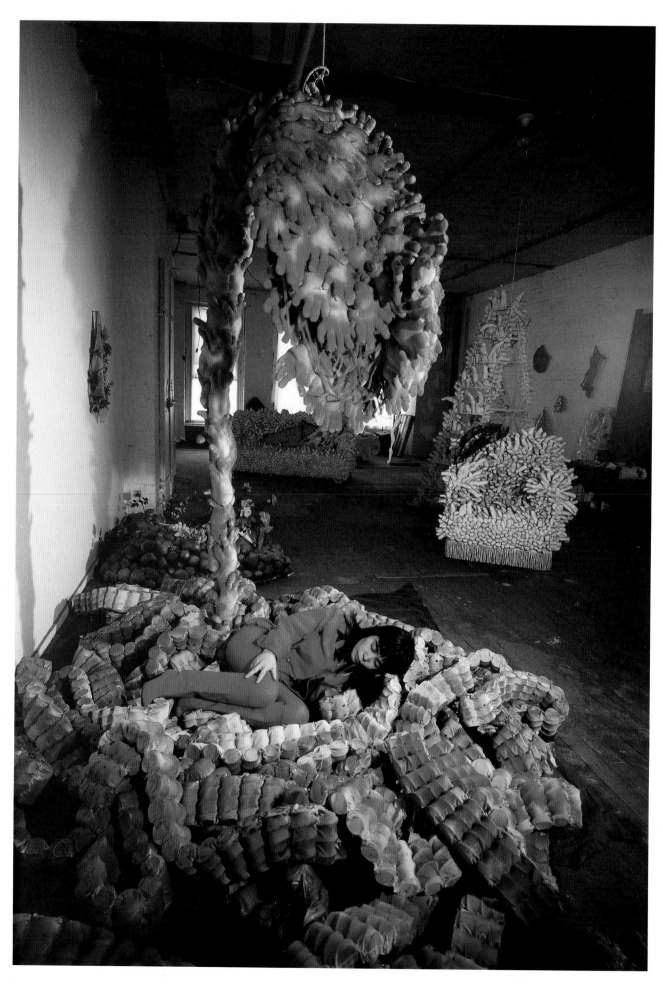

time and have followed her throughout her career. Mirroring the popular assumption that Kusama's mental illness drove the artist helplessly to make her obsessive works, critics of her single-minded pursuit of media attention fail to understand its significance for her project as a whole. In retrospect, it is clear that Kusama's sustained complicity with the popular media was and is an elaborated parody; her acts of brazen self-promotion are a bald-faced challenge to the most enduring paradox of the avant-garde from the 1960s until now: the reconciliation of the rank commercialization of contemporary art with the anti-commodity call to merge art with everyday life.

Kusama's infamous *hors concours* participation in the 1966 Venice Biennale offered her the biggest international platform in her career to date from which to work her subversion. Given space on the lawn in front of the Italian pavilion by her Italian dealer, Renato Cardazzo of Galleria d'Arte del Naviglio in Milan, Kusama intended, as she wrote in a grant application, to 'reveal an important creative new idea' that would 'show the true nature of the avant-garde'.[42] To her sponsor, she merely explained her plan for an installation called *Narcissus Garden*, that would consist of 1,500 mirrored plastic balls spread across the lawn like a kinetic carpet. The biennial was roundly pronounced 'weak and insipid',[43] but Kusama's 'way-out exhibition of mirror balls'[44] caused less of a visual sensation than an outright scandal. No sooner had the *Narcissus Garden* been put in place than Kusama, dressed in a kimono, began to hawk the individual balls to passers-by under a sign that read 'Your Narcissism for Sale, Lira 1,200'. Organizers, horrified at the impropriety of selling 'art like hot dogs or ice cream cones at the Venice Biennale', called the police, who ordered the artist to desist from selling off her installation, which she did. Instead, she passed out self-promotional flyers that featured an over-ripe testimonial to her 'images of strange beauty' that 'press ... on our organs of perception with terrifying insistence' penned by the art-historical eminence, Sir Herbert Read.[45]

The news stories about the *Narcissus Garden* caper that appeared in an array of international publications expressed shock at the artist's crass reminder of the economic undercurrent of international exhibitions like the Venice Biennale. All were accompanied by cheesecake photos of Kusama cavorting amid her installation, minus the kimono but clad fetchingly in a bright red leotard. Like the post-scandal photo sessions that produced these pictures, the entire media ruckus was orchestrated by Kusama and was clearly the centrepiece of her plan to 'reveal an important new creative idea'. As its title announces, *Narcissus Garden* was as much about the promotion of the artist through the media as it was about the dematerialization of a sculptural object through the selling off of its elements. Explaining that the wholesaling of her sculpture was a logical result of the development of contemporary art towards commercial product, she told the Italian magazine *D'Ars Agency* that '*in the past, one used brushes, colours, chisels. Today, the work of art is produced exclusively by the artist's sensibility. One is no*

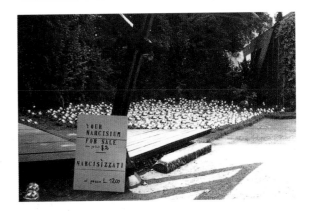

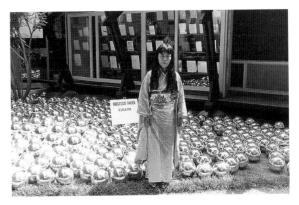

Narcissus Garden
1966
Plastic mirror balls
1,500 balls, ø 20 cm each
Installation, XXXIII Venice
Biennale
The artist selling mirror balls to
passers-by

14th Street Happening
1966
Performance, New York,
documented with colour slides by
Eikoh Hosoe

longer obstructed by the difficulties of the occupation. Today, the artist only has to have an idea for an object.' 'Artists', she continued, '*should integrate themselves into economic life by making their work inexpensive and accessible enough to be bought like items in a supermarket.*'[46]

Over the next several years Kusama's emphasis on publicity proved to be even more radical in its ambition than the mere parody of the craven hypocrisy of the contemporary art world. In 1967 Kusama began to concentrate on public performance, and it is at this moment in her career that it became clear that her sustained bid for notoriety was an attempt to harness fame as a *strategy* – a vehicle through which to achieve her goal to inundate the world with her artistic persona, or its alter ego: the net and the polka dot.

As the hybrid nature of *Narcissus Garden* indicates, Kusama's experiments with Happenings occurred almost simultaneously with her forays into kinetics. For Kusama, both participatory kinetic installations and performance were logical steps in a progression from her environment-sized canvases and rooms full of sculpture, to photographic simulation of activities staged in real time, to actual interaction with the public. 'Everything', Kusama emphasized in a 1968 interview, 'originated from polka dots on a canvas'.[47] Executed on the streets of New York, with an audience that consisted of a hired photographer and any passers-by who might happen upon the artist – as she walked a prescribed route in a full dress kimono, or lay prone on top of an *Accumulation* sculpture – Kusama's earliest actions seemed to have passed unnoticed. The so-called 'naked

performances' that began in outdoor locations all over New York City in 1967 and continued through 1969, succeeded in transforming her into a media personality.

Kusama had experimented with body-painting bikini-clad models in the winter and spring of 1967,[48] but during the months that followed she held a series of 'Body Festivals' every Saturday and Sunday in city parks, where the public was invited to strip and be 'made into art'[49] by Kusama's busy application of polka-dotted body paint. These events were heavily publicized by press releases sporting slogans like 'Please the Body' and 'Learn, Unlearn, Relearn!' They were well attended and, most importantly, covered by the general media, who quickly dubbed Kusama 'The Priestess of Nudity',[50] or more succinctly 'Dotty'.[51] In an effort to increase her visibility, Kusama collaborated with the underground filmmaker Jud Yalkut on *Self-obliteration*, a twenty-three-minute 16mm film that documented the entire summer of naked Happenings. Set to music by Joe Jones and the Tonedeafs, accompanied by a chorus of almost thirty amplified frogs, the work begins with Kusama painting polka dots on flora and fauna (a passing cat) in a natural setting and concludes with a somewhat hilarious 'orgy' scene in which naked hippies, smeared with fluorescent poster paints, nuzzle and grope one another while lying in one of Kusama's mirrored installations.

The year 1968 saw the birth of Kusama's 'Anatomic Explosions', a more directed variation on the Body Festival in which three or four naked dancers covered with polka dots gyrated to rock 'n' roll music in front of public buildings like the New

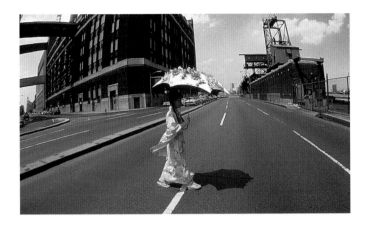

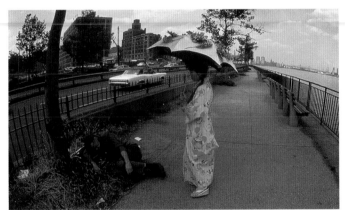

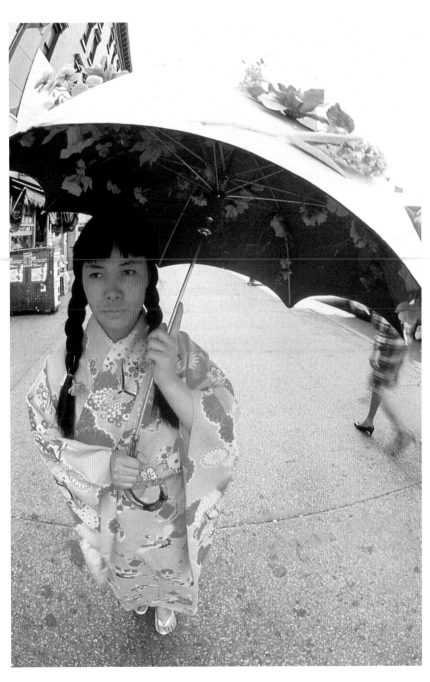

Walking Piece
c. 1966
Performance, New York,
documented with colour slides

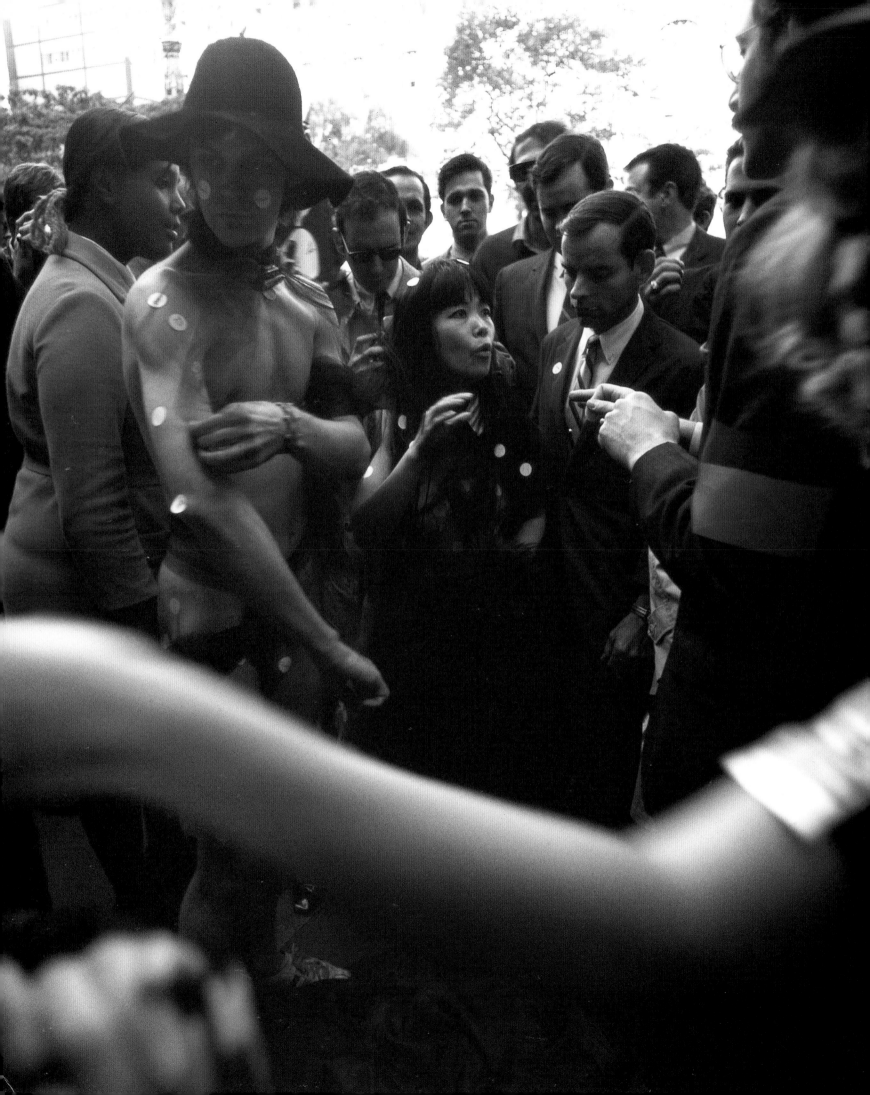

York Stock Exchange, the Statue of Liberty and
the Alice in Wonderland Statue in Central Park
until they were forced to stop by the police.[52]
Kusama called her performances during this period
'social demonstrations'[53] but their thin veneer of
progressive political rhetoric did not disguise the
fact that their true agenda was Kusama's 'symbolic
philosophy with polka dots'.[54]

As with the Body Festivals, Kusama herself
did not participate but rather directed the group
and passed out polka dot covered press releases.
The release for the Wall Street happening proclaim-
ed: 'STOCK IS A FRAUD!' and exhorted all passers-
by to 'OBLITERATE WALL STREET MEN WITH POLKA
DOTS'.[55] At the Statue of Liberty, Kusama's flyer
encouraged her audience to ' ... take it off for
liberty!' 'Nudism', the release continued with
humorous frenzy, '*is the one thing that doesn't
cost money. Property costs money. Stocks cost
money. Only the dollar costs less. Let's protect the
dollar by economizing! Let's tighten our belts! Let's
throw away our belts! LET THE PANTS FALL WHERE
THEY MAY!*'.[56]

In August 1969, after completing naked
actions at the United Nations, the Board of
Elections and the New York subway, Kusama took
her band of nude dancers to another New York
bastion, The Museum of Modern Art. Her *Grand
Orgy to Awaken the Dead at MoMA (Otherwise Known
as The Museum of Modern Art) Featuring Their Usual
Display of Nudes* featured six nude dancers who
waded into the pool in the museum's sculpture
garden and struck poses that mimicked the
surrounding works of art. 'At the Museum', her
release read, 'You can take off your clothes in good

company: MAILLOL, GIACOMETTI, PICASSO'.[57] This
Happening won her the cover of *The New York Daily
News*, which published a half-page photograph
with the caption 'But is it Art?'. Describing this
event to a friend in Europe, Kusama wrote proudly
that she had a 'one-man show' called *Orgy* at the
Modern, adding that 'the photos from this are all
over the world in various publications'.[58]

Notwithstanding Kusama's (no doubt) ironic
claim, as popular media interest in Kusama's
exploits grew, her profile in the art world declined.
Devoted almost entirely in the last years of the
1960s to producing her performances, Kusama's
output of paintings and sculptures was small, as
was her interest in exhibiting in a conventional
gallery or museum situation. In 1968 and again in
1969, Kusama attempted to incorporate her entire
project into commercial businesses. The short-
lived Kusama Enterprises, Inc. offered 'films,
environments, theatrical presentations, paintings,
sculpture, Happenings, events, fashions and body
painting'.[59] The equally ephemeral 'Kusama's
Fashions' (with its affiliate, the 'Kusama Fashion
Institute'), and the 'Kusama Poster Corporation',
touted clothes and posters painted with the
artist's *Infinity Net* pattern. Other dubious
business ventures included the 'Kusama Orgy'
and 'Studio One', billed as a body painting
concern, that offered 'young beautiful models,
male and female'.[60] Struggling financially and
facing waning enthusiasm for her performances
in New York, Kusama returned to Japan in 1970
to stage a series of naked Happenings in Osaka
and Tokyo, all of which were stymied by vigilant
authorities. The early 1970s seemed to have been a

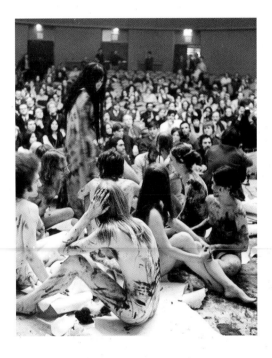

The Sea Bottom
1983
Sewn stuffed fabric, found
objects, lamé powder
184.5 × 186 × 22 cm

time of transition for Kusama in which she concentrated less on the visual than on a new interest, writing fiction. Featured in more than one hundred and fifty articles in 1968, by 1971 Kusama's battle to 'obliterate the world with Polka Dots' was in hiatus. During that year, her archives reveal that not a single word was written about Kusama; after more than a decade of intense involvement with the New York art community and with the media at large, less than two years after her last public Happening she had been forgotten. In 1973 Kusama left New York and returned to Tokyo for good.

V. Japan, Again

Yayoi Kusama's time in New York constituted a decade-long gap in a life and career led primarily in Japan. Although the narrative of her experience abroad is extremely important to emphasize the continuity in Kusama's career, America and Western Europe lost sight of her for approximately two decades. 'I was thought to have been forgotten in the world', wrote Kusama in 1992. '[but] it was only because my information had not reached them.'[61]

Kusama began to show work again in Japan in 1975, but her first important solo exhibition at a major Tokyo gallery occurred seven years later, in 1982. As Alexandra Munroe, in her fine overview of the period, has noted, although Japanese critics had warily followed Kusama's exploits in New York, during the artist's first years back in Japan they had some difficulty assimilating her work into the post 1960s artistic milieu that existed there.[62] In the two years between her return to Japan and

the re-establishment of her visual arts career, Kusama also began to write novels, short stories and poetry. Her first novel *Manhattan Suicide Addict* was published in 1978; since that time, she has published eighteen more. Munroe has argued that Kusama's visual production and her fiction are 'different forms of the same repetitive production of traumatic, phantasmic and transcendental experiences that obsess her',[63] and indeed, it was through her writing that Kusama was re-introduced in Japan to an enthusiastic literary public, thrilled by her novels' explicit sexuality, graphic violence and hallucinatory description of the exoticism of Manhattan subculture. During these first years of her resettlement in Japan, Kusama had undergone periodic treatment for mental illness at the Seiwa Hospital, a private facility specializing in art therapy in the fashionable Tokyo neighborhood of Shinjuku. In 1977, she moved there permanently, retaining a private apartment as well as a studio within close proximity to the facility.

In the early 1980s, Kusama returned to painting and to the creation of large-scale *Accumulation* sculptures and installations. Like many artists of her generation, Kusama has anthologized her own work, recreating with her signature obsessive will to repetition, the net, the dot and the phallus in seemingly endless variation.[64] So closely do some of her *Infinity Nets* of the 1980s resemble those of the early 1960s that works completed in Japan are still mistaken for those made almost thirty years before in New York.[65]

This kind of confusion notwithstanding,

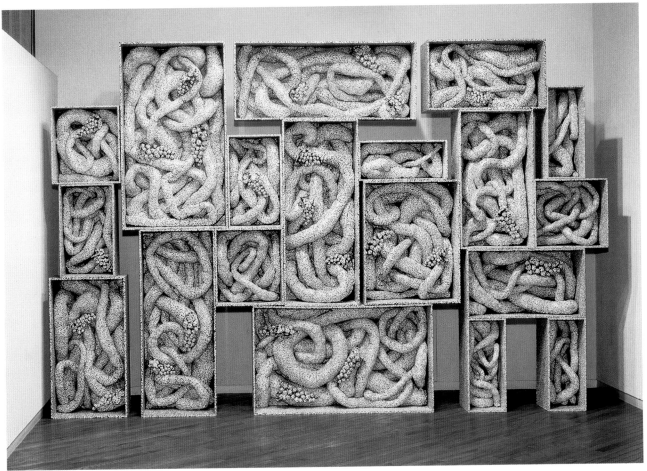

Kusama does not, like the aged de Chirico, copy the same 'classic' painting over and over again. Her work of the past twenty years differs from that of the 1950s and 1960s because until very recently it has lacked two important qualities – her insistence on an aesthetic of the handmade over that of the machine and, concomitantly, the self-referential abstraction inherent in her signature motifs.

In these later paintings, nets, dots and biomorphic shapes proliferate over multiple canvases that form polyptychs of room-sized dimensions. Painted in acrylic with a consistency of pattern that could pass for the results of a stencil, these paintings approach the perfect seriality that the *Infinity Nets* of the early 1960s

never had. The surfaces of the recent works have also changed markedly. Kusama's best net paintings and gouaches have always had an optical, shimmering quality; she had achieved this effect in the early *Infinity Nets* by creating unsystematic circular colonies of cell-like clusters that seem to spiral forth from their painted surfaces. All of Kusama's New York paintings were executed in oil, and her liberal application of the paint gives the best works a luscious if uneven texture and a delicious sense of the artist's touch. The paintings of the 1980s and 1990s have a mute, acrylic flatness, and although they too have an optical dazzle, it is created by the juxtaposition of processed colours and their complements. If the early *Infinity Nets,* with their thickly painted cock-eyed lace work, stood as Kusama's signature, the hard-edged and ruthlessly patterned paintings of the 1980s and 1990s are more like displays of her logo. It is as if Kusama has realized that her identity has finally been established and the time has arrived for its free proliferation and franchise.

However inorganic in execution, the imagery in the late paintings is much less abstract than the paintings of the 1960s, and thus much less about the pattern itself. As if recalling her earliest still lifes from her first Japanese period, in which a nascent net pattern could be discerned in a pile of seeds, the repetitive motifs in many paintings of the past decade have a visual relationship with the dot, the net and the phallus, but are identifiable as forms in nature. Sperm-like sprouts squiggle across these canvases and translucent polka dots of varying sizes are suspended in colourful backgrounds like bubbles in liquid. Whereas works

opposite, **Gentle Are the Stairs to Heaven**
1990
Acrylic on canvas
162 × 130 cm

below, **Flame**
1992
Acrylic on canvas
Triptych, 194 × 130 cm each panel

opposite and overleaf, **Mirror
Room (Pumpkin)**
1991
Mirrors, wood, papier mâché,
paint
200 × 200 × 200 cm
Collection, Hara Museum, Tokyo
left, The artist in the installation

from the 1960s were named by number or letter,
these works bear titles that emphasize their
metaphorical quality. An enormous multi-panel
canvas with a spring green background squirming
with bright red spotted lady bug forms is called
Awe of Life. Another equally large work from the
same year called *Star Dust of One Hundred Million*
features a network of raspberry coloured veins
veiling a lemon yellow background; superimposed
are stripes of white bubble-like dots. The whole
reads like an entire ecosystem. Similarly, the
stuffed phallic *Accumulation* form has continued
to colonize found objects, but in the 1990s these
forms have lost their generalized, overtly sexual
shape and become elongated and tenticular,
draping and curling around objects like sea
creatures, snubbed and rounded off so that they
may be stacked together like so many potatoes, or
pear-shaped and bulbous in the guise of gigantic,
vaguely anthropomorphic inflatables.

VI. Fame, Again

In Japan appreciation for Kusama's work has
grown steadily and in 1993 she was honoured by
being chosen as the first individual, and the first
woman, to represent Japan in the Venice Biennale
of that year. The commissioner of the Japanese
Pavilion, Akira Tatehata, organized a mini-
retrospective of Kusama's career, and included
early *Infinity Nets* as well as recent paintings, her
first sculpture, *Accumulation I*, along with more
recent *Accumulations*, the 1964 *My Flower Bed*, an
enormous hanging sculpture made of stuffed
gloves and bedsprings tinted a lurid, bloody red,
and a number of box sculptures from the 1980s and

1990s. However different this recuperative
homage might seem from her contentious début at
the Biennale twenty-seven years earlier, there was
an element of continuity; once again, Kusama,
never separated from her work, which was
incomplete without her presence, staged a
performance in *Mirror Room (Pumpkin)*, an
installation created for the exhibition. A neat
conflation of two of her mirror installations from
the mid 1960s, the *Peep Show* and the *Infinity
Mirror Room,* the 1993 *Mirror Room (Pumpkin)*
consisted of a large gallery papered floor to ceiling
with a yellow and black polka dot pattern. In the
centre of the space stood a mirrored box the size
of a small room, with a single window in a manner
reminiscent of the 1965 *Peep Show*. In a nod to the
Infinity Mirror Room also of 1965, through that
window the viewer could gaze on what seemed to
be an infinite field of papier mâché pumpkins, all
of which sported the same yellow and black polka
dot design as the exterior gallery.

At the opening of the exhibition Kusama
appeared in the room dressed in a long sorcerer's
robe and peeked hat, both of which matched her
surroundings and caused her to merge with them
in a manner that recalled early interactions with
her *Infinity Nets* and *Accumulations*. Visually a
part of the installation, Kusama was also an active
agent, offering tiny yellow and black polka dotted
pumpkins to anyone who entered the space.
These little pumpkins were a direct reference to
the 2,000 lire mirror balls that the artist had
outrageously hawked from her *Narcissus Garden*
at her first Venice Biennale. The piecemeal sell-off
of the installation in 1966 had been planned as

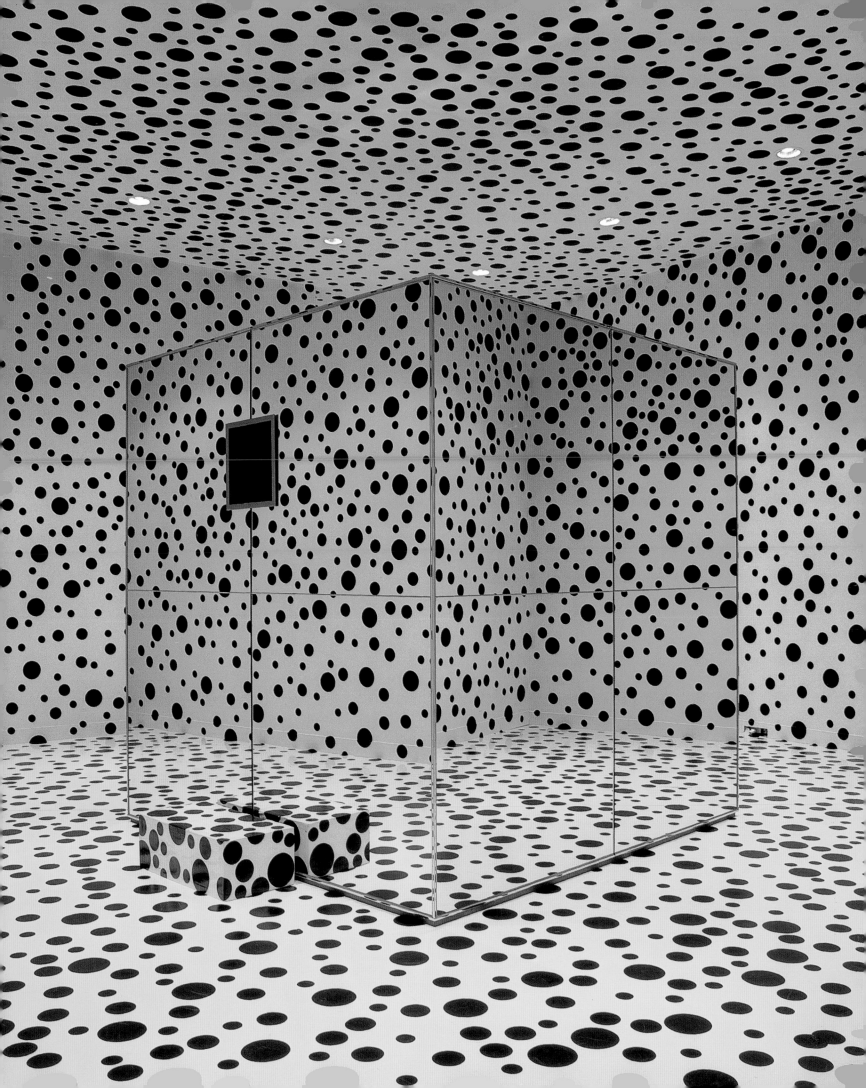

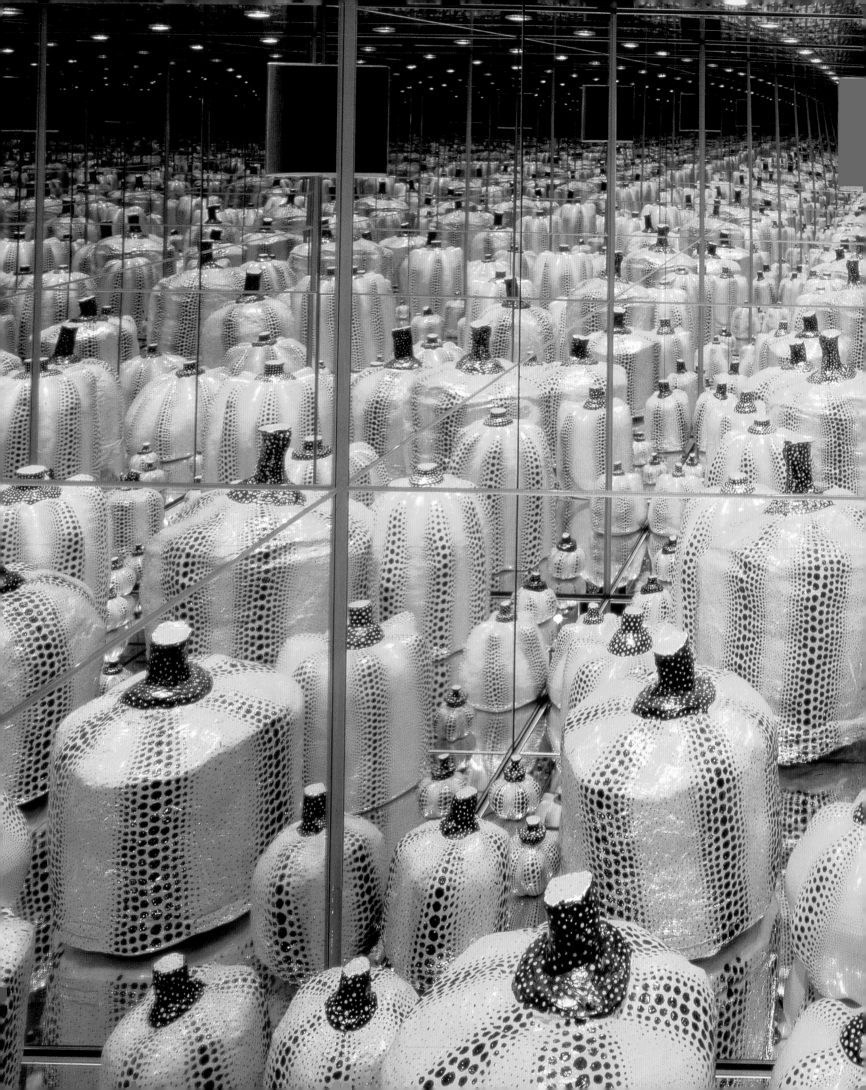

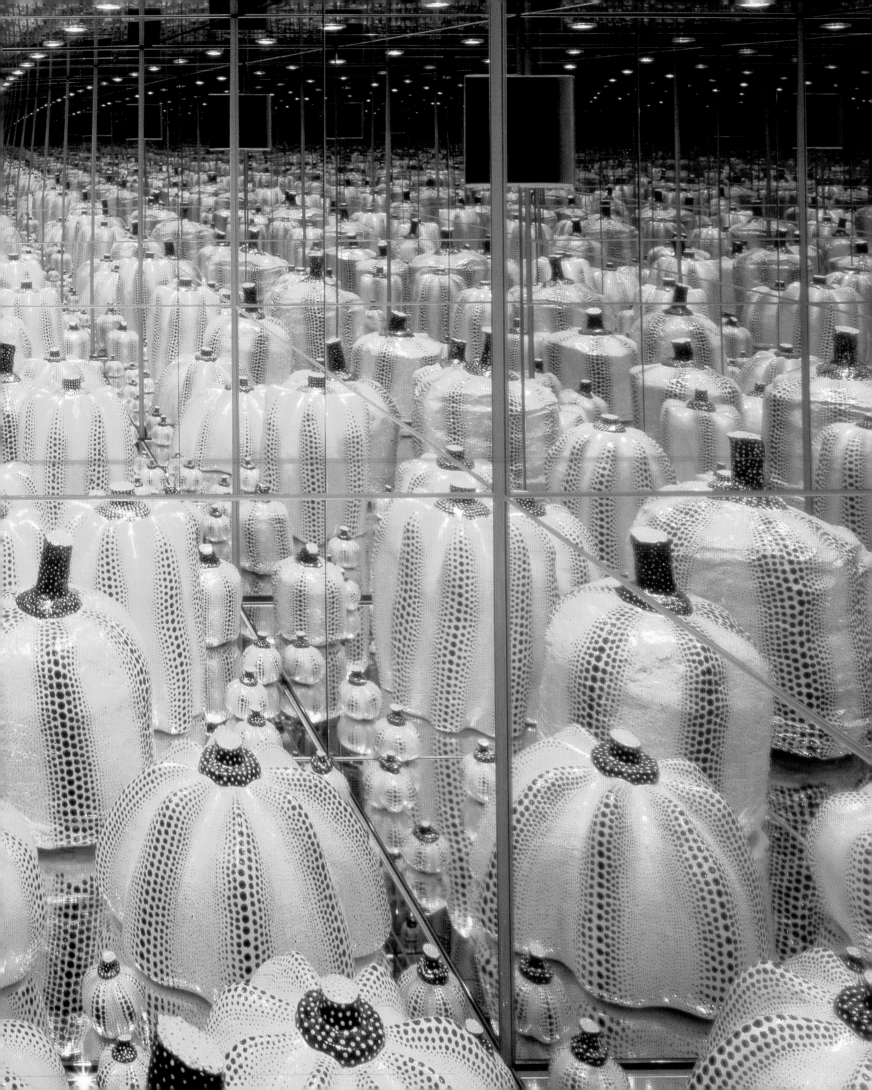

Installation, 'Yayoi Kusama: Now',
Robert Miller Gallery, New York,
1998
foreground, **Dots Accumulation**
1995
Acrylic on canvas
287.5 × 226 cm

background, **Repetition**
1998
Sewn stuffed fabric, wood, paint
120 pieces, 38 × 25.5 × 15 cm
each

a protest and as a punishment of a closed and commodity-obsessed art world. The souvenir giveaway in 1993 was on one hand a gracious acknowledgement of her arrival at the pinnacle of success and on the other a familiar bid to popularize and promote her work to a wider audience.

In her most recent exhibitions Kusama has returned to ideas that she introduced in her *Driving Image* installations in the mid 1960s; mural-sized paintings cover the walls and serve as backdrops for *Accumulation* furniture, and mannequins are overrun with *Infinity Nets*. This re-assimilation of the handmade qualities of work from the 1960s has appeared concurrently with the revival of interest in the United States and Europe in Kusama's work from that period. The return of Kusama's work to the United States after a twenty-year absence started with a little publicized but much seen exhibition at the short-lived Center for

International Contemporary Arts in Manhattan in 1989,[66] and culminated in an in-depth assessment of her New York period organized by the Los Angeles County Museum and The Museum of Modern Art in New York in 1998.[67] These exhibitions and countless smaller ones emphasized Kusama's most austere and minimal work from her Manhattan years – her large monochrome *Infinity Nets* and her first white *Accumulation* sculptures in particular.[68]

It is possible to credit the popularity of the handmade, minimalist Kusama to a lack of familiarity with her ephemeral performance works of the mid 1960s, but it can also be linked to a general tendency identifiable over the past several years, in the US and in Europe, to revive the tropes of Modernism, but in a more humane form. This tendency which, not surprisingly, often uses the Minimal as the metonym of the Modern, is evident in interior design and even in fashion but is most apparent in the work of a younger generation of artists who enlist Minimalism's cool geometries in the service of institutional critique or ironic self-abnegation,[69] and its objective strategies like the use of serial repetition, monochromy and the grid as vehicles for identity-based narrative.[70] This reconsideration of the Modern also includes the retrospective enrichment of the Modernist canon by the inclusion of those artists like the Brazilians Hélio Oiticica and Lygia Clark and the Italian artist Piero Manzoni whose work (consciously or unconsciously) fits visually within its parameters, but remained unrecognized until the onset of a more global consideration of the history of postwar art. The happy coincidence that these

now-included Modernists-in-retrospect are, like Kusama, often women, people of colour and/or people from non-Western backgrounds, serves to reinforce the warmth of this recently refurbished Modernism.

Looking at the early work of Yayoi Kusama helps us begin to understand the history of the 1960s in visual culture – a history that is still under construction. It would be a mistake, however, to allow our appreciation for Kusama's achievement in the 1960s to leave us with the ultimately false impression that 1960s Modernism had a feminine and multicultural face, or that the 1990s, the decade in which Kusama's work has come to maturity, represents any more than a single chapter in an ongoing project that has lasted forty years and counting. There is no doubt that certain elements of Kusama's early work – its will to repetition, its monochromy, its use of found materials – were in sync with what was going on in New York, Milan and Amsterdam during the 1960s. Viewing her entire oeuvre, however, it is immediately clear that hers is an aberrant Modernism – a Modernism run wild; brash and repetitive, kitschy, often tasteless, sometimes ugly. Barely four years into a promising gallery career, Kusama jettisoned her monochromatic restraint; the net gesture, running wild over every surface, was transformed from a passive into an active motif that could spread like an epidemic. It became not only a means by which to cover larger and more varied surfaces with eye-popping pattern but, finally, a strategy of incursion into our very world.

What has euphemistically been called the 'unevenness' of Kusama's oeuvre is not just a matter of our own inability to assimilate certain aspects of it. Rather, it can be seen as evidence of the artist's ongoing resistance to assimilation into any movement, any canon. The great glory of Kusama's work, from her earliest drawings to her newest offerings, is that it remains, because the artist wills it so – every bit as gauche and as angry, as difficult and as aggressive as it was when it was created and when it first flew in the face of an art world too square to grasp its visual and sensory overload, its egoism, its raunchy sexuality. Its mixture of optical illusion, 1960s camp and

Installation, 'Yayoi Kusama: Now', Robert Miller Gallery, New York, 1998
foreground, works from the series
Statue of Venus Obliterated by Infinity Nets
1998
Wood, canvas, mannequins, paint
227.5 × 145.5 × 60 cm each

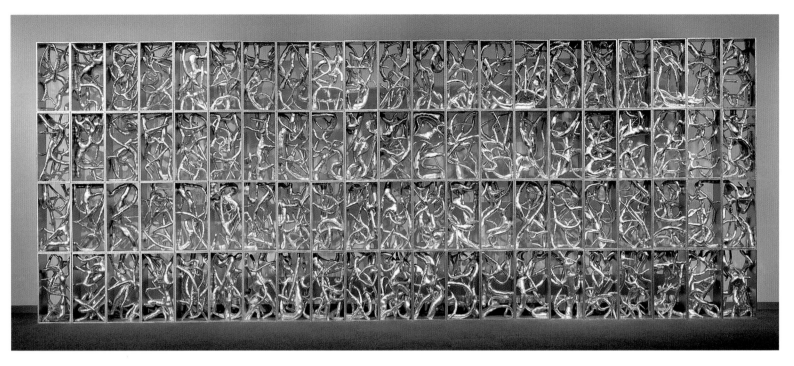

Shooting Stars
1992
Sewn stuffed fabric, wood,
metallic paint
320 × 840 × 30 cm
Collection, Niigata City Art
Museum, Japan

biomorphic ghoulishness is not to be expected from a 'minimalist' – handmade or otherwise. One can, however, find this hybrid of body-oriented, consciously referential work in the studios of young artists worldwide. Kusama's work from the 1960s might serve us well in our newly multicultural retrospective revisionism, but her newer work with its all-out visuality and conscious anti-innovation speaks directly to our sensibilities of the late 1990s.

In a sense though, it is inaccurate to say that Kusama's time has come, because Kusama has not waited for anyone or anything, but rather has barrelled through the decades to represent her self and her work in endless variation, not to an art-going public, but to the world.

1 This point was made by Akira Tatehata in 'Magnificent Obsession', Japanese Pavilion (cat.), XLV Venice Biennale, *Yayoi Kusama*, Japan Foundation, Tokyo, 1993

2 Yayoi Kusama, quoted by Akira Tatehata in 'Magnificent Obsession', p. 13

3 Unsigned article, 'A Woman Makes Her Way in the International Art Scene', *Geijutsu Shinco*, Vol. 12, No. 5, Tokyo, 1961, pp. 127–130

4 Yayoi Kusama, 'My Holy Land of Dreams for a Bright Future', *Yayoi Kusama: Printworks*, Shuichi Abe, Tokyo, 1992, p. 140

5 Yayoi Kusama, 'Driving Image: Why Do I Create Art', *Driving Image: Yayoi Kusama*, New York, Tokyo, 1986, n.p.

6 See Naoko Seki, *In Full Bloom: Yayoi Kusama, Years in Japan*, Tokyo Museum of Contemporary Art, 1999. Based on close study of what seems to be Kusama's earliest surviving work as an adult, *Untitled*, a still life from the late 1940s painted in Nihonga style, Seki argues that the *Infinity Net* pattern can be traced to Kusama's stylized rendering of rows of corn kernels and seeds.

7 Yayoi Kusama, letter to Georgia O'Keeffe, 1957, quoted by Bhupendra Karia, *Yayoi Kusama: A Retrospective*, Center for International Contemporary Arts, New York, 1989, p. 73

8 Georgia O'Keeffe, letter to Kusama, 1957, Yayoi Kusama archive

9 By 1959, in art circles in New York, Abstract Expressionism was, if not academic, clearly no longer the vanguard movement.

10 'A Woman Makes Her Way in the International Art Scene', op. cit., pp. 127–130

11 Yayoi Kusama, quoted by Akira Tatehata, 'Magnificent Obsession', op. cit., p. 12. This did not stop critics like Sidney Tillim and Donald Judd from comparing Kusama's paintings to Jackson Pollock, Clifford Still, Mark Rothko and Barnett Newman.

12 Sidney Tillim, 'In the Galleries: Yayoi Kusama,' *Arts Magazine*, New York, October, 1959, p. 56

13 Donald Judd, 'Reviews and Previews: New Names this Month', *ARTnews*, New York, October, 1959, p. 17

14 Ibid.

15 Donald Judd, 'In the Galleries: Yayoi Kusama', *Arts Magazine*, New York, September, 1964, pp. 68-69

16 Jack Burnham, *Beyond Modern Sculpture: The Effects of Science and Technology on the Sculpture of This Century*, George Braziller, New York, 1968, p. 254

17 Ibid., p. 354

18 Otto Piene, 'The Development of Group ZERO', *The Times Literary Supplement*, London, Thursday, 3 September 1964. Yves Klein, Piero Manzoni and Lucio Fontana also appeared in Zero publications as adherents.

19 The grid as a ready-made, all-over organizational system allowed for the creation of a 'non-compositional' field in which figure and ground were elided in a visual special effect that served as another defining quality of the New Tendency, as reported by Enrico Castellani in his introduction for the exhibition catalog, *Monochrome Malerei*, Städtische Museum, Essen, Germany, 1961.

20 Yayoi Kusama, interviewed by Gordon Brown, WABC Radio, New York, June 1964; first published in *De nieuwe stijl/The New Style: Werk van de internationale avant-garde*, Vol. 1, De Bezige Bij, Amsterdam, 1965, pp. 163-64. Reprinted in this volume, pp. 100-105

21 Lucy Lippard, quoted by Alexandra Munroe, 'Obsession, Fantasy and Outrage: The Art of Yayoi Kusama', *Yayoi Kusama: A Retrospective*, op. cit., p. 25. Lippard's article, 'Eccentric Abstraction', was published in *Art International*, New York, November, 1966, pp. 34–40

22 Donald Judd, 'In the Galleries', op. cit., pp. 68–69

23 Hans Haacke, telephone interview with Alexandra Munroe and Reiko Tomii, December, 1988, unpublished

24 Yayoi Kusama in a recent interview with Lynn Zelevansky described these works as 'the doubling of the fetish'. See 'Driving Image: Yayoi Kusama in New York', in *Love Forever: Yayoi Kusama, 1958–1968*, Los Angeles County Museum of Art/The Museum of Modern Art, New York, 1998

25 See Lynn Zelevansky, 'Driving Image', op. cit.

26 Ed Sommer, 'Letter From Germany: Yayoi Kusama at the Galerie M.E. Thelen, Essen (May)', *Art International*, Lugano, October, 1966, p. 46

27 See Lynn Zelevansky, 'Driving Image', op. cit.

28 Hans Haacke, op. cit.

29 Alexandra Munroe, op. cit., p. 24

30 Yayoi Kusama, interviewed by Gordon Brown, op. cit.

31 Flyer published for 'Driving Image Show', Castellane Gallery, New York

32 Ed Sommer, 'Letter From Germany', op. cit.

33 'The Inner and the Outer Space', Moderna Museet, Stockholm, 1966, featuring over fifty artists from Malevich to Frank Stella, attempted to unite the monochrome tendency, serial repetition of primary structures and the technological experimentation of kinetic art under the Nouvelle Tendence umbrella. Dividing twentieth-century art into two divergent streams defined by Duchamp's Readymades on one hand and Malevich's white on white Suprematist compositions on the other, the show attempted to trace the trajectory of contemporary art along the lines of the latter. Along with works by Max Bill, Josef Albers and Enrico Castellani – clearly devoted to the exploration of opticality and spatial phenomena – the phallus-covered rowboat was chosen, rather than an *Infinity Net* painting. Thus, extraordinarily, this found object covered with thousands of squirming sexual forms found company next to the austerity of Albers' *Homage to the Square*.

34 Yayoi Kusama, interviewed by Gordon Brown, op. cit.

35 Al van Starrex, 'Some Far-Out – With and Without Clothes,' *Mr*, New York, July, 1969, pp. 38–39, 41, 61

36 Kusama, for example, staged a Happening at Warhol's East Village discotheque, The Electric Circus, in 1967

37 Yayoi Kusama, interview with Laura Hoptman, March, 1998

38 Robert Rosenblum, 'Warhol as Art History', in Kynaston McShine, ed., *Andy Warhol: A Retrospective,* The Museum of Modern Art, New York, 1989, p. 29

39 *Kusama's Peep Show* premiered at the Castellane Gallery in March 1966, several months before Lucas Samaras showed his better-known mirrored environment, *Room 2*, at the Pace Gallery, New York

40 For all public appearances, Kusama is accompanied by a still photographer and a videographer who record her activities for press reproduction as well as for her personal archive.

41 In 1968, 161 articles were published about Kusama, only one of which appeared in an art-related publication.

42 Yayoi Kusama, letter to Porter McCray, 11 March 1966, Yayoi Kusama archive

43 Norman Narotzky, 'The Venice Biennial: Pease Porridge in the Pot Nine Days Old', *Arts Magazine*, New York, September–October, 1966, pp. 42–44

44 Ibid.

45 Sir Herbert Read's words were written in 1964 in response to Kusama's 'Driving Image Show' in New York and were originally published by the artist in flyer form on that occasion.

46 Gordon Brown, 'Yayoi Kusama', *D'Ars Agency*, New York, June, 1966, p. 140

47 Jud Yalkut, 'The Polka Dot Way of Life: Conversations with Yayoi Kusama', *New York Free Press*, New York, 15 February 1968, pp. 8–9

48 At the Black Gate Theatre, a experimental multi-media space and subsequently at Andy Warhol's discotheque the Electric Circus.

49 Jud Yalkut, 'The Polka Dot Way of Life', op. cit., p. 8

50 Rolf Boost, 'Yayoi: Priestess van het naakt', *Algemeen Dagblad*, Rotterdam, 21 November 1967, p. 11

51 Alfred Carl, 'Call Her Dotty', *New York Sunday News*, New York, 13 August 1967, pp. 10, 31

52 Kusama remembers vividly having been arrested only once. (press conference with Kusama, The Museum of Modern Art, New York, 1999)

53 Jud Yalkut, 'The Polka Dot Way of Life', op. cit., p. 8

54 Ibid.

55 Press release, 'Wall Street Anatomic Explosion', New York, Fall, 1968

56 Press release, 'Naked Event at the Statue of Liberty', New York, July, 1968

57 24 August 1969

58 Letter to Dr Udo Kulturmann, quoted in Bhupendra Karia, ed., *Yayoi Kusama: A Retrospective*, op. cit., p. 95

59 Ibid., p. 90

60 Ibid., p. 91

61 Yayoi Kusama, *Yayoi Kusama: Printworks*, op. cit., p. 141

62 Alexandra Munroe, 'Obsession, Fantasy and Outrage', op. cit., pp. 32–33

63 Alexandra Munroe, 'Between Heaven and Earth: The Literary Art of Yayoi Kusama', *Love Forever: Yayoi Kusama, 1958–1968*, op. cit., p. 71

64 Warhol, Johns, Lichtenstein, to name three of the most obvious examples. See Robert Rosenblum, 'Warhol as Art History', op. cit., p. 32

65 See *Yayoi Kusama: A Retrospective*, op. cit., Figure 19, *Accumulation*, painted with acrylic on what appears to be new canvas mounted on stretchers made in Japan, but dated 1960.

66 'Yayoi Kusama: A Retrospective', curated by Alexandra Munroe, Center for International Contemporary Art, New York, 1990

67 'Love Forever: Yayoi Kusama, 1958–1968', co-curated by Lynn Zelevansky, Los Angeles County Museum and Laura Hoptman, The Museum of Modern Art, New York; toured to the Walker Art Center, Minneapolis, and the Museum of Contemporary Art, Tokyo.

68 Although not exclusively, except in the case of *Love Forever*

69 For example, furniture and environments by the New York-based sculptor Jorge Pardo, which adopt the look of modern design but remain for the most part non-functional.

70 For example, the work of Félix Gonzalez Torres.

Pumpkin
1994
Plastic, polyurethane paint
200 × 250 × 250 cm
Collection, Naoshima
Contemporary Museum, Kagawa,
Japan

Contents

I

On 29 April 1966 an exhibition of work by Yayoi Kusama, a Japanese artist from New York who was little known by the German public, opened in the M.E. Thelen Gallery in Essen, Germany. In this show a completely new experience was offered to the local audience, which significantly expanded their perception of art. I had been invited to select artists who had never previously had solo shows in Germany.[1] The opportunity was a challenge; I had made similar attempts as Director of the Städtisches Museum in nearby Leverkusen, from 1959 to 1964, and I was already familiar with Kusama's work as I had included her painting *Composition* (1959), a large white canvas in her *Infinity Net* series, in a group exhibition, 'Monochrome Malerei' ('Monochrome Painting'), at the museum in spring 1960, giving the young artist her first exposure in Europe.[2] This painting, a brilliant variation of the internationally current concept of the monochrome, fitted well into the show, which included works by the German Zero group: Heinz Mack, Otto Piene, Günther Uecker; the Italian artists Lucio Fontana, Francesco Lo Savio, Enrico Castellani and Piero Manzoni; and the French artist Yves Klein.

The Essen exhibition of Kusama's *Driving Image* (1959–64) consisted of an environment walled with *Infinity Net* paintings and spread with a carpet of dry macaroni, in which were 'adult' female mannequins and a smaller young 'girl'; a TV set; a mirrored dressing table; kitchen chairs and a table set for tea; and high-heeled shoes ranged on a step ladder and scattered on the floor – all covered with net patterns or dots painted in complementary colours, a characteristic feature of Kusama's obsessive works. For this exhibition, known as 'Driving Image Show', there were five subtitles: 'Sex Obsession', 'Food Obsession', 'Compulsive Furniture', 'Repetitive Room' and 'Macaroni Vision'.[3]

'Driving Image Show' had previously been shown in two earlier versions, incorporating a wider range of elements, at Castellane Gallery, New York, in 1964 and at Galleria d'Arte del Naviglio, Milan, in 1966. In a 1964 interview Kusama described *Driving Image*: '*my Aggregation-Sculpture … arises from a deep, driving compulsion to realize in visible form the repetitive image inside of me. When this image is given freedom, it overflows the limits of time and space. People have said that [it] presents an irresistible force … that goes by its own momentum once it has started.*'[4]

In the Essen exhibition catalogue I stated that Kusama's work should be seen in the

Driving Image (detail)
1959–64
Sewn stuffed fabric, wood, canvas,
mannequins, household objects,
paint, macaroni carpet,
soundtrack
Installation, 'Driving Image
Show', Galerie M.E. Thelen, Essen,
Germany, 1966

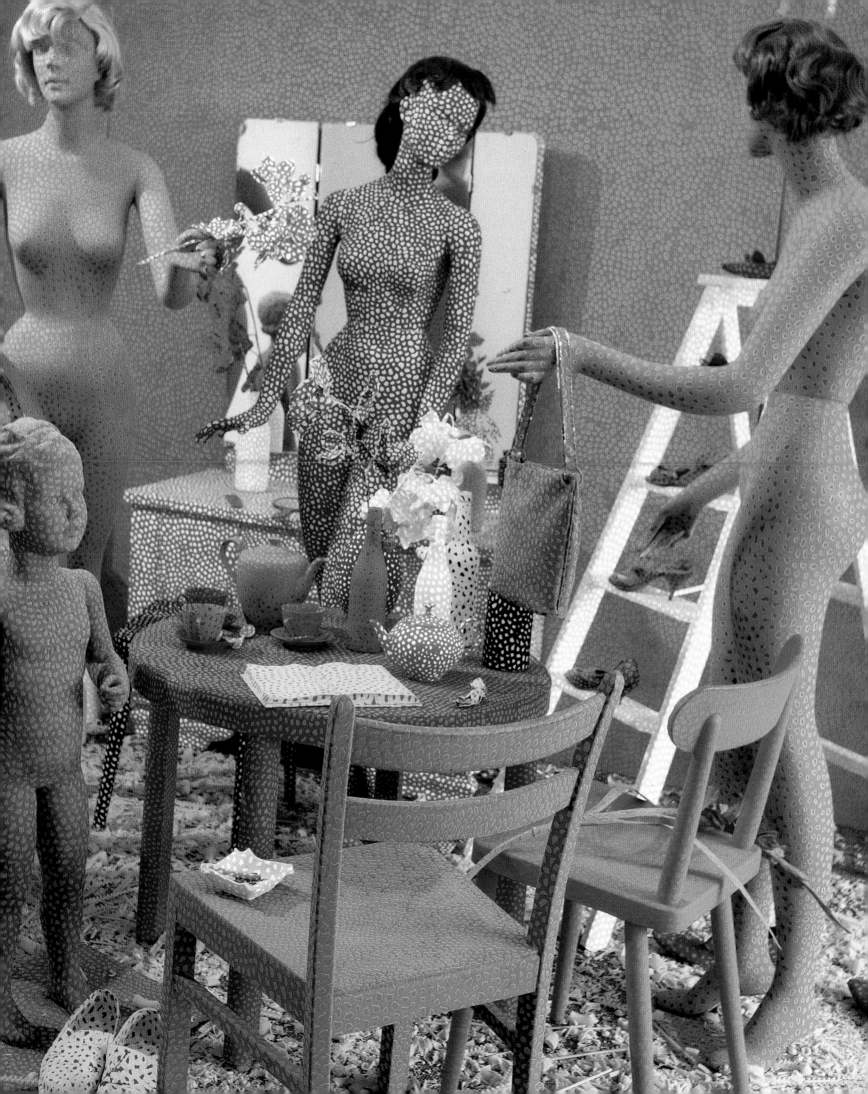

context not only of her fellow artists in the United States, such as Roy Lichtenstein, Claes Oldenburg, George Segal and Marisol, but of European artists, including Yves Klein, Lucio Fontana, the Zero and Nul groups and what became known as the New Tendency.[5] Kusama's work could be seen to combine the artistic tendencies of both continents, which at the time were considered as opposed traditions: it combined structural clarity and emotional suggestibility in a way which heightened its unique, extraordinary power in the context of the polarized international art tendencies of the time, described by Yves Klein in terms of 'a new, unlimited, un-fixated, non-compositional and non-problematic art'.[6]

It was fascinating to see the reaction to *Driving Image* at Essen. Here, the piece had been made all the more startling by the addition of a loud soundtrack of Beatles songs playing in the background. Moreover, by covering the floor of the gallery with dry macaroni, Kusama invited audience participation: each step resulted in an acoustic response from the work. A reviewer wrote: '*Everything in this show is different: macaroni and noodles are spread out on the floor. Beat music sounds from the loudspeaker. A blue TV set gives the local news. Three window-mannequins stand painted with dots. All the objects in the room have the measles: chairs, tables, ashtrays – even the cigarettes.*'[7] The same reviewer also mentioned the artist in the space: '*In an intense pink kimono the small Japanese artist Yayoi Kusama moves around with a great deal of make-up, a Grecian hairdo and much perfume. She never smiles.*' He went on to say, '*This has nothing to do with joking or humour; even the gallery looks serious*', adding, '*Only the visitors seem to be amused … The astonished visitors are stuck with their laughter in their throats.*' A German television crew arrived and arranged an interview in the gallery; the audience was impressed at how well the artist handled the interview, in a most serious, dignified manner.

One of the few German critics who immediately recognized the significance of the Essen show was Ed Sommer. Like Donald Judd and Dore Ashton in New York, he had early understood the importance of Kusama's art. Sommer wrote: '*Kusama crammed a room with furniture and utensils … The setting offered no surprises except for the uniform covering of all the objects assembled. A painted network – green on red, red on green, white on red – both unified and estranged the scene. Unified in their homogeneous skin, the objects seemed released from their customary functions. Defunctionalized, new, unfamiliar, they nevertheless demanded recognition: "That's a brush; a comb; a plate." But simultaneously, our perception*

Driving Image (detail)
1959–64
Sewn stuffed fabric, wood, canvas
mannequins, household objects,
paint, macaroni carpet,
soundtrack
The artist with installation in
progress, Galerie M.E. Thelen,
Essen, Germany, 1966

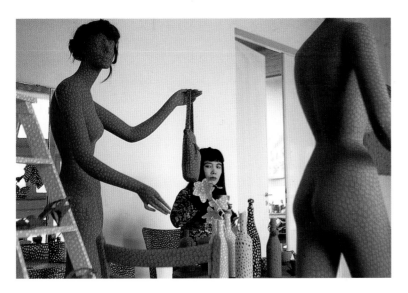

was troubled as the separate, distinguishable things tended to dissolve. The blond and brown hair of the dummies, the large looking-glass of the dressing table, the floor strewn with macaroni, were the only remnants of our diversely surfaced world.'[8]

II

The exhibition of *Driving Image* was an event of some significance in international art in the mid 1960s. Until around 1960, art had been primarily conceived of as individual works, which could be defined as drawing, painting or sculpture, with few cross-over elements between media. From its earliest beginnings, Kusama's art transcended such boundaries; she created an obsessive quality, in which forms are expanded instead of limited. Even in her early drawings from the 1950s these obsessive forms are visible and tend to expand beyond the frame of the drawing or painting. From the beginning, a strong desire to expand the perception of the outside world was central to Kusama's development. The early, delicate drawings developed into the monumental white *Infinity Net* paintings, which soon expanded into compulsively constructed sculptures and finally environments, Happenings and films in which each part is only relevant in the context of the whole.

Driving Image is a crucial point in this development, as here what is important is the total ensemble, not the individual work. The unifying patterned surface of the objects, and even the acoustic effect of the music, all contribute to the overall work. What much later became known as installation or environmental art has one of its multifaceted origins in Kusama's 'Driving Image Show' exhibitions in New York in 1964 and in Milan and Essen in 1966.[9] It was important for Kusama to make the viewer part of the overall context of the work, which included her visions of extreme situations. At the opening of the 'Driving Image Show' at Castellane Gallery, New York, in 1964, for example, she unleashed two dogs into the crowd. Recalling this spectacle, she wrote in her notebook, 'Macaroni-coated dogs ran barking frantically through the legs of viewers who were screaming in fright at the sound of the macaroni cracking under their feet'.[10]

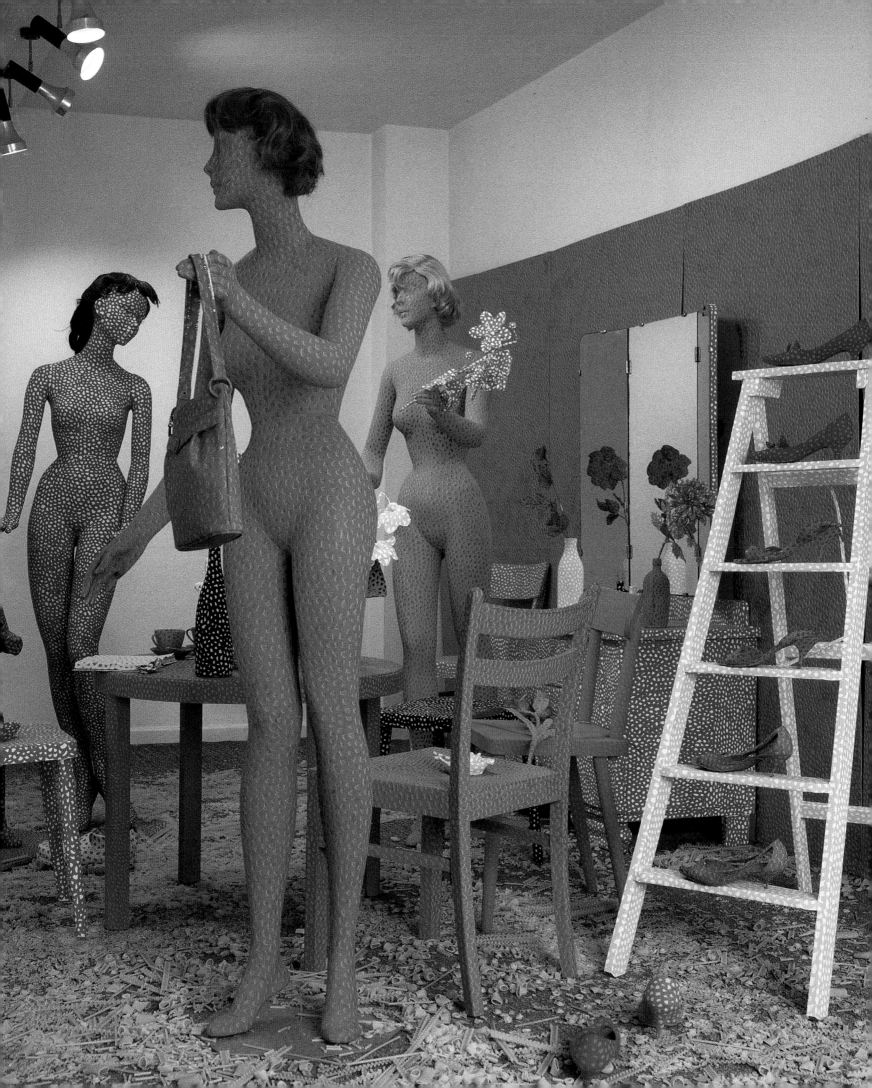

Driving Image (detail)
1959–64
Sewn stuffed fabric, wood, canvas,
mannequins, household objects,
paint, macaroni carpet,
soundtrack
Installation, 'Driving Image
Show', Galerie M.E. Thelen, Essen,
Germany, 1966

III

The forms and details in Kusama's work refer to a sense of overwhelming meaning: in most of her works in different media the common theme is the creation of a world view from a female perspective. The *Infinity Net* paintings can be seen as referring to weaving patterns; the objects used in most of her environments are household articles, such as furniture, food and utensils. The obsessive image of sexuality, so strongly manifested in many of Kusama's works, is from a female perspective, often involving the artist's own physical participation. It is significant that the artist and her body are part of the total work, either in photographic documentation or in events in which the body becomes an integral part.

Alexandra Munroe has referred in this context to the Essen exhibition of *Driving Image*, noting: '*In this installation, Kusama actualizes the hallucination which first inspired her to create environmental art: a room – its furnishings, objects and inhabitants glazed in a ubiquitous, psychedelic pattern of dots and nets. The cheery look of the scene is deceptive and ironic: the subject is the depersonalized modern woman, trapped by her domestic environment and by her redundant functions relating to food and sex. The interconnecting oneness which binds Kusama's people and things dissolves the distinction between self and other, subject and object, animate and inanimate. The net represents Kusama's desire for relationship, simultaneously denying it by denying differentiation.*'[11] In the Essen version of *Driving Image*, the adult female and young girl mannequins are the major players; their environment is a dressing room with mirrors and other devices for the beautification of the female body, while the kitchen is set to serve tea. Yet nothing can be separated out of the overall surface imagery, which reinforces the matter-of-fact acceptance of a world in which divergent activities co-exist. In this sense Kusama's compulsively covered furniture is not just the reproduction or manipulation of existing familiar objects, but a transformation of them into a meaningful world of female experience, rendered transparent in this new form. The accumulations of phallus-like shapes which characterize Kusama's other furniture sculptures as well as her environments (for example, the *Infinity Mirror Room*, 1965), are vivid manifestations of a visionary woman capable of perceiving new artistic forms. Carla Gottlieb gave an early, unorthodox but valid vision of Kusama's obsessive concepts: 'The drive to the proliferation of shapes is so powerful that the viewer can visualize their encroachment upon the environment in spite of their being tied to a shape. The irrepressible

vitality and assertion of the self are characteristics of all of Kusama's sculpture.'[12]

The meaning of many of Kusama's works may not only concern woman in a male-dominated, phallocentric world, but the survival of woman and the transcendence of gender into a wider, cosmic perspective. When asked in 1964 to interpret her title, *Driving Image*, Kusama confided: 'I am deeply terrified by the obsessions crawling over my body, whether they come from within me or from outside. I fluctuate between feelings of reality and unreality.' She added: 'I, myself, delight in my obsessions.'[13]

It is significant that Kusama's multifaceted works, expanding in numerous directions, perpetuate basic human concerns. Sexual, socio-political and existential themes are articulated in a multitude of combined media. In an interview with John Gruen in 1968 Kusama stated: 'Our earth is only one polka dot among millions of others ... We must forget ourselves with polka dots. We must lose ourselves in the ever-advancing stream of eternity.'[14] Such statements recall those articulated in the work of Samuel Beckett, for example at the close of his novel *The Unnameable*. In her autobiographical artistic manifesto of 1975, *The Struggle and Wanderings of My Soul*, Kusama reiterated the statement she had first made in 1964 when questioned about the impetus behind *Driving Image*: 'I feel as if I were driving on an endless highway until my death ... I will continue to desire and, at the same time, to escape all sorts of feelings and visions until the end of my days. Whether or not I cannot stop living, yet I cannot escape from death.'[15]

1 Other artists shown at Galerie M.E. Thelen, Essen, in the years between 1965 and 1970, before and after Kusama, were Piero Manzoni, Carla Accardi, Alain Jacquet, Lygia Clark, Pino Pascali, Paul Thek, Laura Grisi, Tetsumi Kudo and Robert Graham.

2 Udo Kultermann, 'Die sanfte Revolution: Die Ausstellung "Monochrome Malerei" und die Kunst um 1960', *Sammlung Lenz-Schoenberg* (cat.), Central House of Art, Moscow, 1989

3 *Yayoi Kusama* (cat.), Galerie M.E. Thelen, Essen, 1966

4 Yayoi Kusama, quoted in Udo Kultermann, 'Lucid Logic: The Art of Yayoi Kusama Unveils a Female Worldview', *Sculpture*, Washington, DC, January 1997, p. 28. See also Lynn Zelevansky, 'Driving Image: Yayoi Kusama in New York', *Love Forever: Yayoi Kusama 1958–1968* (cat.), The Museum of Modern Art, New York, 1998

5 *Yayoi Kusama* (cat.), op. cit.

6 See Udo Kultermann, 'The Construction of Freedom: Re-evaluating the Art of Yves Klein', *Nouveau Réalisme* (cat.), Musée du Jeu de Paume, Paris, 1999

7 Anonymous editorial article in local Essen newspaper, April 1966

8 Ed Sommer, 'Letter from Germany: Kusama at Galerie M.E. Thelen', *Art International*, No. 10, Lugano, October 1966. Sommer also saw a connection between Kusama's art and that of emerging young European artists such as Günther Uecker.

9 A parallel but quite different manifestation of this tendency towards the ensemble was Kusama's exhibition at the XXXIII Venice Biennale, 1966, entitled *Narcissus Garden*, where she assembled 1,500 industrially manufactured mirror balls in the gardens outside the Italian Pavilion.

10 Yayoi Kusama, artist's statement, *c*. 1964

11 Alexandra Munroe, 'Obsession, Fantasy and Outrage: The Art of Yayoi Kusama', *Yayoi Kusama: A Retrospective*, Center for International Contemporary Arts, New York, 1989, p. 26

12 Carla Gottlieb, *Beyond Modern Art*, Dutton, New York, 1976, p. 182

13 Interview prepared for WABC radio, New York by Gordon Brown, executive editor of *Art Voices*; first published in *De nieuwe stijl/The New Style: Werk van de internationale avant-garde*, Vol. 1, De Bezige Bij, Amsterdam, 1965, pp. 163–64. Reprinted in this volume, pp. 100-5

14 John Gruen, 'The Underground', *Vogue*, New York, October 1968. Contemporaneously with this interview, I remember seeing with Kusama in New York the just-released film *Bonnie and Clyde*, in which – in Kusama's perception – polka dots were manifested even in the gunshot wounds of the bodies.

15 Yayoi Kusama, *The Struggle and Wanderings of My Soul*, originally published in Japanese as 'Waga tamashii no henreki to tatakai' in the journal *Geijutsu seikatsu* (*Art and Life*), Tokyo, 1975; see this volume, pp. 118-22. See also Udo Kultermann, 'Schweigen in der Mitte des Schweigens: Ein Thema der Moderner Kultur', *Idea IX* (Jahrbuch der Hamburger Kunsthalle), 1990, pp. 254–56

Driving Image (detail)
1959–64
Sewn stuffed fabric, wood, canvas, mannequins, household objects, paint, macaroni carpet, soundtrack
Installation, 'Driving Image Show', Galerie M.E. Thelen, Essen, Germany, 1966

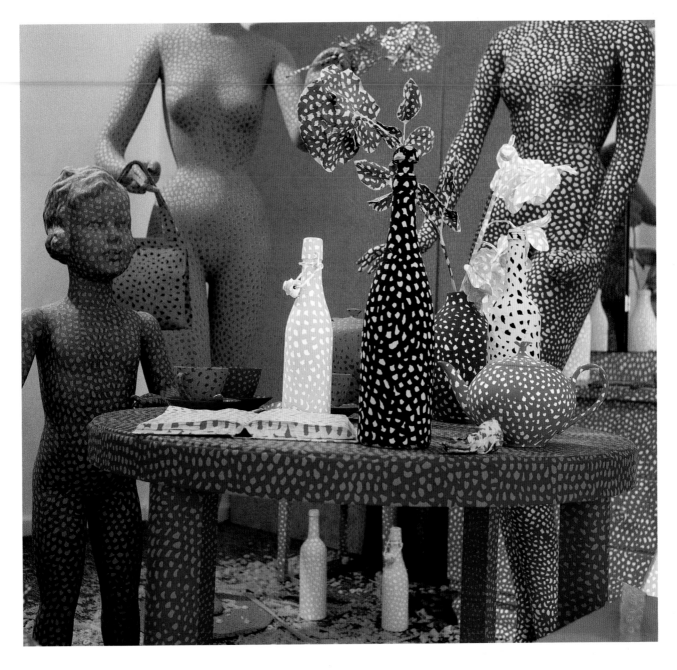

Contents

I

Innocently, I carried my mother on my back
she was so light, I cried
unable to make more than three steps

II

I even think of dying
as a daily medicine:
my heart aches

III

Is there any way to end this life
if only I had a heart
to urge a leap from the heights

IV

I was struck by surprise
in front of a mirror store
I was walking in rags

V

I play with a crab
in tears
on the white sand beach on a small island in the Eastern Sea

VI

One day I recall
the pain of my first love long ago
lying on my belly on the sand, on the sand mountain

Translated from Japanese by Reiko Tomii

No. Green No. 1
1961
Oil on canvas
178 × 124.5 cm
Collection, Baltimore Museum of
Art

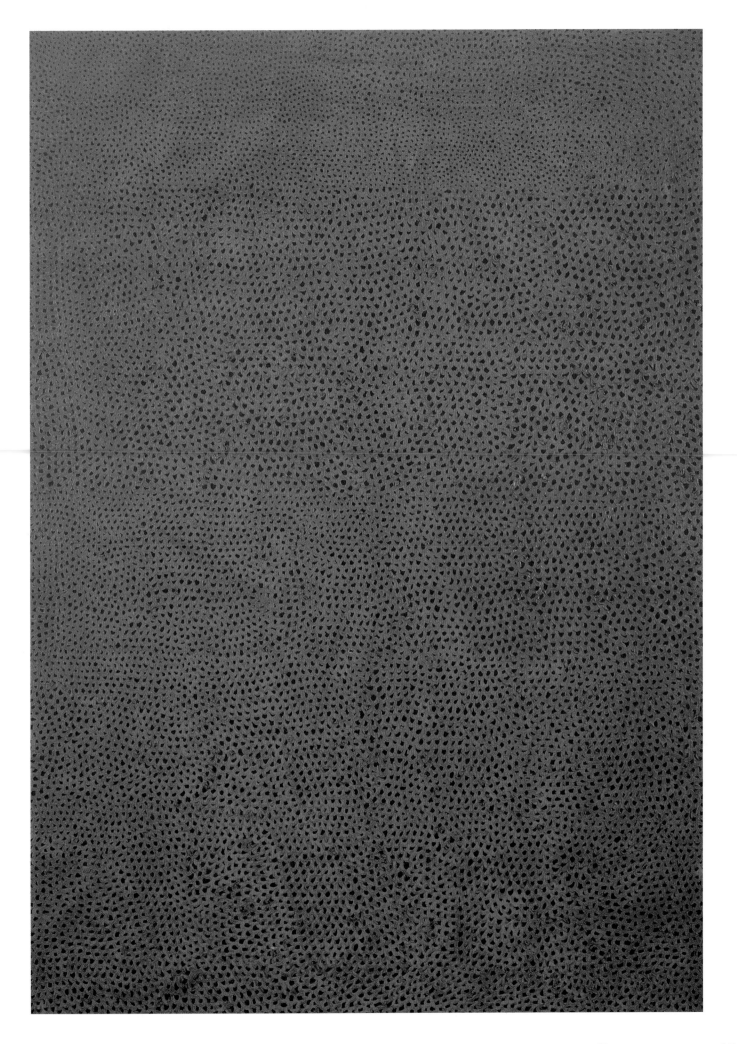

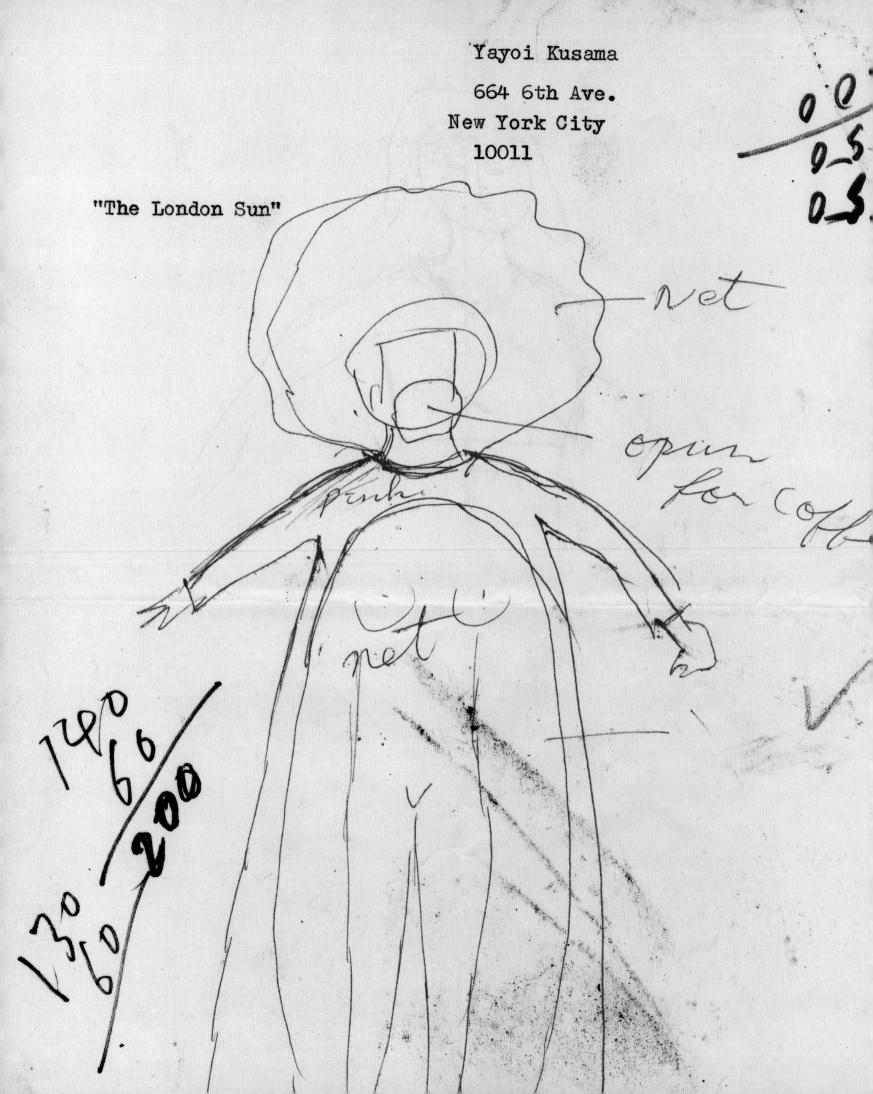

Contents

Interview with Gordon Brown (extract) 1964

Gordon Brown Miss Kusama, are the stuffed sacs with which you cover all those household objects really phallic symbols?

Yayoi Kusama **Everybody says so.**

Brown How long does it take you to complete one of your sculptures?

Kusama **That depends on the size of the sculpture. For example, my *Ten Guest Table* (1963) took me one month to finish.**

Brown In your January exhibit, the *One Thousand Boats Show* (Gertrude Stein Gallery, New York, Winter 1963/4), which provoked so much attention in the art world, many people were moved to wonder about the actual basis of its star attraction. Was that a real boat?

Kusama **Yes, that was a real nine-foot rowboat.**

Brown And I may say that the other 999 were black and white mural images that dramatically created the frame of mind in which to view the real one. Both multiplication of the image and the multiplication of those curious phallic bumps were found to be, you might say, hypnotic by the viewers. I have noticed that the accumulation of many similar elements is the one concept that runs through all the numerous styles in which you have created. Could you tell us the origin of that tendency?

Kusama **Well, I arrived at my present style after years of experimentation.**

Brown Would you tell us more about that?

Kusama **Yes, I started when I was a child. I used to tear clothing, papers, even the books I read, into thousands of pieces with scissors and razor blades. I also liked to shatter the windows, mirrors and dishes with stones and hammer.**

Brown You must have been a little demon around the house. What did you do after that?

Kusama **Later, I painted intricate pictures of the tiny networks found in leaves, butterfly**

Ten-Guest Table and **Eleven Feet**
1963
Sewn stuffed fabric, table, knives,
forks, plates, napkins, shoes
Dimensions unknown

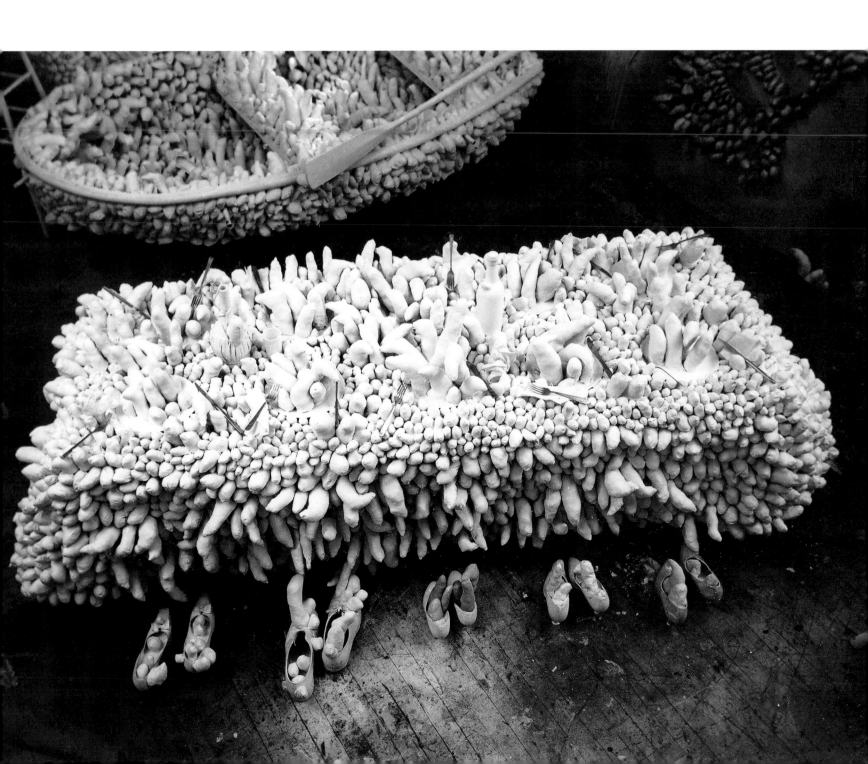

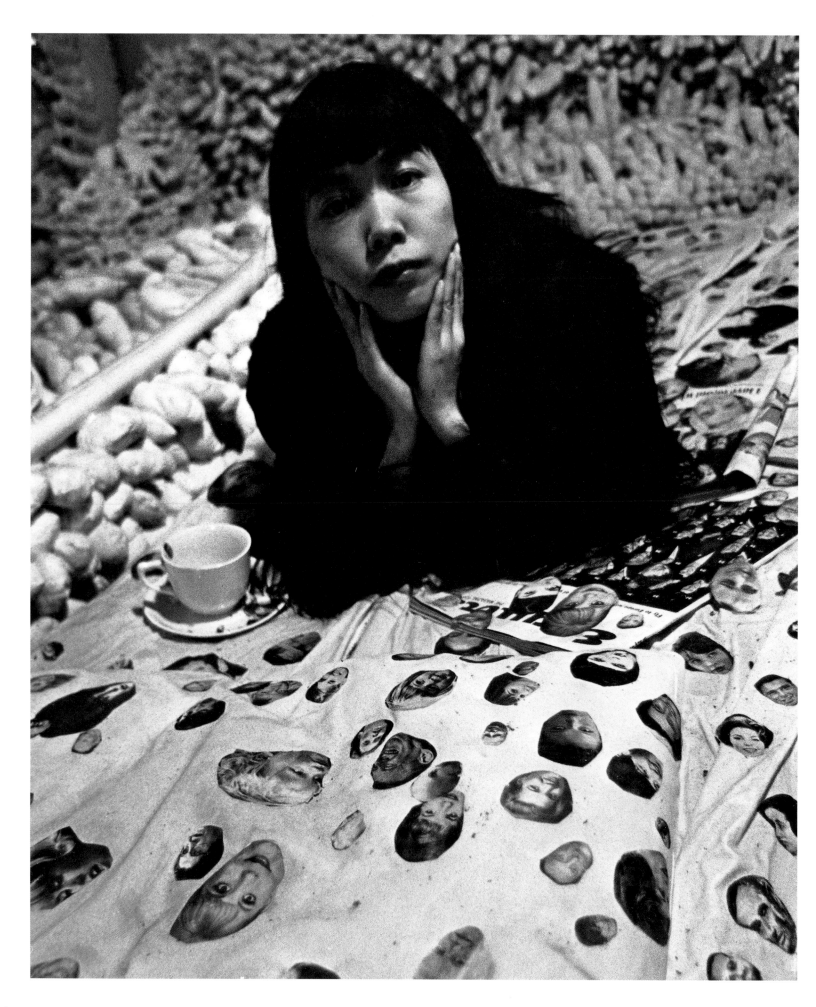

wings, etc., with Chinese ink. These covered the entire paper and looked like giant webs. Later on, I cut out thousands of little faces from magazines and collected them in a box. Many years afterwards, when I was in America, I made collages of these too.

Brown What were some of the other materials you used in your more mature collages?

Kusama **I made many collages of postage stamps, airmail stickers and paper dollars.**

Brown Were these the works that made up your first solo show in New York?

Kusama **No, my first solo show in New York consisted of my giant *Infinity Net* paintings. I showed five of these at the Brata Gallery (1959).**

Brown Could you describe these paintings for readers who might not have seen them?

Kusama **My net paintings were very large canvases without composition – without beginning, end or centre. The entire canvas would be occupied by monochromatic net. This endless repetition caused a kind of dizzy, empty, hypnotic feeling.**

Brown Why did you choose a non-compositional, monochromatic form of expression?

Kusama **I have no interest in the conventional logic and philosophy of art. I forgot all the theories of composition and colour. This style resulted in empty, nihilistic canvases that the critics did not always understand. For example, Mr Sidney Tillim called them Impressionism, and Mr Jack Kroll wrote: 'Potential resolutions have been launched by the Zen vigil.' But my paintings had nothing to do with Impressionism or with Zen Buddhism. Anyway, I made net paintings for several years. I guess I came under a spell.**

Brown You mean that you became in a sense overpowered by your own work?

Kusama **Well, you might say that I came under the spell of repetition and aggregation. My nets grew beyond myself and beyond the canvases I was covering with them. They began to cover the walls, the ceiling, and finally the whole universe. I was always standing at the centre of the obsession, over the passionate accretion and repetition inside of me.**

Accumulation of Nets (No. 7)
1962
Photocollage
74 × 62 cm
Collection, The Museum of Modern
Art, New York

Brown How large did your net paintings finally get?

Kusama **One was 33 feet long. My 22-foot painting was in the international show in the Amsterdam museum two years ago. ('Tentoonstelling Nul', Stedelijk Museum, Amsterdam, 1962, curated by Henk Peeters.)**

Brown What happened after you had made your 33-foot painting?

Kusama **This is when I began my *Aggregation* sculpture – a logical development of everything I have done since I was a child. It arises from a deep, driving compulsion to realize in visible form the repetitive image inside of me. When this image is given freedom, it overflows the limits of time and space. People have said that my *Aggregation* sculpture presents an irresistible force, a force that goes by its own momentum once it has started. I give to this sculpture the name *Driving Image*.**

I feel as if I were driving on the highways or carried on a conveyer belt without ending until my death. This is like continuing to drink thousands of cups of coffee or eating thousands of feet of macaroni. This is to continue to desire and to escape all sorts of feelings and visions until the end of my days whether I want to or not. I cannot stop living and yet I cannot escape from death.

This consciousness of living in continuation sometimes drives me crazy. It makes me sick before and after my work. On the other hand, I am deeply terrified by the obsessions crawling over my body, whether they come from within me or from outside. I fluctuate between feelings of reality and unreality. I am neither Christian nor a Buddhist nor anyone with great control over her self.

I find myself being put into a uniform environment, one which is strangely mechanized and standardized. I feel this strongly in highly civilized America and particularly in New York. In the gap between people and the strange jungle of civilized society lies many psychosomatic problems. I am always deeply interested in the background of problems involved in the relationship of people and society. My artistic expressions always grow from the aggregation of these […]

Interview prepared for WABC radio by Gordon Brown, executive editor of *Art Voices*; first published in *De nieuwe stijl/The New Style: Werk van de internationale avant-garde*, Vol. 1, De Bezige Bij, Amsterdam, 1965, pp. 163–164.

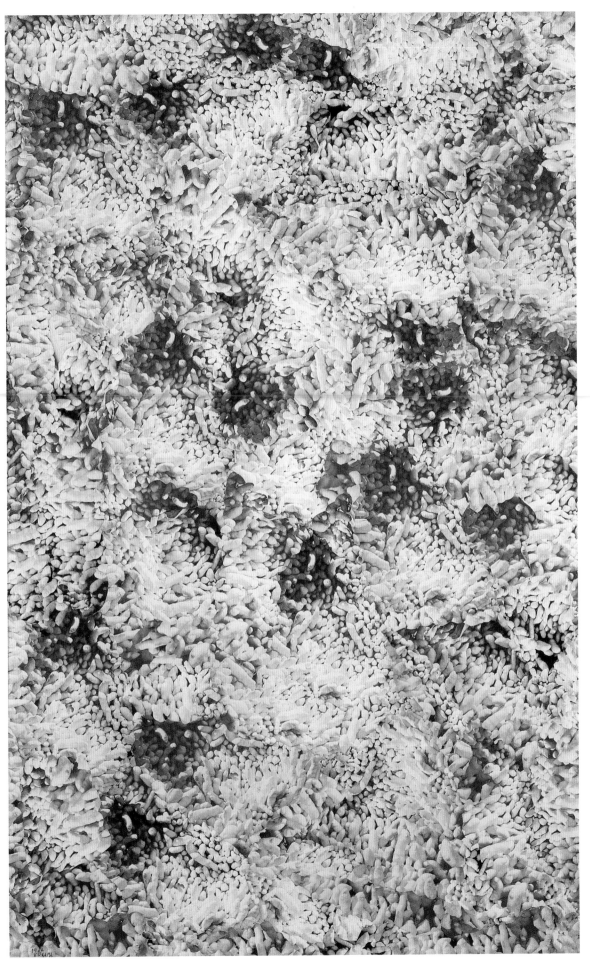

Accretion (No. 3)
1964
Collaged paper
112 × 71 cm
Collection, Oita Art Museum,
Japan

An Open Letter to My Hero, Richard M. Nixon 1968

Nixon Orgy
The artist's studio, New York,
1968

Our earth is like one little polka dot, among millions of other celestial bodies, one orb full of hatred and strife amid the peaceful, silent spheres. Let's you and I change all that and make this world a new Garden of Eden.

Let's forget ourselves, dearest Richard, and become one with the Absolute, all together in the alltogether. As we soar through the heavens, we'll paint each other with polka dots, lose our egos in timeless eternity, and finally discover the naked truth:

You can't eradicate violence by using more violence.

This truth is written in spheres with which I will lovingly, soothingly, adorn your hard masculine body. Gently! Gently! Dear Richard. Calm your manly fighting spirit!

11 November 1968.

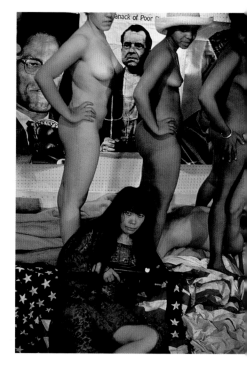

Anatomic Explosion, Wall Street 1968

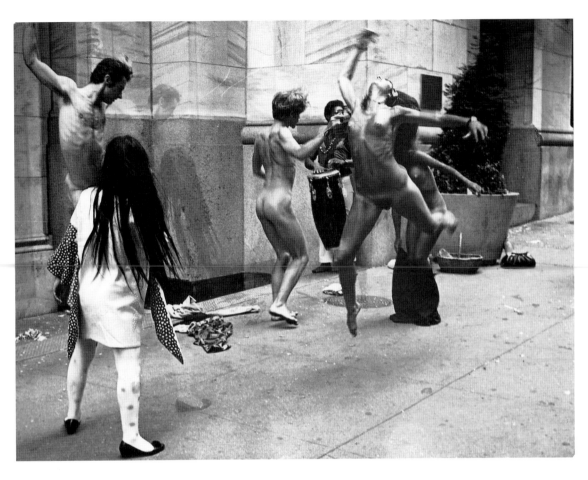

STOCK IS A FRAUD!

STOCK MEANS NOTHING TO THE WORKING MAN.

STOCK IS A LOT OF CAPITALIST BULLSHIT.

We want to stop this game. The money made with this stock is enabling the war
to continue. We protest this cruel, greedy instrument of the war establishment.

STOCK IS FOR BURNING.

STOCK IS FOR BURNING.

STOCK MUST BE BURNED!

Don't pay taxes. Stop the 10 per cent tax!

Burn Wall Street.

Wall Street men must become farmers and fishermen.

Wall Street men must stop all of this fake 'business'.

OBLITERATE WALL STREET MEN WITH POLKA DOTS.

OBLITERATE WALL STREET MEN WITH POLKA DOTS ON THEIR

NAKED BODIES.

BE IN ... BE NAKED, NAKED, NAKED.

Press release for Naked Protest at Wall Street, New York, 10.30 a.m., Sunday 15 October 1968.

Naked Event at the Stock
Exchange
Happening outside the Stock
Exchange, New York, 1968

Homosexual Wedding 1968

This is the first Homosexual Wedding ever to be performed in the United States. The ceremony will be conducted by Yayoi Kusama, known for her widely publicised out-of-door naked happenings at the Statue of Liberty, the New York Stock Exchange and many other public places. Kusama, whose sculptures and paintings have been exhibited in the leading museums of contemporary art in Europe and the United States, has designed the costumes for the Homosexual Wedding.

Both the bride and groom will wear a fantastic 'orgy' wedding gown, designed for two instead of one. 'Clothes ought to bring people together, not separate them', Kusama insists.

Kusama will see to it that the bride and groom get together after the wedding ceremony. The guests will act as witnesses to the wedding and all subsequent festivities and events.

'The purpose of this marriage is to bring out into the open what has hitherto been concealed', says Kusama. 'Love can now be free, but to make it completely free, it must be liberated from all sexual frustrations imposed by society. Homosexuality is a normal physical and psychological reaction, neither to be extolled or decried. It is the normal reaction of many people to homosexuality that makes homosexuality abnormal.

'Once sexual frustrations have been removed, there will be no more overemphasis on sex and the artist will be free to channel his creative energies into true art.

'Sex is the same, whether or not a marriage has been performed.'

The Homosexual Wedding will take place at the Church of Self-obliteration on Monday 25 November, at 8pm.

Press release from the 'Church of Self-obliteration', 31–33 Walker Street at Church, New York City, 1968.

Homosexual Wedding
Happening, the 'Church of Self-obliteration', 31–33 Walker Street at Church, New York, 1968

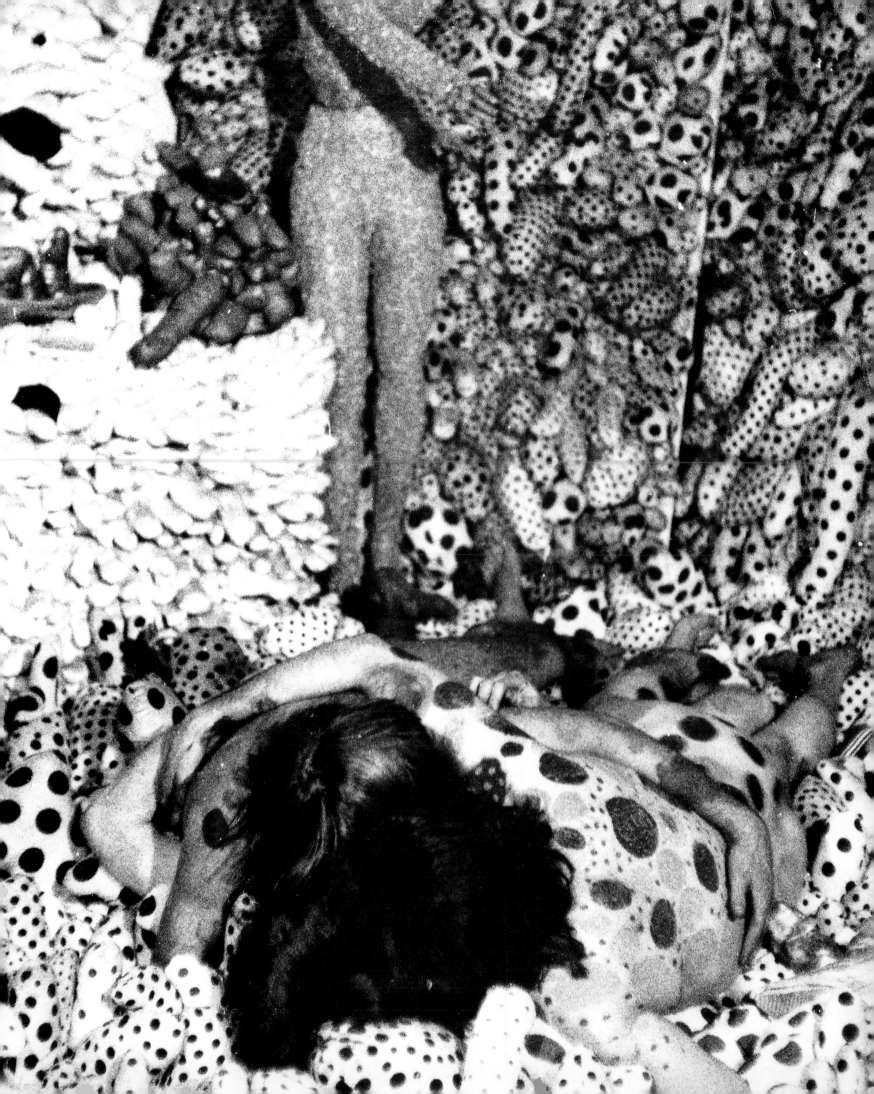

Naked Self-Obliteration: Interview with Jud Yalkut 1968

Jud Yalkut In your career as a painter and sculptor, you presented your first *Self-Destruction Happening* on Dutch television in 1965. When did you first start doing Happenings on an intensive basis?

Yayoi Kusama **From June 16–18, 1967, I held a Dot event called 'Self-obliteration, an Audio-visual Light Performance' at the Black Gate Theater (2nd Avenue, New York), with several models in bikinis amid pieces of furniture, all of which were painted with fluorescent polka-dots to the music machines of Joe Jones and His Tonedeafs – a chorus of almost thirty amplified frogs. Everything originated from polka-dots on a canvas, spilling forth onto the easel, the floor, the people, with everyone finally painting themselves, each other and the floor.**

Yalkut It was then that we first began the filming of our movie 'Self-Obliteration'.

Kusama **Yes. Later, I held two more happenings at Group 212 in Woodstock, New York, which you also filmed, where, to live rock and roll music, a number of people took off their clothes and painted each other fluorescently under black light, as slides of my *Infinity Net* paintings were projected on everyone's body, and also a dog. Later that summer, I started a body-painting 'Body Festival' at the Chrysler Museum in Provincetown on September 1st and 2nd. The local papers called this 'making people into art'. Boston TV introduced this happening into New York also. Also, that summer in Central Park, at the Japan Society 'Japanese Promenade', which included Kabuki dancing and the tea ceremony, and was sponsored by the New York Department of Parks, I obliterated myself and a horse and rode through the Festival. The first discotheque performance was with the Group Image on the stage of the Electric Circus street party, when St Marks Place was closed to traffic and the street was jammed with thousands under umbrellas. My dancers performed on the balcony through projections from across the street.**

Yalkut When did you start your first series of Naked Happenings?

Kusama **November 3rd, 1967, at the Orez Gallery in the Hague, the Netherlands. I had a one-person show with polka-dotted mannequins fluorescing in many colours, and fluorescing polka-dots everywhere, on the walls, floor and ceiling. Many articles appeared in the leading Dutch newspapers about this 'Love Room'.**

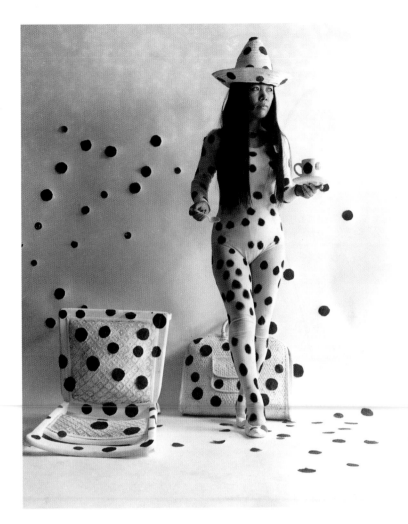
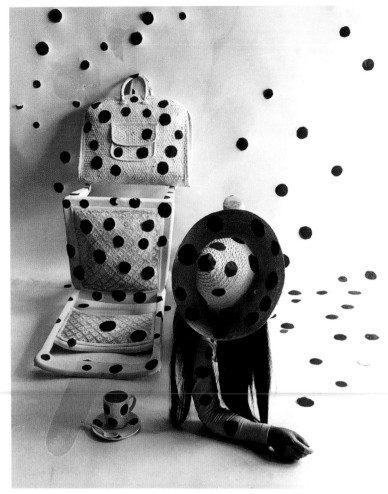

Self-obliteration by Dots
(details)
1968
Performance, documented with
black and white photographs by
Hal Reif

That same night, at the Catholic Students' Center in Delft, under a strobe light, more than thirty leading Dutch artists, including Jan Schoonhoven, 2nd prizewinner at the Sao Paulo Biennale, took off their clothing while the Novum Jazz Orchestra played. I started painting Schoonhoven and everyone painted each other with polka-dots in the strobe light. This scene was introduced to Belgium and Germany, as well as Holland, on Dutch television. It was the first time naked people appeared on their television. Many critics and Directors of the museums were in the audience. This social demonstration continued until five in the morning, with body painting and rock and roll. The police arrived that morning and closed the Catholic Student Centre, and took away the performing licenses of the naked musicians. The Delft townspeople invited the director of the Stedelijk Museum, Amsterdam to lecture on 'Kusama's naked demonstration and sex revolution' but he did not wish to risk his prestige. It was a complete scandal in peaceful Holland.

On November 18, I had another naked demonstration at the altar of the Schiediems Museum in Rotterdam, once a church two hundred years ago. Three or four hundred townspeople left disturbed and the Trustees of the Museum wanted to fire the young, progressive Director, who received the support of many citizens and young people who wrote letters and talked to newspapers to keep his job. I told the press and radio people who came to me, 'If the Director is fired and the Catholic Center closed, I will do the naked demonstrations at all the museums and churches in Holland and you will have to close them all'.

At the Amsterdam Museum on 8 December, too many journalists made the situation over formal and nudity was unsuccessful. On 9 December, ten artists and dancers participated in a naked demonstration at the Bird-Club, the biggest nightclub in

Amsterdam. Later that night, under the huge dome of the National Fair Exposition Hall, ten thousand students watched while several people painted each other's naked bodies, but the police came and arrested the participants of this 'Love-In Festival', and jumped on the stage while hundreds of young people clamoured for continued nakedness. Spectacular publicity followed throughout Holland and even the stewardess on the plane back recognized my face.

Yalkut Do you have any other comments to make about our film collaboration?

Kusama **We took three months through the summer of 1967 to film, including the Gate Theater and 212 Happenings, my watercolours and pastels from 1945 to 1964, my *Aggregation* sculptures, and my 1965 *Flower Bed*. We filmed body-painting parties with my Electric Circus dancers, and the film builds to a specially staged but spontaneous naked body painting orgy in my *Infinity Mirror Room* [at Kusama's studio on 14th Street]. I also obliterated cats, dogs, a horse, rocks, lakes, mountains, New York City and the Statue of Liberty with polka-dots, and did many obliterations associated with nature. I consider myself very lucky to have worked with you. The colour photography was tremendously beautiful and we communicated very well.**

Yalkut After your spectacular Naked Demonstrations recently at the Palm Gardens and the Gymnasium Discotheque in New York, what would you like to say about the underlying philosophy behind your 'Self-Obliterations'?

Kusama **As I wrote in the poster for my first 'Self-Obliteration' performance: 'Become one with eternity. Obliterate your personality. Become part of your environment. Forget yourself. Self-destruction is the only way out.' My performances are a kind of symbolic philosophy with polka-dots. A polka-dot has the form of the sun which is a symbol of the energy of the whole world and our living life, and also the form of the moon which is calm. Round, soft, colourful, senseless and unknowing. Polka-dots can't stay alone; like the communicative life of people, two or three and more polka-dots become movement. Our earth is only one polka-dot among a million stars in the cosmos. Polka-dots are a way to infinity. When we obliterate nature and our bodies with polka-dots, we become part of the unity of our environment. I become part of the eternal and we obliterate ourselves in Love.**

The New York Free Press & West Side News, New York, 15 February, 1968.

Kusama's Self-obliteration
1968
16mm film, directed by and
starring Yayoi Kusama
Filmed by Jud Yalkut
Film stills

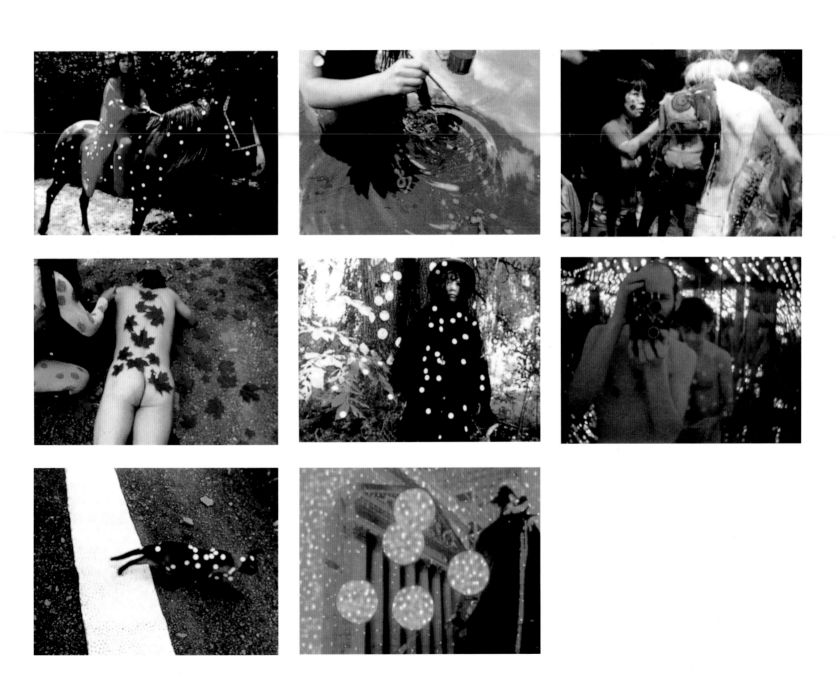

Take a Subway Ride from Jail to Paradise 1968

Fashion Happening, New York,
c. 1968–69

Fashion show, Kusama's Boutique,
New York, 1969

Ask Miss Subway to take it off!

**Every morning, as you go to work in the subway you see the same girl or boy waiting
for a train, sitting opposite you in miniskirt or slacks, or getting off at your station.
By now, you have certainly chosen your favourite, the girl or boy you have never met
but would like to know most.**

Why remain strangers?

Let's get to know one another!

We know the surest way: Let's all take off our clothes in the subway!

Grand get-together naked happening by Kusama and her naked boy and girl dancers.

Transform the subway into Paradise by participating in this epoch-making event!

**Why remain 'boxed-in' in the subway or, what amounts to the same thing, in your
apartment? 'Rapid transit' in the subway, as it is now, is a delusion; you're really
not getting anywhere.**

**Break through the bars of your prisons! Demand Freedom! Make life interesting!
Why remain passive in the face of boredom and monotony? We're seeing the same
shows, reading the same things eternally, when positive action is what is needed.**

LET'S CHANGE LIFE!

Press release for Happening on the Carnasie Line BMT 14th SW, New York, Sunday 12 noon, 17 November
1968.

Why Look Like Other People? 1968

Buck the establishment! Why look like other people?

Haven't you a personality? Express it!

I invite you to attend my 'Fashion Promenade' on Fifth Avenue from the foot of St. Patrick's Cathedral up Fifth Avenue to 57th Street on Sunday 5 October, at 1 p.m.

As my attractive young models walk along these streets, they will gradually divest themselves of their excess clothing, eventually displaying the *Natural Look*, responding to the *Natural Urge* decreed by the Cosmic forces of planet *Earth*.

My Fashion Institute is busy manufacturing and designing clothes that enhance your own personality and humanity in spite of our drab, machine-made, industrialized environment. These fashion designs have the beauty of passing clouds in a clear blue sky, of the multicoloured foliage of Autumn trees. They have the handmade look that comes from expert craftmanship.

See my 'Peekaboo', 'See-Through' and 'Open' pants, miniskirts and body stockings in the cloth and in the flesh. There are holes all over – holes that radiate life-giving energy – part of my Holy War against the establishment.

Other items in my collection include African printed minishifts for both sexes meant to be worn by two people at the same time. My 'Silver Squid' design has a hood covering the head, holes for the breasts and stream-like strands of material extending to the floor.

I'm waiting for you at the rendezvous.

Oceans of love from

Kusama

Press release from Kusama Fashion Institute, 146 West 29th Street, New York City, 1968.

Alice in Wonderland 1968

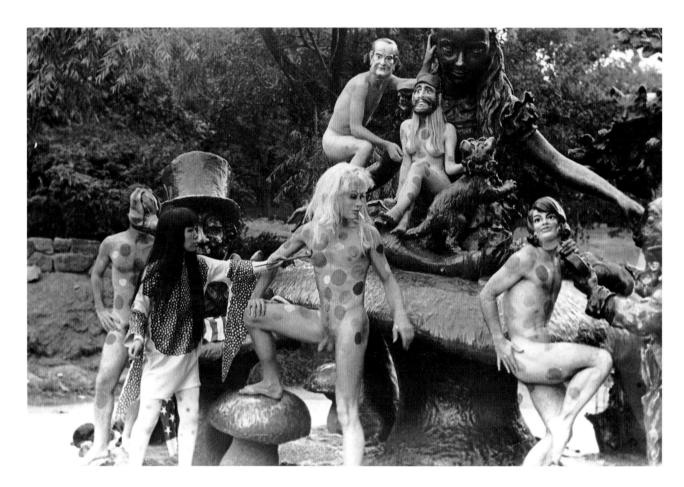

Alice In Wonderland

Featuring me, *Kusama*, mad as a hatter, and my troupe of nude dancers.
How about taking a trip with me out to Central Park where free tea will be provided
under the magic mushroom of the Alice In Wonderland Statue. Alice was the
grandmother of the Hippies. When she was low, Alice was the first to take pills
to make her high.

I, Kusama, am the modern Alice in Wonderland.

Like Alice, who went through the looking-glass, I, Kusama, (who have lived for years
in my famous, specially-built room entirely covered by mirrors), have opened up
a world of fantasy and freedom. My world is peopled by a group of real nude girl and
boy dancers covered by genuine hand-painted polka dots. You, too, can join my
adventurous dance of life.

Paint the beautiful blonde Lydia Lee.
Paint your friends.
Have your friends paint you.
All together in the all-together.
LOVE – LOVE – LOVE – LOVE – LOVE

Rendezvous at the *Alice in Wonderland* Statue in Central Park, Sunday 11 August,
at 5 a.m. Because of the appropriate hour, free tea will be provided.

My dancers: Ernie Blake, Rick Erling, Lydia Lee, Ted Ryan and Paul Sanford.

Press release for *Alice in Wonderland* Happening, Central Park, New York, 11 August 1968.

Grand Orgy to Awaken the Dead 1969

Grand Orgy to Awaken the Dead at MoMA (Otherwise Known as The Museum of Modern Art) Featuring Their Usual Display of Nudes
Naked Happening, Rockefeller Gardens, The Museum of Modern Art, New York, 1969

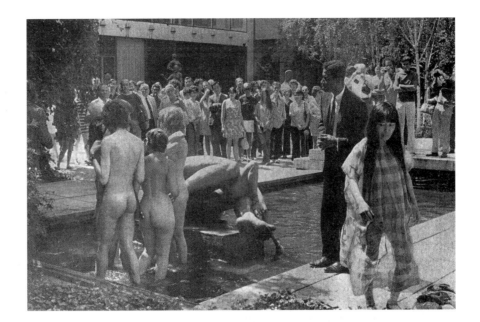

A Message from Kusama

Grand Orgy to Awaken the Dead at MoMA (Otherwise known as the Museum of Modern Art). Featuring their usual display of nudes. At the museum you can take your clothes off in good company: RENOIR, MAILLOL, GIACOMETTI, PICASSO. I positively guarantee that these characters will all be present and all will be in the nude. (Sociological note: The nude has become socially acceptable among the more permanent residents of the garden of the museum. Phalli also as *à la mode*, particularly the harder varieties in granite, basalt and bronze.) This being the case, we will make this celebration traditional, in keeping with the tone of the Museum of Modern Art.

Thoughts on the Mausoleum of Modern Art

What's modern here? I don't see it.
Van Gogh, Cezanne, these other ghosts, all are dead or dying.
While the dead show art, living artists die.
Fame and reputations are sold across the counter.
Here art, hard as diamonds, prevails over love;
Diamonds for grand dames attending their funeral.
MoMA is political, a show place for vanity.
Politics has no place in love and art.
No life stirs in empty room where *Don't touch* is the rule.
Exhibitions should be free and not a dollar fifty.
Art should be priced for all to own – at the supermarket.
Soft sculpture is alive, always preferable to hard sculpture.
My love is like mixed media, mixing you and me.

Cast includes Lunar Eclipse, Crystal Violence, Lasar Beam, Dill Dough, Infra Red, Looney Tunes.

Press release for the Happening *Grand Orgy to Awaken the Dead at MoMA (Otherwise Known as The Museum of Modern Art) Featuring Their Usual Display of Nudes*, Rockefeller Gardens, The Museum of Modern Art, New York, 24 August 1969.

The Struggle and Wanderings of My Soul (extracts) 1975

I

It started from hallucination.

Ever since I reached the age of reason: nature, the universe, people, blood, flowers and various other things have been etched in my vision and hearing and deep into my mind, as strange, frightful and mysterious occurrences. They have captivated my whole life and stayed with it persistently. These strange, uncanny things, which came in and out of my soul, often ran after me obsessively, with such persistence that it was akin to hatred, and drove me into half madness for many years. The only way to free myself from them was to control myself – by visually reproducing on paper with pencils or paints, or by drawing from memory these 'nondescript' occurrences, which brightened or darkened in the deep of the sea, agitated me and drove me to angry destruction, as I tried to find out what these frightening monsters really were.

Since psychiatrists were not as popular then as today, I kept secret the insecure feeling that plagued me every day; the illusions and hallucinations that visited me occasionally, and my partial hearing defect. I was in fear that people might discover these secrets. I had no one to consult with about the asthma caused by the tension between me and the outer world. Talking about man–woman relationships was a taboo. Things in human society were mostly shrouded in mystery. The gap between me and my parents and society was maddeningly irritating and unreasonable. I probably already had the sense of despair all around me when I was in my mother's womb.

Painting pictures seemed to be the only way to let me survive in this world, and was rather like an outburst in my passion, in desperation. Thus my art started from something primitive and instinctive, far removed from art.

One day, when I was a little girl, I found myself trembling, all over my body, with fear, amid flowers incarnate, which had appeared all of a sudden. I was surrounded by several hundreds of violets in a flower garden. The violets, with uncanny expressions, were chatting among themselves just like human beings. No sooner had they and I had spiritual dialogues than I became infatuated with them, drawn into the glitter of illusion, away from this world. This was not an illusion but the real world, I told myself. I developed goose pimples; my feet were shaking. When I tried to run back home, my feet did not budge an inch, even if my mind was telling me to hurry. I became confused, and both my mind and body were dragged into the unknown world. I managed to return to the dark closet in my house, and when I murmured to myself 'Was I scared?', I realised that my voice had become that of a dog. I went out into the yard and talked to the dog to ascertain it. Sure enough and to my surprise, I had become a dog.

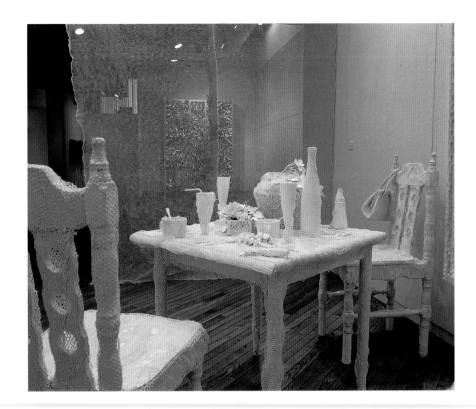

Underneath the green duckweed, in a weirdly quiet pond, was a shadow, trying to lure my soul. My soul was repeatedly drawn into the pond; I almost drowned by stepping into it. A strange memory. Was this the tranquillity of the precise moment when my soul was departing from my body? All through my life, I have been forced to wander obsessively between life and death, incessantly possessed by time and space.

One day I was looking at a red flower-patterned table cloth on a table, and then when I looked up, I saw the ceiling, the window panes and the pillars completely covered with the same red flower patterns. With the whole room, my whole body and the whole universe covered entirely with the flower patterns, I would self-obliterate; be buried in the infinitude of endless time and the absoluteness of space, and be reduced to nothingness, I thought. This was not an illusion but a reality, I told myself. I panicked. I had to run away from here, otherwise the spell of the red flowers would deprive me of my life. I ran up the stairs frantically. When I looked below me, the stairs below were falling apart one by one, causing me to fall down and sprain my ankle.

Dissolution and accumulation. Proliferation and fragmentation. The feeling of myself obliterating and the reverberation from the invisible universe. What were they? I was often troubled by a thin silk-like greyish-coloured veil that came to envelop me. On the day this happened, people receded far away from me and looked small. I could not comprehend what was being discussed between me and others. When I went out on such a day, I forgot my way home and, after wandering some time, I often crouched under the eaves of someone's house to spend the whole night quietly in the darkness, trying to remember how to get home. I lost the sense of time, speed and distance, and of how to talk with people. I ended up locking myself in a room. Thus I turned into a more manageable, 'worthless child'.

While coming and going between this world and the unknown one, I fell sick a number of times and became a prisoner of artistic creation. By painting pictures on paper and canvas and by making weird objects, I began gradually to repeat the work of calling forth and back the place for my soul. For me, these experiences were not temporizing artistic endeavours nor makeshift art to catch up with the trend of the times – like a chameleon changing the colour of its skin according to its circumstances –

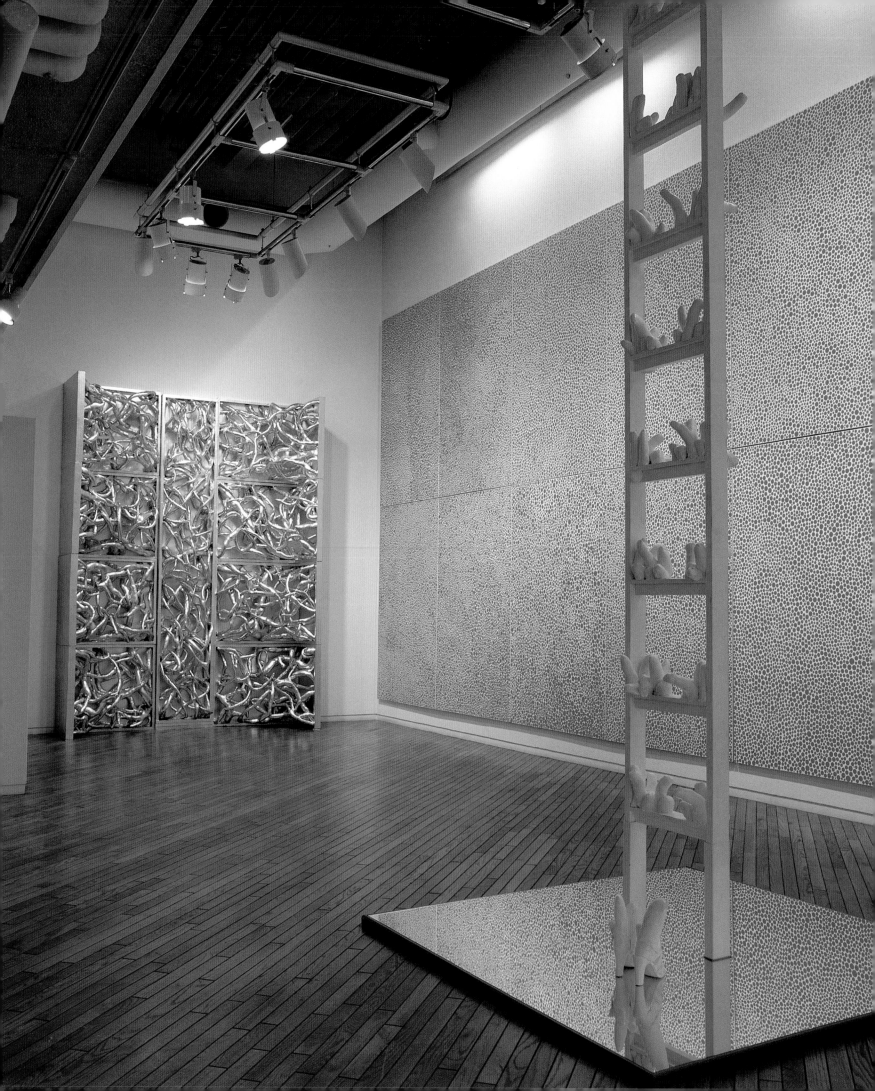

Installation, 'Yayoi Kusama: My
Solitary Way to Death', Fuji
Television Gallery, Tokyo, 1994
foreground, **My Solitary Way to
Death**
1994
Sewn stuffed fabric, wood, mirror
406 × 160 × 160 cm

background, left, **Prisoner's Door**
1994
Sewn stuffed fabric, wood, silver
paint
313 × 240 × 63 cm

background, right, **Pink Dots – Let
Me Rest in a Tomb of Stars**
1993–94
Acrylic on canvas
16 parts, 194 × 130 cm each

**but were an attempt at artistic creation based on the inevitability that emerged from
within me; a calling […]**

**Feeling miserable in the unhappy atmosphere at home, all I could think of was
to paint. As I was totally lacking in social and general common sense, there was always
friction between me and my surroundings. My spiritual burden and uneasiness
naturally became intensified in proportion to the rise of accusations levelled at me from
the people around me. As a result, the bleakness of my future appeared to be even
more dismal. The accumulation of these incidents gradually brutalized and devastated
my mind. My mother was vehemently against my becoming a painter, from the
perspective of a woman's happiness. In view of the social conditions of those days, my
mother probably thought, 'There is no future for women painters', and imagined that
I would become sick and poor when I got old, and that I might commit suicide by
hanging myself. Besides, as my feudalistic old family was still sticking to the stereotype
that 'painters and actors belong in the same category as beggars', my mother, furious
about my painting pictures day and night without doing anything else, often kicked my
palette. Sometimes our quarrels turned into scuffles. Since I kept painting an enormous
amount of pictures, they reached the ceiling when I piled them up. With images flowing
forth from my mind like a volcanic eruption, the problem for me was how to secure
enough canvas, paper and paints. I tried every possible means, running all over the
place to find them.**

**Because I made my debut as an unusual child, I was placed in a rather delicate
position in the parochial Japanese art circles, and was isolated from them. The rumour
that 'she is insane' was spreading like wildfire. My hometown has the towering
Japanese Alps on both sides and the sun hides itself early in the evening beyond the
mountains. What is out there beyond those mountains that soak up the sunbeams?
My curiosity towards the unknown places developed into my desire to see foreign
countries with my own eyes. On one fine day, my burning desire to go to the United
States was realized as I flew over the Pacific […]**

II

**All I wanted to do was to breathe the vitality of the time in which I lived to the best of
my ability and blossom as a bright red flower towards the future, just as butterflies fly
over the fields and mountains in search of a place to die, silkworms emit threads, or as
flowers are coloured red or purple to symbolize their being alive. History clearly shows,
however, that such a flower has been regarded as heretical in any given time. Whatever**

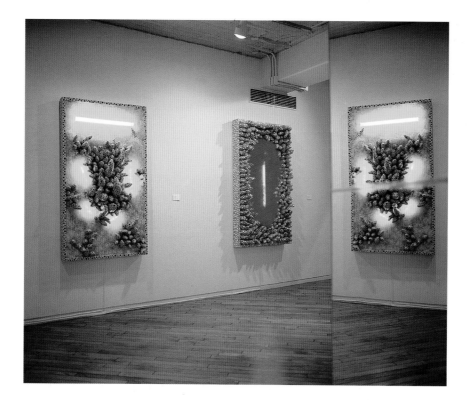

left, Installation, 'Yayoi Kusama: My Solitary Way to Death', Fuji Television Gallery, Tokyo, 1994

opposite, **My Bleeding Heart**
1994
Sewn stuffed fabric, wood, paint, fluorescent light
145 × 81.5 × 27 cm

I do seems to cause misunderstandings and scandals without my knowledge, and the more serious I become the worse become the relationships between me and the outer world. I have always felt miserable in society over the results of what I did as an avant-garde artist. There are thick walls of established systems and restrictions before us. And there are the falsehoods of masses of people, distrust in politics, loss of humanity and confusion, the violence of the mass media, pollution … The spiritual deterioration of humankind tries continually to cloud the bright future that lies ahead of us.

I firmly believe that the creative philosophy of art is ultimately born in solitary meditation and rises from the quietude of reposed soul to glitter and flutter in the splendour of the five colours.

Now the theme of my artistic creation is 'death'. The arrogance of humankind stemming from the progress of science and the development of almighty machines has deprived life of its brightness and diminished people's ability to form mental images. The information society, which has become violent, the uniformed culture and the pollution of nature … In this hell on earth, the mystery of life has already stopped breathing. The death that awaits us has abandoned its solemn serenity, and we are losing sight of tranquil death. Beyond the decadence of humanity and the idiotic ugliness of this earth, which is breeding cockroaches and rats, stars are twinkling with subdued silvery lustre. This is surprising. My momentary life, that is supported by some invisible force, exists in illusions in a brief moment of quietude amidst hundreds of millions of endless light years. The self-revolution which I had been pursuing as a means to live was actually a means to death. What death signifies, its colours and spatial beauty, the quietude of its footprints, and the 'nothingness' after death: I am now at the stage of creating art for the repose of my soul, embracing all of these.

First published as 'Waga tamashii no henreki to tatakai' ('Odyssey of My Struggling Soul'), *Geijutsu seikatsu* (*Art and Life*), Tokyo, November, 1975, pp. 96-113.

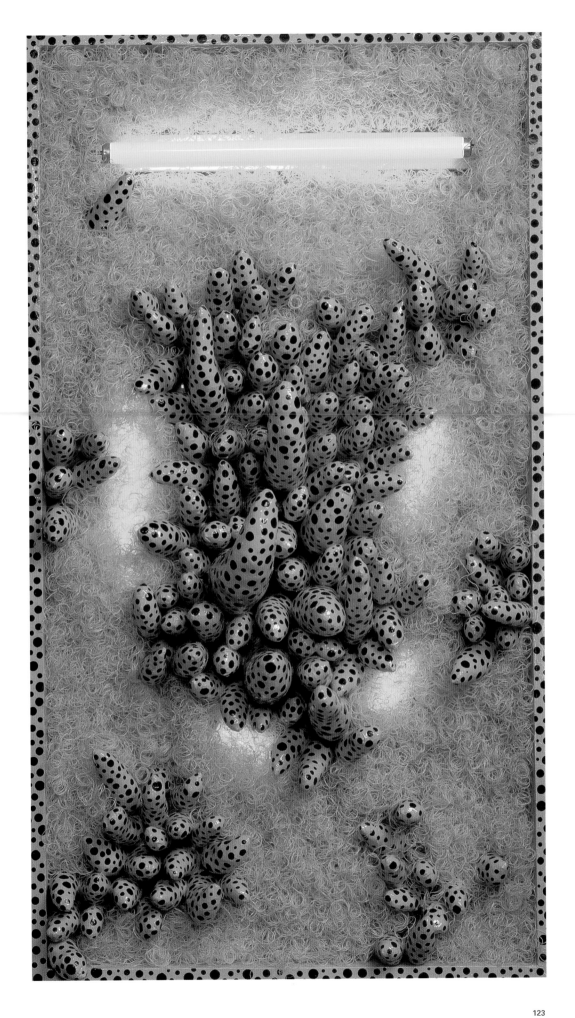

Manhattan Suicide Addict (extract) 1978

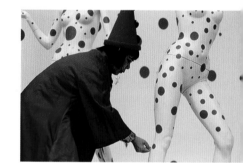

Become one with eternity. Obliterate your personality.

Become part of your environment. Forget yourself.

Self-destruction is the only way out! On your trip, take along one of our live bodies.

I like to say about the underlying philosophy behind our 'Self-obliterations' as I wrote in the manifesto for my first 'Self-obliteration' performance, 'Become one with eternity'.

Obliterate your personality. My performances are a kind of symbolic philosophy with polka dots. A polka dot has the form of the sun which is a symbol of the energy of whole world and our living life, and also the form of the moon which is calm, round, soft, colourful, senseless and unknowing. Polka dots can't stay alone, like the communicative life of people.

Two and three and more polka dots become movement. Our earth is only one polka dot among the million stars in the cosmos.

Polka dots are a way to infinity.

When we obliterate nature and our bodies with polka dots, we become part of the unity of our environment, I become part of the eternal, and we obliterate ourselves in love.

Manhattan jisatsu misui joshuhan (*Manhattan Suicide Addict*), Kosakusha, Tokyo, 1978.

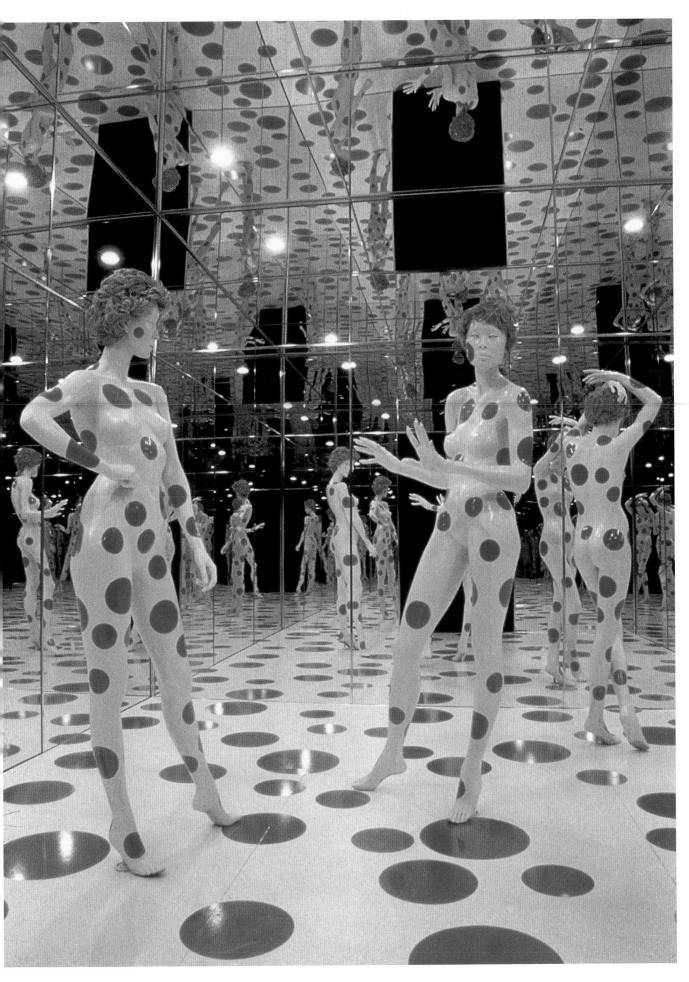

left, **Repetitive Vision**
1996
Mannequins, mirrors, paint
Dimensions variable
Installation, The Mattress Factory,
Pittsburgh, Pennsylvania, 1998

overleaf, **Dots Obsession**
1998
Inflatable vinyl environment
Dimensions variable
left, Installation (red version),
'Organic', Palais des Arts, Ecole
des Beaux Arts, Musée de
l'histoire de la Médecine,
Toulouse
right, The artist in installation
(yellow version), The Mattress
Factory, Pittsburgh, Pennsylvania

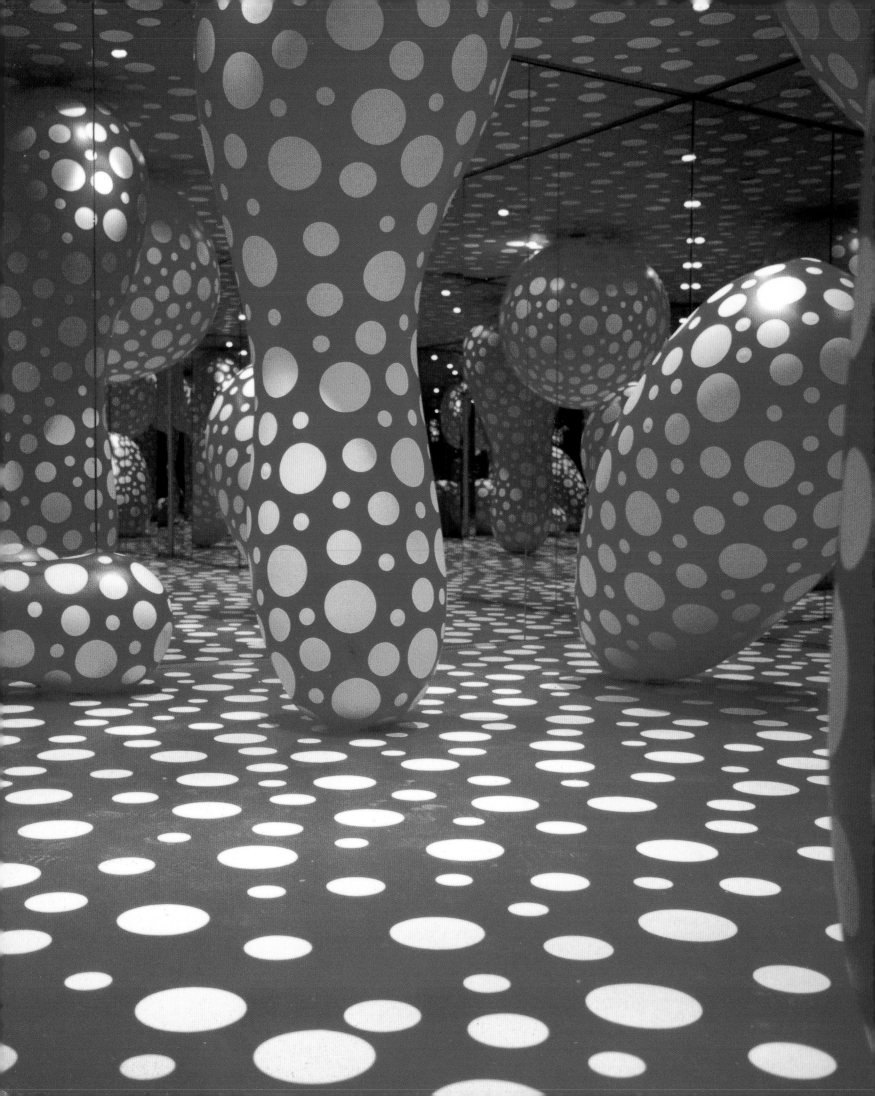

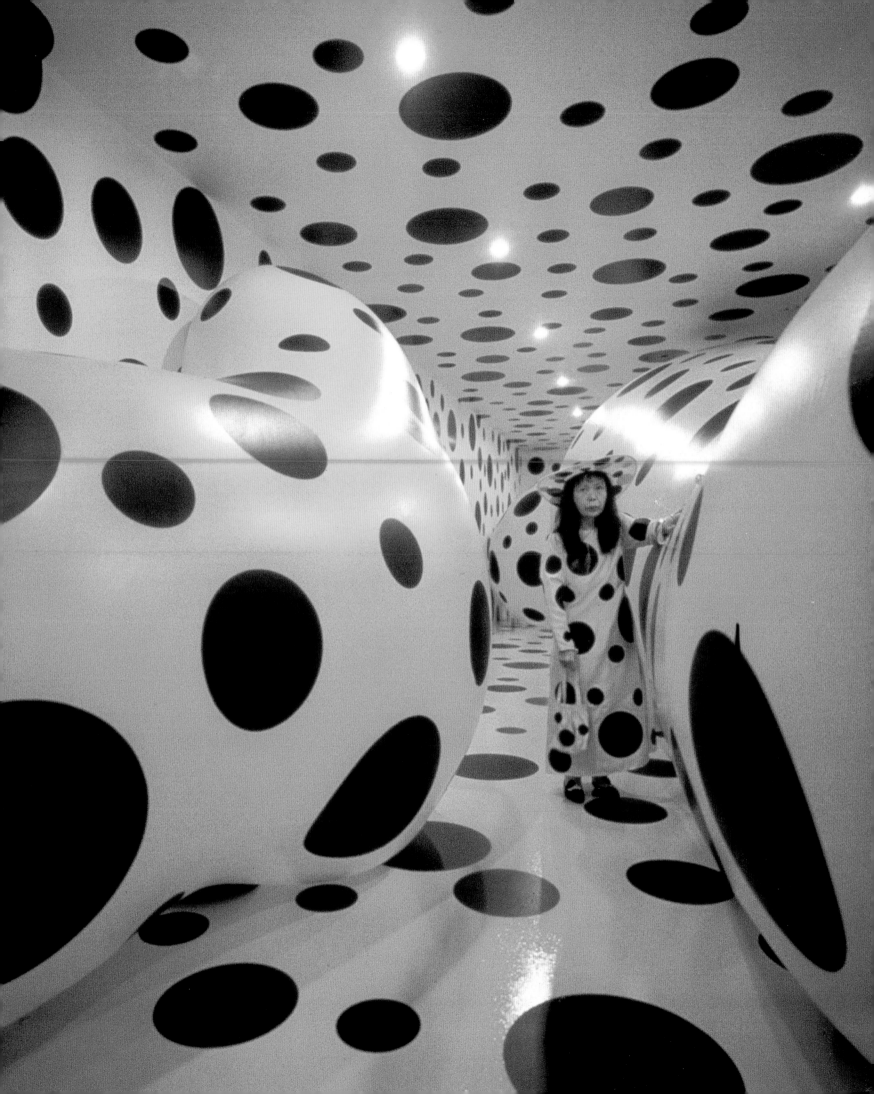

Violet Obsession 1978

Violet Obsession
1994
Sewn stuffed fabric, boat, paint
110 × 382 × 185 cm
Collection, The Museum of Modern
Art, New York

one day suddenly my voice
is the voice of a violet
calming my heart holding my breath
they're all for real, aren't they
all these things that happened today

violets came out of the tablecloth
crawled up and on to my body
one by one they stuck there
violets *sumire* flowers
they came to lay claim to this love of mine

full to the brim with danger
I stand petrified in the fragrance
just look even on the ceiling and pillars
violets adhere
youth is hard to hold on to
violets, please don't talk to me
give me back my voice, now a violet voice
I don't want to grow up not yet
all I ask is one more year
just leave us alone that long

Violet Obsession: Poems, translated by Hisako Ifshin, Ralph McCarthy, Liza Lowitz, Wandering Mind Books,

Berkeley, California, 1998, pp. 39-40. First published in *Shishu: Kakunaru-Urei*, Jiritsu Shobo, Tokyo,1989.

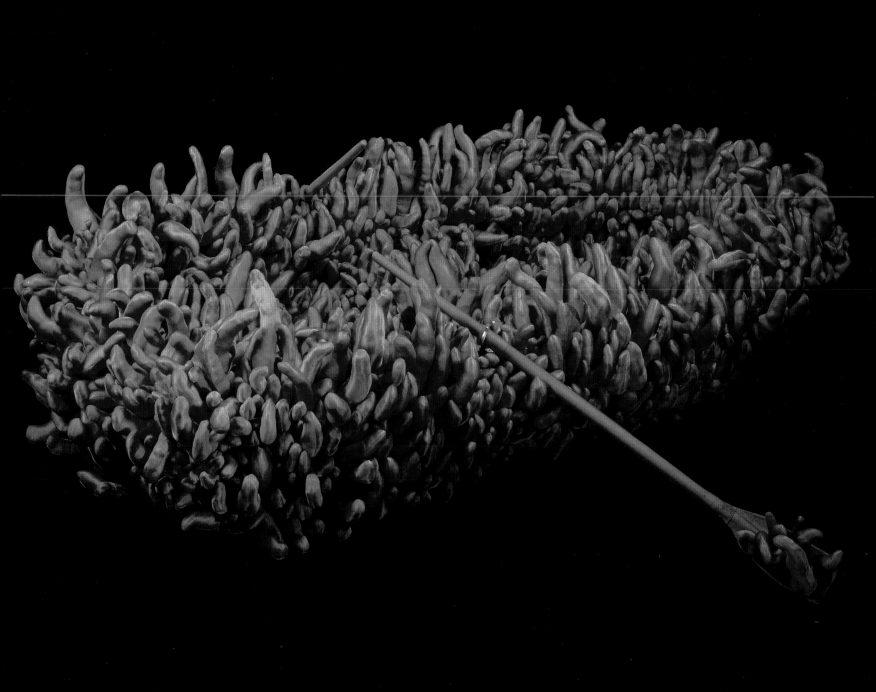

Lost 1983

it fell to the earth

a stone from a pocket collection

the beggar returns beneath his bridge

there's a hole in his pocket and it has fallen

among the stones of the riverbed he roams each day

searching for that one

stone from his pocket

where did it drop? he searches the whole riverbed

but can't find it

it's shaped just like all the other stones

a graveyard of stones stretching to the ends of the universe

once more the beggar

wanders about filling his pocket with stones

shapes blurred in sundown clouds

a deep-blue stone a brachiosaurus once sat on

an agate-coloured stone once embraced by a salamander

the white-gray bone of a blind snake, fossilized

a striped rock with a red strawberry inside

a crack in a brown stone where the shadow of a pterosaur hides

a silver peacock a butterfly egg a fragment

the glare of billions of variations

he stops, perplexed

the sound of wind and light dripping stardust

for hundreds of millions of light years a sound the stones have heard

is faintly transmitted through the soles of the feet

that orphan stone that fell, forgotten indistinguishable

never again to return to this breast

Violet Obsession: Poems, translated by Hisako Ifshin, Ralph McCarthy, Liza Lowitz, Wandering Mind Books,

Berkeley, California, 1998, pp. 39-40. First published in *Shishu: Kakunaru-Urei*, Jiritsu Shobo, Tokyo,1989.

The Hustlers' Grotto of Christopher Street (extracts) 1984

Beyond My Illusion – Butterfly
(detail)
1999
Sewn stuffed fabric, found
objects, gold paint
80 × 80 × 20 cm

In the hustlers' grotto of Christopher Street the beautiful Davids that inhabit the rows of apartment buildings keep their rooms dark in the daytime, closing their blinds against the sun and devouring sleep. But when night arrives, whispers of love rekindle the flame of fleshly desire by falling to earth with the stars and prowling beside the waveless lake of Narcissus. During such days as these, the pale young narcissus buds have no time for warming to women. The youths spend all the daylight hours exposed to the scorching landlocked sun, searching for marks among the sightseers. They loiter on Washington Square or get picked up on Christopher Street by gay foreign seamen who've come from the piers to look for fun in Manhattan.

Wealthy middle-aged or elderly homosexual gentlemen like Bob were everywhere. That it had been difficult recently for Henry and other chickens to find johns was due to the fact that young would-be hustlers from all over America – boys for whom money was secondary to the desire for adventure – had been flocking to Manhattan, particularly downtown. All of them were competitors as far as Henry was concerned. As were the other residents of Henry's five-storey brick apartment building, all of whom – with the exception of Billy, who made a living dealing drugs – were also involved in male prostitution. Most of them just got by from day to day. They financed one another, borrowing and lending money, and sometimes even shared their food. On rainy days, business on the street corners could turn as bleak as the weather. At times like that it was best to call Yanni's organisation, the Paranoiac Club, and have her find you a client. Yanni earned her commission simply by phoning her regular customers and sending them boys. It was amusing to her how easily the money came in. All she needed was a telephone. Mr Greenberg was an official member of her clandestine organisation. He'd met dozens of homosexual boys and young men through this club.

But never, he thought as he caressed Henry's body, had he met a boy as beautiful and captivating as this.

The chickens Bob had had sex with so far – even those who weren't necessarily gay – would invariably greet their client with a face that suggested they considered this path, the path of manly love, the highest form of art. That was part of the ABC of hustling – or, rather, of prostitution in general.

In spite of which, the relatively unsubmissive Henry earned more than most. He may have been the top money maker of all, in fact.

But the money he earned was no sooner in his hands than it was gone. It was almost like magic, the way he made it disappear.

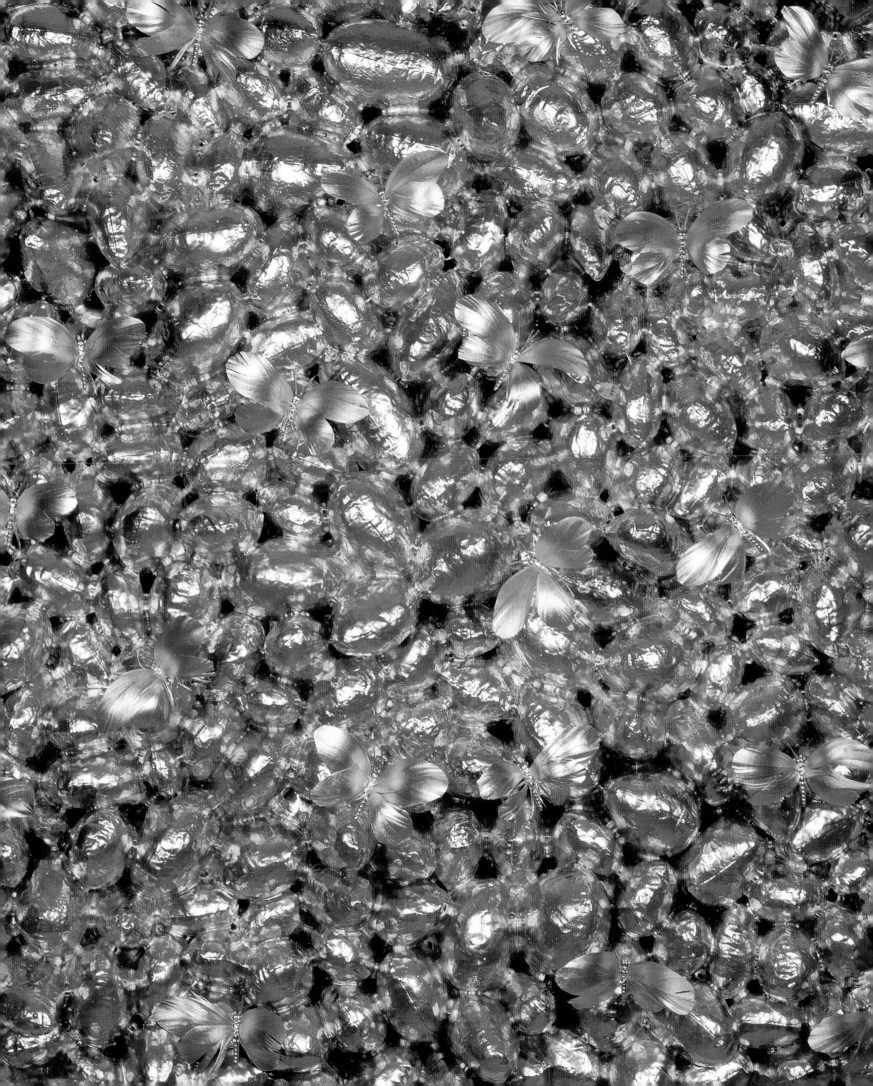

Henry was, yes, an insatiable soul, a vagabond of the night who roamed the pleasure quarters seeking dissipation and oblivion. He used money to ransom food and drugs, and in order to obtain that money he begrudgingly sold his flesh and his anus. The fact that business on the corners was so affected by the weather put him on the same level as a street performer.

But no matter how much junk he injected, it was never enough. His appetite and sex drive decreased daily, in inverse proportion to his growing need, and he was becoming more and more enervated. To have to work the sex trade each day disgusted him, especially now the drug had eaten away at his libido […]

Because of the nature of trading money for sex, each day was individually coloured by the situations it presented; everything was as transient as clouds floating by in the sky. The boys in Yanni's club were sold casually, as if they were cakes wrapped in pretty paper and tied with ribbons. They were not interested, therefore, in talking rot about homosexual art or how some artist like da Vinci, hundreds of years after his death, did this or that for the homosexuals of today. For them it was take the money, here's my asshole, see you later. This way was more New York – and more now. Some even saw themselves as being on the cutting edge of rationalism.

But Henry was sullen in his beauty tonight, a forbidding rose whose thorns drew blood with every touch […]

Henry was in the kitchen downstairs brewing a pot of coffee and pouring it into two cups when Mr Greenberg called for him to come into the bedroom on the second floor. As Henry ambled in, Greenberg said: 'Call me Robert. Or better yet, Bob.'

Judging from this attempt at familiarity, Greenberg obviously thought of them as lovers already. This though they'd met only hours earlier. Or was he simply saying that, though there was no telling what the night might bring, at least they could be on a first-name basis? Bob placed the two coffee cups on the table beside the bed and took a sip. Then he gently reached over and turned out the light. A moth flew in through the dark window and landed in Henry's coffee, scattering tiny scales – silver dust that fell from its wings as it scraped them on the white porcelain rim of the cup. For a moment the surface of the coffee turned from brown to a vivid silver. They thought it was starlight streaming in through a corner of the window. Surely that was what it had been – a silver falling star. It was as if the star had collided with their four pupils and disintegrated. Lured into the atmosphere by the earth's gravity, it had crashed, sprinkling its

Silver on the Earth
1990
Sewn stuffed fabric, found
objects, silver paint
180 × 180 × 12 cm

powdery silver dust in the men's eyes before vaporizing. At that moment the window frame seemed to be filled once again with the green of the forest trees that had melted into the dark. When the silhouettes of the two men, embedded in the square green-dyed darkness of the frame, flickered like the hesitant love-call of man to man, Bob murmured this question: 'Henry, are you bi? I mean, do you also go with women? […]

At length, somewhat frustrated, Bob whispered: 'Henry, don't you like me?' This question struck Henry as absurd. A sexual pervert and a dealer in perverted sex who pretended to be perverted lay one atop the other in bed, probing each other's hearts, negotiating over an anal cavity. The moth that had bumped its wings against the rim of the cup and scattered its scales was now sinking in a sea of coffee, its entire body saturated with caffeine. Its internal organs soaked brown, the moth was gasping in its final agony.

Henry suddenly and inexplicably sat up, took the cup from the table, and drank what remained of the coffee.

His tongue was sticky from Bob's body fluids and coated with a cloying, sour smell. The silver scales in the coffee slid over the surface of his tongue, which was so chafed from sucking Bob's member that it seemed to have lost the ability to taste. But though his tongue turned silver, the odour of body fluids could not be erased.

The silver coffee, which sparkled even in the night, dyed Henry's insides silver too. As his intestines changed colour with the scales that had spilled from the moth's wings, Bob drew near once more. No doubt the interior of the forbidden door was now silver as well […]

The Hustlers' Grotto of Christopher Street, Wandering Mind Books, Berkeley, California, 1998. Translated by Ralph F. McCarthy.

Across the Water: Interview with Damien Hirst (extract) 1998

Damien Hirst Do you feel that your work is optimistic?

Yayoi Kusama **No, I don't feel my work is optimistic. Each piece of work is the condensation of my life.**

Hirst What do you think is the difference between Kusama's *Peep Show* (or *Endless Love Show*, 1966) and the infinity room by Lucas Samaras (*Mirrored Room 2*, 1966)?

Kusama **Lucas Samaras is always copying other artists' work. His work lacks originality, I think. He made the mirrored room series inspired by my work. Therefore, my infinity room has nothing to do with his vision.**

Hirst Does your illness have a name?

Kusama **It is obsessional neurosis. I have been suffering from this disease for more than fifty years. Painting pictures has been therapy for me to overcome the illness.**

Hirst Do you think the growth of cancer is the same as the growth of a flower?

Kusama **Cancer is what people fear, but a flower is what people visualize. But ultimately, they are the same. When they die, they become dust. People too become dust when they die.**

Hirst Art is about life, and the art world is about money. How have you separated the two? And fame? Why have you tried to incorporate yourself into your work so often?

Kusama **I think of fame and money like shoes and umbrellas. How one uses his or her money reflects that person's character. I try to incorporate myself into my work as a means to break out of my illness.**

Hirst What are you doing now?

Kusama **I have been in a mental hospital for more than twenty years, because of my mental disorder caused by traumatic experiences I had in my childhood. I am certain that I will die a 'death while doing art' in this hospital. Every day I create sculptures and**

other formative art pieces, write novels and poems, and compose music as well.

Hirst Where the hell are you trying to go in that crazy pink boat?

Kusama **Alone in the pink boat, I am trying to sail on the sea of death, leaving behind a large number of my artworks.**

Hirst What are you afraid of?

Kusama **I am afraid of loneliness. I know I will be more lonely as I get older, but I can't tell at this moment how lonely I would be until I have actually become old.**

Hirst Do you like mess in your life?

Kusama **I like both mess and order in my life.**

Hirst Money is a tiny part of life. Do you manage to keep it bay?

Kusama **Money comes to me from various countries of the world in large amounts. Art is eternal, but money comes and goes. It just circulates. Money is not for saving.**

Hirst Did you come from a rich background?

Kusama **Yes, I came from a rich background. My parents wanted me to marry a wealthy man rather than going through the hardships in the United States. I owe a great deal to many people who helped me in my struggle to pursue an artistic career to become what I am today. I am grateful to them, as I know I would not have been able to achieve what I have if it had not been for them.**

Hirst Do you feel lonely being an artist?

Kusama **I am very lonely being an artist, and in my own life. It is almost unbearable, especially when I hear the sound of tree leaves trembling in a wind storm. When I go up to the rooftop of a high-rise building, I feel an urge to die by jumping from it. My passion for art is what has prevented me from doing that.**

above, **Cosmic Door**
1995
Acrylic on canvas
3 parts, 194 × 389.5 cm overall

overleaf, **Infinity Mirrored Room
– Love Forever**
1996
Coloured lights, mirrors
195 × 117 × 101.5 cm

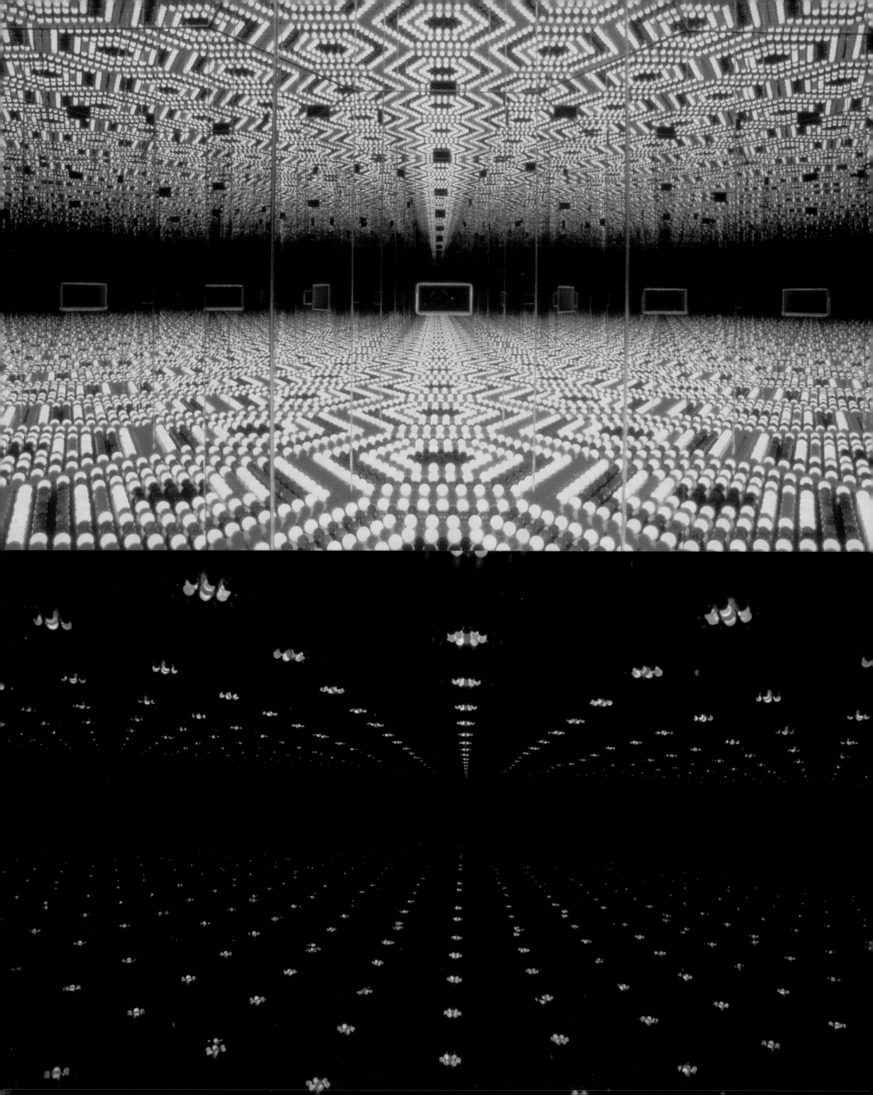

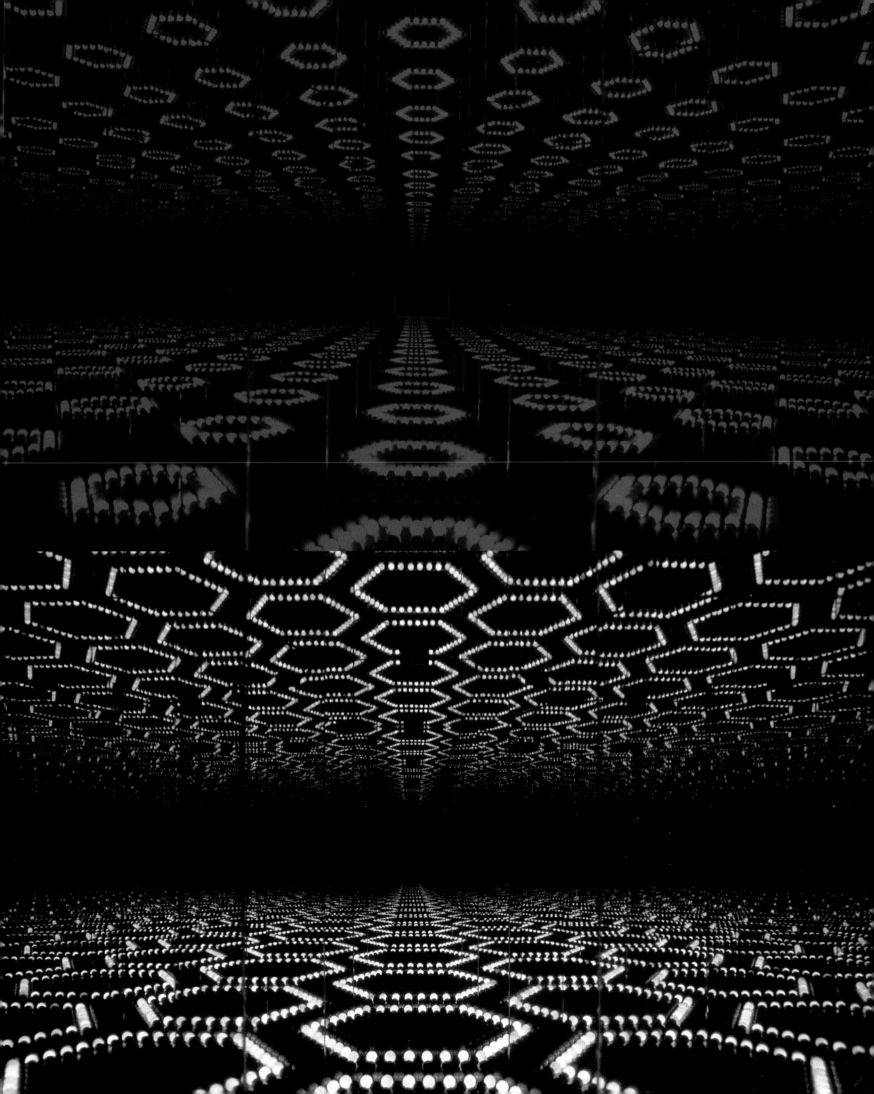

Beyond My Illusion (detail)
1999
Sewn stuffed fabric, wood,
canvas, household objects,
furniture, mannequins, metallic
paint
Dimensions variable

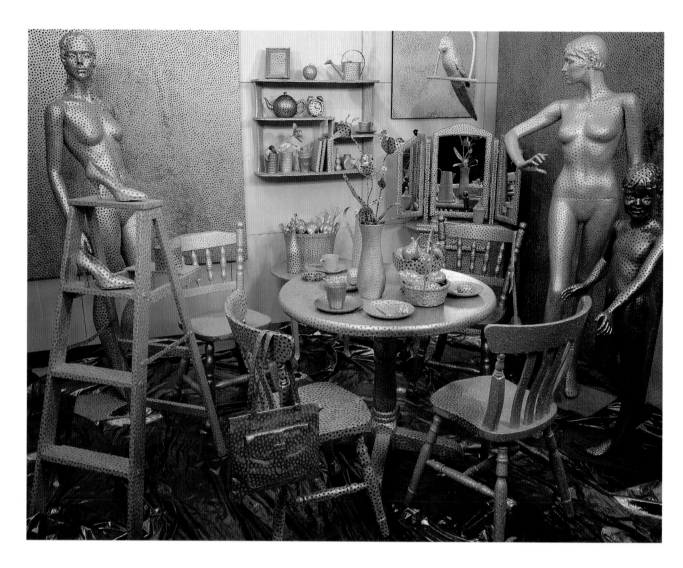

Hirst What is the longest time you've ever had a relationship?

Kusama **It is with art, of course; I have done an enormous amount of paintings since my childhood.**

Hirst And with another person, a lover?

Kusama **I had the longest relationship with Joseph Cornell, as a lover. I have lived with my disease continuously since my childhood.**

Hirst Do you prefer your art to be in art galleries or in people's homes?

Kusama **I prefer my art in museum collections, as nobody would ruin or steal them […]**

Hirst Do you use playfulness, fun and childishness (in a good way) to deal with death? As it's not easily visible in your work.

Kusama **I don't know yet what death is. I am prepared for it, though.**

Hirst What don't you like about yourself?

Kusama **The fact that I have the disease.**

Hirst How have you changed your life?

Kusama **I have become reticent. Time has become more precious as I work concentratedly, so I don't go out. I don't go to see other artists' shows any more. I try to avoid seeing people. I don't attend art-related meetings. I am lonelier now.**

Hirst What do you think is the difference between being alone and being lonely?

Kusama **'Being alone' is the feeling I have when I confront death. Loneliness can be cured by taking a different view of things. Loneliness can disappear with the passage of time.**

Hirst Do you feel more like a colourist, a painter, an artist or a sculptor?

Kusama **I feel more like a sculptor.**

Hirst What means more to you than art?

Kusama **I am interested in international problems, such as wars and refugees as well. I am trying to learn about them every day […]**

Hirst What's your earliest memory?

Kusama **I was born on highlands. I remember the beautiful stars at night. They were so beautiful that I felt the sky was falling upon me.**

Hirst Are you afraid of death?

Kusama **I am not afraid of death.**

Hirst Are you afraid of life?

Kusama **I am not afraid of life.**

Yayoi Kusama: Now (cat.), Robert Miller Gallery, New York, 1998, pp. 9-14.

Nets
1997–98
Acrylic on canvas
Dimensions variable

Contents

Yayoi Kusama Born 1929 in Matsumoto, Nagano Prefecture, Japan, lives and works in Tokyo

Selected exhibitions and projects
1948-59

1948
Enters senior class at the Kyoto Municipal School of Arts and Crafts

1952
'New Works by Yayoi Kusama: The Second Solo Exhibition',
First Community Centre, Matsumoto (solo)
Cat. *New Works by Yayoi Kusama: The Second Solo Exhibition*, First Community Centre, Matsumoto, texts Nobuya Abe, Yayoi Kusama, Shuzo Takiguchi, Choichiro Majima, Yu Matsuzawa, Kieko Yamazaki

1954
Shirokiya Department Store, Tokyo (solo)

1955
Takemiya Gallery, Tokyo (solo)

'International Watercolor Exhibition: Eighteenth Biennial',
Brooklyn Museum, New York (group)
Cat. *International Watercolor Exhibition: Eighteenth Biennial*, Brooklyn Museum, New York, text John Gordon

Yayoi Kusama, studio, New York, 1958

1957
Dusanne Gallery, Seattle (solo)

1958
Moves to New York

Studies, Art Students' League, New York

'Modern Japanese Paintings',
Brata Gallery, New York (Group)

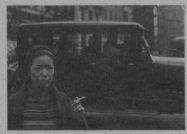

Yayoi Kusama, New York, 1959

1959
Brata Gallery, New York (solo)

NOVEMBER 23 THROUGH DECEMBER 12, 1959

RECENT PAINTINGS BY

YAYOI KUSAMA

NOVA GALLERY
27 STANHOPE STREET
BOSTON CIRCLE 7-9150

HOURS: TUES.-FRI. 10 TO 4; SAT. 10 TO 6; CLOSED MONDAYS

'Recent Paintings by Yayoi Kusama',
Nova Gallery, Boston (solo)

'International Watercolor Exhibition: Twentieth Biennial',
Brooklyn Museum, New York (group)
Cat. *International Watercolor Exhibition: Twentieth Biennial*, Brooklyn Museum, New York, text John Gordon

Selected articles and interviews
1948-59

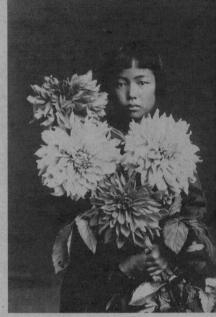

Yayoi Kusama, 1939

1954
Author unknown, 'Solo Exhibition of Yayoi Kusama', *Atelier*, Tokyo, May
Tsuruoka, Masao, 'Solo Exhibition of Yayoi Kusama', *Mizue*, Tokyo, May

1955

Okamoto, Kenjiro, 'New Faces: Yayoi Kusama', *Geijutsu Shincho*, Tokyo, May

1958

Installation view, Dusanne Gallery, Seattle

Author unknown, 'Art World Discussed at a Gallery', *Geijutsu Shincho*, Tokyo, September

1959
Ashton, Dore, 'Art Tenth Street Views', *New York Times*, 23 October
Judd, Donald, 'Reviews and Previews: New Names This Month – Yayoi Kusama', *ARTnews*, New York, October
Kiplinger, Suzanne, 'Art: 10th Street Views', *Village Voice*, New York, 28 October
Tillim, Sidney, 'In the Galleries: Yayoi Kusama', *Arts Magazine*, New York, October

Taylor, Richard, 'Events in Art', *Boston Sunday Herald*, 6 December

RETURN POSTAGE GUARANTEED, 1906 LAKEVIEW PLACE, SEATTLE, WASHINGTON

yayoi kusama
dusanne gallery

AN EXHIBITION OF PAINTINGS BY YAYOI KUSAMA, DECEMBER 9 TO 28, 1957 AT THE DUSANNE GALLERY

1906 LAKEVIEW PLACE, 'CORNER OF LAKEVIEW BOULEVARD', PREVIEW, SUNDAY AFTERNOON DEC. 8

FROM 2 TO 6 P.M. GALLERY HOURS: FROM 1 TO 6 PM EVERY DAY, EXCEPT SUNDAYS AND MONDAYS.

Selected exhibitions and projects
1960-62

1960
Brata Gallery, New York, toured to **Gallery One**, Baltimore (group)

'Monochrome Malerei',
Städtisches Museum, Leverkusen, Germany (group)
Cat. *Monochrome Malerei*, Städtisches Museum, Leverkusen, Germany, texts Enrico Castellani, Udo Kultermann, Otto Piene, Arnulf Rainer, et al.

Gres Gallery, Washington, DC (solo)

'Drawings, Paintings and Sculpture',
Stephen Radich Gallery, New York (group)

'Japanese Abstraction',
Gres Gallery, Washington, DC (group)

1961
'Yayoi Kusama: Paintings',
Stephen Radich Gallery, New York (solo)

'Internationale Malerei 1960–1961',
Galerie 59, Aschaffenburg, Germany (group)

Gres Gallery, Washington, DC (group)

'Avantgarde 61',
Stadtisches Museum, Trier, Germany (group)

'The 1961 Pittsburgh International Exhibition of Contemporary Painting and Sculpture',
Carnegie Institute, Pittsburgh (group)
Cat. *The 1961 Pittsburgh International Exhibition of Contemporary Painting and Sculpture*, Carnegie Institute Press, Pittsburgh, text Gordon Bailey Washburn

'Yayoi Kusama: Watercolors' (with Franco Assetto),
Gres Gallery, Washington, DC (solo)

'Gres Artists Selected for the Pittsburgh International Exhibition of Contemporary Painting and Sculpture',
Gres Gallery, Chicago (group)

'1961 Whitney Annual',
Whitney Museum of American Art, New York (group)
Cat. *1961 Whitney Annual*, Whitney Museum of American Art, New York, no text

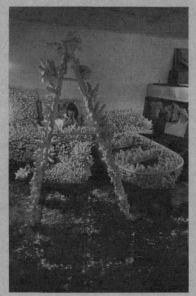

1962
'Accrochage 1962',
Galerie A, Amsterdam (group)

Yayoi Kusama, studio, New York, c. 1962–63

Selected articles and interviews
1960-62

1961
Ashton, Dore, 'New York Notes: Yayoi Kusama', *Art International*, Zurich, June–August
Kroll, Jack, 'Reviews and Previews: Yayoi Kusama', *ARTnews*, New York, May
Tillim, Sydney, 'In the Galleries: Yayoi Kusama', *Arts Magazine*, New York, May–June
Burrows, Carlyle, 'A Non-objective Trend of Detail', *Herald Tribune*, New York, 5 May
Preston, Stuart, 'Twentieth Century Sense and Sensibility', *New York Times*, 7 May

Friedlander, Alberta, 'Another New Gallery: Gres Opens with Works by 10', *Chicago Daily News*, 2 December

Author unknown, 'Three Extraordinary Japanese Artists at the Whitney Museum', *Rafu shinpo*, Tokyo, 1 January, 1962

Wiznitzer, Louis, 'Young Japanese Female Has Conquered Manhattan', *Revista do Globo*, Porto Alegre, 24 June–7 July

1962

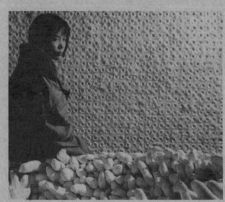

Yayoi Kusama, studio, New York, 1962

Selected exhibitions and projects
1962-64

'Tentoonstelling Nul',
Stedelijk Museum, Amsterdam (group)
Cat. *Tentoonstelling Nul*, Stedelijk Museum,
Amsterdam, texts Henk Peeters, et al.

'Nieuwe Tendenzen',
State University Gallery, Leiden, Amsterdam (group)

Green Gallery, New York (group)

'Anno 62',
Galerie 't Venster, Rotterdam (group)

The Museum of Modern Art, New York (group)

1963
'New Work: Part I',
Green Gallery, New York (group)

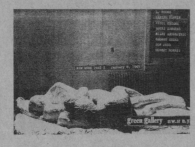

'Panorama van de nieuwe tendenzen',
Gallery Amstel, Amsterdam (group)

'No Show',
Gertrude Stein Gallery, New York (group)

'Aggregation: One Thousand Boats Show',
Gertrude Stein Gallery, New York (solo)

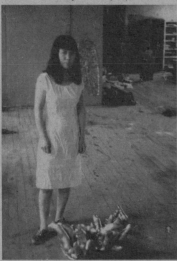

Yayoi Kusama, studio, New York, 1964

1964
'The New Art',
Davison Art Center, Wesleyan University, Connecticut
(group)
Cat. *The New Art*, Davison Art Center, Wesleyan
University, Connecticut, text Lawrence Alloway

'Driving Image Show',
Castellane Gallery, New York (solo)

'Mikro Zero/Nul/Mikro Nieuwe Realime',
Galerie Delta, Rotterdam, toured to **Rhedena Lyceum**,
Velp; **Galerie Amstel 47**, Amsterdam (group)

Selected articles and interviews
1962-64

Van Keuren, Jan, 'Nul=0 Nul', *De Groene
Amsterdammer*, Amsterdam, 24 March

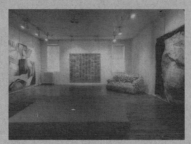

Installation view, group show, Green Gallery, New York

1963
Rose, Barbara, 'New York Letter: Green Gallery', *Art
International*, Lugano, 5 December

Author unknown, 'Gallery Previews: Kusama', *Art
Voices*, New York, January, 1964
Castile, Rand, 'Reviews and Previews: Kusama',
ARTnews, New York, April, 1964
Johnson, Jill, 'Kusama's One Thousand Boats Show',
ARTnews, New York, February, 1964
O'Doherty, Brian, 'Exhibitions Playing a Wide Field:
International Selection of Painting and Sculpture in
Local Galleries', *New York Times*, 29 December
Sandler, Irving, 'In the Galleries: Kusama', *New York
Post*, 5 January, 1964
Tillim, Sidney, 'In the Galleries: Yayoi Kusama', *Arts
Magazine*, New York, February, 1964

Judd, Donald, 'Local History', *Arts Yearbook: New York –
The New Art World*, Vol. 7, New York
Kitazawa, Kiyoji, 'Transforming Self into "Demon":
About Miss Yayoi Kusama', *Shinshu geien*, Nagano, 1
January
Restany, Pierre, 'Le Japon a rejoint l'art moderne en
prolongeant ses traditions', *La Galeries des Arts*, Paris,
November

1964

Author unknown, 'Ten Guest Tables', *Arts Voices*, New
York, June
Author unknown, 'An Eccentric Exhibition of Yayoi
Kusama', *Geijutsu seikatsu*, Tokyo, January, 1965
O'Doherty, Brian, 'Kusama Explores a New Area', *New
York Times*, 25 April
Judd, Donald, 'In the Galleries: Yayoi Kusama', *Arts
Magazine*, New York, September

Peeters, Henk, '0=Nul: De niewe tendenzen',
Museumjournaal voor moderne kunst, Amsterdam, April

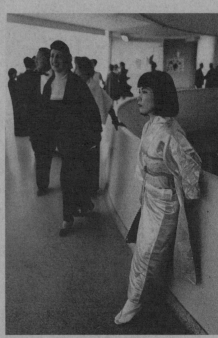

Yayoi Kusama, Solomon R. Guggenheim Museum, New York, 1964

Cat. *Zero=0=Nul*, Galerie Delta, Rotterdam, text Frank
Th. Gribling

International Gallery, Prague (group)

'Group Zero',
Institute of Contemporary Art, University of
Pennsylvania, Philadelphia, toured to **Washington
Gallery of Modern Art**, Washington, DC (group)
Cat. *Group Zero*, Institute of Contemporary Art,
University of Pennsylvania, Philadelphia, texts Samuel
Adams Green, Otto Piene, et al.

1965
'Aktuell 65',
Galerie Aktuell, Bern (group)

'De nieuwe stijl: Werk van de internationale avant-
garde',
Galerie de Bezige Bij, Amsterdam (group)
Cat. *De nieuwe stijl: Werk van de internationale avant-
garde*, Galerie de Bezige Bij, Amsterdam, texts
Armando, Henk Peeters, Hans Sleutelaar

'Nul negentienhonderd viff en zestig',
Stedelijk Museum, Amsterdam (group)
Cat. *Nul negentienhonderd viff en zestig*, Stedelijk
Museum, Amsterdam, texts Gordon Brown, Yayoi
Kusama, et al.

International Galerij Orez, The Hague (solo)

Yayoi Kusama with Lucio Fontana, Stedelijk Museum,
Amsterdam, 1965

'Zero Avantgarde',
Galleria del Cavallino, Venice (group)

'Japanese Artists Abroad: Europe and America',
National Museum of Modern Art, Tokyo (group)
Cat. *Japanese Artists Abroad: Europe and America*,
National Museum of Modern Art, Tokyo, texts
Masayoshi Honma, Michiaki Kawakita, et al.

'Floor Show',
Castellane Gallery, New York (solo)

Ashton, Dore, 'New York Commentary: Resurrecting
Some Recent Traditions', *Studio International*, London,
March
Brown, Gordon, 'Obsessional Painting', *Art Voices*, New
York, March

1965

Author unknown, 'Erotiek in Orez: Practical jokes en
kunst', *Het Vrije Volk*, The Hague, 21 May
N., J., 'Kusama: Root Furniture and Macaroni
Wardrobe', *Het Vrije Volk*, The Hague, 22 May

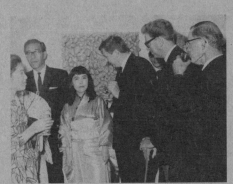

Yayoi Kusama, International Galerij Orez, The Hague

Benedikt, Michael, 'New York Letter: Sculpture in
Plastic, Cloth, Electric Light, Chrome, Neon, and
Bronze', *Art International*, Lugano, January, 1965
Brown, Gordon, 'The Imagination Critic: A Reply to the
Preceding Article', *Art Voices*, New York, Summer
Cremer, Jan, 'My Flower Bed (Painted Cloth) by Yayoi
Kusama', *Art Voices*, New York, Fall
Jacobs, Jay, 'In the Galleries: Yayoi Kusama', *Arts
Magazine*, New York, January, 1965
Lippard, Lucy R., 'New York Letter: Recent Sculpture as
Escape', *Art International*, Lugano, February, 1965
Von Hennenberg, Josephine, 'Teamwork versus
Individualism: Will the New Group Movement
Revolutionize Design?', *Art Voices*, New York, Winter
Willard, Charlotte, 'In the Art Galleries', *New York Post*,
14 November

Opening, 'Zero Avantgarde', Galleria del Cavallino, Venice

Selected exhibitions and projects
1966

1966
'Driving Image Show',
Galleria d'Arte del Naviglio 2, Milan (solo)
Cat. *Yayoi Kusama*, Galleria d'Arte del Naviglio, Milan,
texts Gordon Brown, Yayoi Kusama, Herbert Read

'Kusama's Peep Show: Endless Love Show',
Castellane Gallery, New York (solo)

'Zero op Zee',
Internationale Galerij Orez, The Hague (group)

'Driving Image Show',
Galerie M.E. Thelen, Essen (solo)
Cat. *Yayoi Kusama*, Galerie M.E. Thelen, Essen, text Udo
Kultermann

XXXIII Venice Biennale (group)
Installation outside the Italian Pavilion: Narcissus
Garden

'The Object Transformed',
The Museum of Modern Art, New York (group)
Cat. *The Object Transformed*, The Museum of Modern
Art, New York, texts Mildred Constantine, Arthur
Drexler

'New Collection',
Chrysler Museum, Provincetown (group)

'Total-Realismus',
organized in conjunction with Galerij Orez, The Hague
Galerie Potsdamer, Berlin (group)

'Inner and Outer Space: An Exhibition Devoted to
Universal Art',
Moderna Museet, Stockholm (group)
Cat. *Inner and Outer Space: An Exhibition Devoted to
Universal Art*, Moderna Museet, Stockholm, texts
Pontus Hulten, et al.

Selected articles and interviews
1966

1966

Benedikt, Michael, 'New York Letter: Light Sculpture
and Sky Ecstasy', *Art International*, Lugano, September
Schjeldahl, Peter, 'Reviews and Previews: Kusama',
ARTnews, New York, May

Author unknown, 'Die Beatles sangen dazu: Kusama
aus Japan eröffnete gestern ihre Schau', *Gross Essen*,
30 April
Berkson, William, 'In the Galleries: Kusama', *Arts
Magazine*, New York, May
Kultermann, Udo, 'Yayoi Kusama: Überreal', *Artis*,
Stuttgart, June
Sello, Gottfried, 'Kunstkalender: Kusama's Driving
Image Show', *Die Zeit*, Hamburg, 27 May
Sommer, Ed, 'Letter from Germany: Yayoi Kusama at
the Galerie M.E. Thelen', *Art International*, Lugano,
October

Author unknown, 'World Snap: Yayoi Kusama Decorates
the Garden of Italian Pavilion at the Venice Biennale',
Geijutsu Shincho, Tokyo, September
Braun, Michael, 'Michael Braun Reports on the Venice
Biennial', *Queen*, New York, July
Brown, Gordon, 'Yayoi Kusama', *d'Arts*, Milan, 10
April–20 October
Milani, Milena, 'Una biennale tutta sexy', *ABC*, Madrid,
3 July
Narotzky, Norman, 'The Venice Biennial: Pease
Porridge in the Pot Nine Days Old', *Arts Magazine*, New
York, September–October

Clay, Jean, 'Art ... Should Change Man: Commentary
from Stockholm', *Studio International*, London, March

Oguchi, Yoshio, 'A Female Artist in New York: Yayoi
Kusama', *Ato/Art*, Kyoto, March
Lippard, Lucy R., 'Eccentric Abstraction', *Art
International*, Lugano, November
Alloway, Lawrence, 'Arts in Escalation: The History of
Happenings, a Question of Sources', *Arts Magazine*,
New York, December–January

YAYOI

KUSAMA

441ᵉ Mostra del Naviglio
dal 26 gennaio al 9 febbraio 1966

NAVIGLIO 2 - Galleria d'Arte - Via Manzoni 45 (Sale interne) -Milano

Selected exhibitions and projects
1966-68

1967

'Objecten: Made in USA',
Galerie Delta, Rotterdam (group)
Cat. *Objecten: Made in USA*, Galerie Delta, Rotterdam,
text Hans Sonnenberg

'Ausstelling: Serielle Formationen',
Studio Galerie, Johann Wolfgang Goethe Universität,
Frankfurt (group)
Cat. *Ausstelling: Serielle Formationen*, Studio Galerie,
Johann Wolfgang Goethe Universität, Frankfurt, texts
Siegfried Bartels, Paul Maenz, Peter Roehr

Happening, *Self-obliteration by Kusama: An Audio-
visual-light Performance*,
Black Gate Theater, New York

Stages Body Festivals,
Tompkins Square Park and Washington Square Park,
New York

Stages Body Festival,
Chrysler Art Museum, Provincetown

'Love Room',
Galerij Orez, The Hague (solo)

1968

Screenings, *Kusama's Self-obliteration*, at various
spaces, New York

'Three Blind Mice',
Stedelijk van Abbemuseum, Eindhoven, The
Netherlands, toured to **Aint Piecterbdij**, Ghent (group)

Galerie Mickery, Loenersloot, The Netherlands (solo)

Series of Happenings in New York, *The Anatomic
Explosion*,
New York Stock Exchange; Statue of Liberty; St. Mark's
Church; Alice in Wonderland statue, Central Park;
United Nations building; United Federation of
Teachers; Wall Street; Board of Elections headquarters;
Subway, New York

Filming at Andy Warhol's studio, New York

Selected articles and interviews
1966-68

Kultermann, Udo, 'Die Sprache des Schweigens: Uber
des Symbolmilieu der Farbe Weiss', *Quadrum*, No. 20,
Brussels

1967

Carl, Alfred, 'Call Her Dotty', *New York Sunday News*, 13
August
Wyatt, Hugh; Singleton, Donald, 'Find Bodies in East
Side Park: Covered All Over with Strange Spots', *New
York Sunday News*, 16 July

Boost, Rolf, 'Yayoi: Priesteres van het naakt', *Algemeen
Dagblad*, Rotterdam, 21 November

Author unknown, 'In the Galleries: Kusama on Her
Japanese Stroll through Central Park', *Arts Magazine*,
New York, September–October
Lippard, Lucy R., 'The Silent Art', *Art in America*, New
York, January–February,

1968

Wetzsteon, Ross, 'The Way of All Flesh: Stripping for
Inaction', *Village Voice*, New York, 15 February

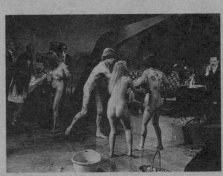

Naked Happening, *The Allan Burke Show*, November, 1968

Author unknown, '"Bare Facts" Presented in a Political
Protest', *New York Times*, 4 November
Author unknown, 'Four Nudes Protest the War in
Vietnam', *New York Times*, 12 November
Author unknown, 'Four Nudes Turn Back on the War',
San Francisco Chronicle, 12 November
Gruen, John, 'Underground', *Vogue*, New York, 1
October
Modzelewski, Joesph, 'Hippies Go Square-Shooting',
New York Daily News, 23 September
Weaver, Neal, 'The Polka Dot Girl Strikes Again, or
Kusama's Infamous Spectacular', *After Dark*, New York,
May
Van Starrex, Al, 'Kusama and Her "Naked Happenings"',
Mr, New York, August
Wyatt, Hugh, '4 Eves and an Adam Burn Commie Flag',
New York Daily News, 9 September

Selected exhibitions and projects
1968-77

'Soft and Apparently Soft Sculpture',
organized by the American Federation of the Arts
Georgia Museum of Art, Georgia University, Athens;
State University of New York, College of Oswego;
Cedar Rapids Art Center, Iowa; **Michigan State
University**, East Lansing; **Andrew Dickinson White
Museum of Art**, Cornell University, Ithica (group)

Happening, *Homosexual Wedding*,
Church of Self-obliteration, Walker Street, New York

1969
Happening to launch artist Louis Abolafia's campaign
for Mayor of New York,
Central Park, New York

Opens fashion boutique,
404 Sixth Avenue, New York

Happening, *Grand Orgy to Awaken the Dead*,
The Museum of Modern Art, New York

1970
'Zero-Unexecuted',
Institute of the History of Arts, University of
Amsterdam (group)

1971
Kusama's *Self-obliteration* featured at the first annual
'New York Erotic Film Festival'

1973
Returns to live in Japan

1975
'Message of Death from Hades',
Nishimura Gallery, Tokyo (solo)
Cat. *Message of Death from Hades*, Nishimura Gallery,
Tokyo, text Yusuke Nakahara

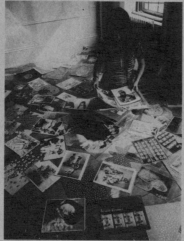

1977
'Improbable Furniture',
Institute of Contemporary Art, University of
Pennsylvania, Philadelphia, toured to **La Jolla
Museum of Contemporary Art**, California; **Museum of**

Selected articles and interviews
1968-77

Junker, Howard, 'The Theater of the Nude', *Playboy*,
New York, November
Yalkut, Jud, 'The Polka Dot Way of Life: Conversation
with Yayoi Kusama', *New York Free Press*, 15 February

1969

Author unknown, 'Six Young Women and Two Men Led
by Y. Kusama Cavort in Nude for 20 Minutes in "Grand
Orgy to Awaken the Dead"', *New York Times*, 25 August
Author unknown, 'But Is It Art?', *New York Daily News*,
25 August

Stange, John, 'Kookie Kusama: Fun City's New Nude
Goddess of Free Love', *Ace*, New York, March
Van Starrex, Allan, 'Bonnie and Clyde in the Nude: As
Directed by Kusama, High Priestess of Self-
Obliteration', *Man to Man*, New York, May
Goldstein, Al, 'I Blew My Top at the Orgy by Kusama',
Sophisticated Swapper, New York, June
Restany, Pierre, 'La sessualitá come linguaggio
artistico', *io*, Turin, September

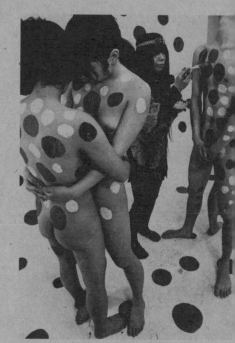

Body Painting Happening, studio of Bungei-shunju-sha, Tokyo, 1969

1975
Author unknown, 'The First Exhibition in Japan after
20 Years', *Mainici shinbun*, Tokyo, 20 December

1976
Muto, Naoji, 'Patterns of Life and Death: Obsessional
Art of Yayoi Kusama', *Re.jyowaiyo*, Tokyo, 20 December

1977

Selected exhibitions and projects
1977-82

Contemporary Art, Chicago (group)
Cat. *Improbable Furniture*, Institute of Contemporary
Art, University of Pennsylvania, Philadelphia, texts
Suzanne Delehanty, Robert Pincus-Witten

'Obsessional Art, A Requiem for Death and Life',
Osaka Formes Gallery, Tokyo (solo)

1978
'Design and Art of Modern Chairs',
National Museum of Art, Osaka (group)
Cat. *Design and Art of Modern Chairs*, National Museum
of Art, Osaka, texts Hisao Miyajiua, Arata Isozaki

1979
'Weich und Plastisch (Soft Art)',
Kunsthaus, Zurich (group)
Cat. *Weich und Plastisch (Soft Art)*, Kunsthaus, Zurich,
texts Magdalena Abakanowicz, Erika Billeter, Mildred
Constantine, Richard Paul Lohse, André Thomkins

1980
'International Moderns from the Permanent
Collection',
Chrysler Museum, Norfolk, Virginia (group)

Tokyu Department Store, Nagano (solo)

1981
'My Manifesto for 1981',
Sendai Civic Gallery, Sendai (solo)
Cat. *My Manifesto for 1981*, Abe Studio, Tokyo, text
Toshiaki Minemura

'Two Decades of Contemporary Japanese Art',
Kodosha Gallery, Ichinoseki (group)

'The 1960s: A Decade of Change in Contemporary Art',
National Museum of Modern Art, Tokyo, toured to
National Museum of Modern Art, Kyoto (group)
Cat. *The 1960s: A Decade of Change in Contemporary
Art*, National Museum of Modern Art, Tokyo, text Tamon
Miki

1982
Fuji Television Gallery, Tokyo (solo)
Cat. *Kusama Yayoi*, Fuji Television Gallery, Tokyo, texts
Gordon Brown, Udo Kultermann, Herbert Read, Yusuke
Nakahara

Galleria d'Arte del Naviglio, Milan (solo)
Cat. *Yayoi Kusama*, Galleria d'Arte del Naviglio, Milan,
text Masatoshi Tamaki

Selected articles and interviews
1977-82

Tamaki, Masatoshi, 'Yayoi Kusama', *d'Arts*, Milan,
November

1978
Miyajima, Hisao, 'Shift towards Post-Functionalism:
"Design and Art of Modern Chairs"', *BT*, Tokyo, October

Kusama, Yayoi; Fujimoto, Tokuji; Ibe, Masataka, 'A
Panel Discussion with Yayoi Kusama: Part 1', *Shinshu
orai*, Matsumoto, October

1980

Author unknown, 'Infinite Accumulation by Yayoi
Kusama', *Geijutsu Shincho*, Tokyo, September

1981

1982
Author unknown, 'Obsessional Artist Yayoi Kusama's
Exhibition at the Fuji Television Gallery', *Zen Tokyo
shinbun*, 31 March
Author unknown, 'The Hallucinatory World of
"Nothingness": Yayoi Kusama Retrospective', *Asashi
shinbun*, Tokyo, 7 April
Author unknown, 'Galleries: Landscape Obliteration by
Yayoi Kusama', *Geijutsu Shincho*, Tokyo, May
Sasaki, Mieko, 'Going Dotty over Dot Infinities', *Daily
Yomiuri*, Tokyo, 25 March
Shiraishi, Kazuko, 'Yayoi Kusama: Breathing and
Accumulating Nets', *BT*, Tokyo, June

Yoshida, Yoshie, 'Obsession: Interview with Yayoi
Kusama', *Ato bijon*, Tokyo, June
Nakahara, Yusuke; Kusama, Yayoi, 'Yayoi Kusama', *BOX
News*, No. 82, Box Gallery, Nagoya, January

masatoshi tamaki
presenta

yayoi kusama

giovedì 9 dicembre 1982
dalle ore 19

galleria del naviglio
20121 milano via manzoni 45 tel. 661.538

Selected exhibitions and projects
1983-86

1983
Receives Tenth Literary Award for New Writers, *Yasei jidai*, Kadokawa Shoten, Tokyo

Jardin de Luseine, Tokyo (solo)

'Yayoi Kusama: 1950–1970',
Galerie Ornis, The Hague (solo)

'Trends of Japanese Art in the 1960s II – Towards Diversity',
Tokyo Metropolitan Art Museum (group)
Cat. *Trends of Japanese Art in the 1960s II – Towards Diversity*, Tokyo Metropolitan Art Museum, text Yasuyoshi Saito

1984
'Blam! The Explosion of Pop, Minimalism and Performance, 1958–1964',
Whitney Museum of American Art, New York (group)
Cat. *Blam! The Explosion of Pop, Minimalism and Performance, 1958–1964*, Whitney Museum of American Art, New York, texts Barbara Haskell, John H. Hanhardt

1985
'Reconstructions: Avant-Garde Art in Japan, 1945–1965',
Museum of Modern Art, Oxford, toured to
Fruitmarket Gallery, Edinburgh (group)
Cat. *Reconstructions: Avant-Garde Art in Japan, 1945–1965*, Museum of Modern Art, Oxford, texts David Elliot, et al.

1986
Musée Municipal, Dole, France, toured to **Musée des beaux-arts**, Calais (solo)
Cat. *Yayoi Kusama*, Musée des beaux-arts, Calais, texts Félix Guattari, François Julien, Yayoi Kusama, Patrick Le Nouëne, Pierre Restany

'Japon des Avant-Garde, 1910–70',
Musée national d'art moderne, Centre Georges Pompidou, Paris (group)
Cat. *Japon des Avant-Garde, 1910–70*, Centre Georges Pompidou, Paris, texts Asahi Shinbunsha, et al.

'Infinity ∞ Explosion',
Fuji Television Gallery, Tokyo (solo)
Cat. *Infinity ∞ Explosion*, Fuji Television Gallery, Tokyo, texts Félix Guattari, Toshiaki Minemura

Selected articles and interviews
1983-86

1983

Van garrel, Betty, 'Kusama's obsessies in zilver en goud', *HRC Handelsblad*, Rotterdam, 28 June

Minoru, Ueda, 'Illuminant Scene 2, From Artist's Atelier: Ueda Minoru Interviews Yayoi Kusama', *Print Communication*, Tokyo, April

1984
Glueck, Grace, 'Art: Exploring Six Years of Pop, Minimalism, and Perfomance', *New York Times*, 28 September
Author unknown, 'Art: "Blam! The Explosion of Pop, Minimalism and Performance, 1958–1964"', *Village Voice*, New York, 9 October

Kudo, Yukio, 'Letter-Interview 14: Miss Yayoi Kusama and Her "Pumpkin"', *In.ui.redi/Inoui Lady*, No. 22, Japan
Okada, Takahiko, 'Recent Work by Yayoi Kusama: Overcoming the Fear of Repetition', *Hanga geijutsu*, Tokyo, Winter
Falkman, Sigrid, 'Three Japanese Woman: Isolation and Oppression', *Artes*, No. 4, Milan

1986
Julien, François, 'Paris: Yayoi Kusama', *Beaux Arts*, Paris, October

Amine, Patrick, 'Yayoi Kusama: L'obsession de la matière molle et du petit pois', *Art Press*, Paris, December
Ooka, Makoto, 'My Impressions of the Exhibition "Japon des Avant-Garde" in Paris', *Geijutsu Shincho*, Tokyo, February, 1987

Selected exhibitions and projects
1987-94

1987
Kitakyushu Municipal Museum of Art, Fukuoka,
Japan (solo)
Cat. *Yayoi Kusama ten*, Kitakyushu Municipal Museum
of Art, Fukuoka, Japan, texts Yayoi Kusama, Toshiaki
Minemura, Shin.ichi Nakazawa, Jun.ichi Nakajima,
Herbert Read

1988
'Yayoi Kusama: Soul Burning Flashes',
Fuji Television Gallery, Tokyo (solo)
Cat. *Yayoi Kusama: Soul Burning Flashes*, Fuji Television
Gallery, Tokyo, text Yayoi Kusama

'Gruppe Zero',
Galerie Schoeller, Dusseldorf (group)

1989
'The "Junk" Aesthetic: Assemblage of the 1950s and
Early 1960s',
**Whitney Museum of American Art at Equitable
Center**, New York (group)

'Yayoi Kusama: A Retrospective',
Center for International Contemporary Arts, New
York (solo)
Cat. *Yayoi Kusama: A Retrospective*, Center for
International Contemporary Arts, New York, texts
Bhupendra Karia, Alexandra Munroe, et al.

Yayoi Kusama with Nobuyoshi Araki, Tokyo

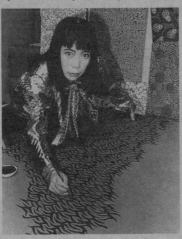

'In Context: Yayoi Kusama, Soul-Burning Flashes',
Museum of Modern Art, Oxford (solo)

1992
'Yayoi Kusama: Bursting Galaxies',
Sogetsu Museum of Art, Tokyo, toured to **Niigata City
Art Museum** (solo)
Cat. *Yayoi Kusama: Bursting Galaxies*, Sogetsu Museum
of Art, Tokyo, text Yayoi Kusama

Yayoi Kusama, studio, Tokyo, 1989

1993
Japanese Pavilion,
XLV Venice Biennale (group)
Cat. *Yayoi Kusama*, Japan Foundation, Tokyo, texts
Yayoi Kusama, Akira Tatehata

Abject Art: Repulsion and Desire in Contemporary Art',
Whitney Museum of Contemporary Art, New York
(group)
Cat. *Abject Art: Repulsion and Desire in Contemporary
Art*, Whitney Museum of Contemporary Art, New York,
texts Leslie C. Jones, et al.

'Japanese Outsider Art: Inhabitants of Another World',
Setagaya Art Museum, Tokyo (group)

1994
'Japanese Art after 1945: Scream against the Sky',

Selected articles and interviews
1987-94

1988
Author unknown, 'Soul Burning Flash: Yayoi Kusama
Exhibition', *Shin bijutsu*, Tokyo, 21 August
Murata, Makoto, 'Art Today: Yayoi Kusama', *Ikebana
Rysei*, Tokyo, August
Uno, Kuni.ichi, 'Castration and Cosmos: Yayoi Kusama
Exhibition', *BT*, Tokyo, September

1989

Smith, Roberta, 'Intense Personal Visions of a Fragile
Japanese Artist', *New York Times*, 20 October
Wye, Pamela, 'Yayoi Kusama: A Retrospective', *Arts
Magazine*, New York, December
Cooke, Lynne, 'Yayoi Kusama: A Retrospective',
Burlington Magazine, London, February, 1990
Adams, Brookes, 'Proliferating Obsessions', *Art in
America*, New York, April, 1990
Berkson, Bill, 'Yayoi Kusama: A Retrospective',
Artforum, New York, Summer 1990
Levin, Kim, 'Yayoi Kusama', *Village Voice*, New York, 31
October

1992
Friis-Hansen, Dana, 'Yayoi Kusama: Bursting Galaxies',
Flash Art, Milan, January–February, 1993

1994

Selected exhibitions and projects
1994-97

Yokohama Museum of Art, toured to **Solomon R. Guggenheim Museum**, SoHo, New York; **Museum of Modern Art**, San Francisco (group)

'When the Body Becomes Art',
Itabashi Art Museum, Tokyo (group)

'Yayoi Kusama: My Solitary Way to Death',
Fuji Television Gallery, Tokyo (solo)

Shinano Art Museum, Nagano Prefecture (solo)

1995
'Division of Labor: "Women's Work" in Contemporary Art',
Bronx Museum of the Arts, New York, toured to
Museum of Contemporary Art, Los Angeles (group)

'Yayoi Kusama: I Who Committed Suicide',
Ota Fine Arts, Tokyo (solo)

'Revolution: Art of the Sixties from Warhol to Beuys',
Museum of Contemporary Art, Tokyo (group)

1996
'Inside the Visible: An Elliptical Traverse of Twentieth-century Art',
Institute of Contemporary Art, Boston, toured to
Whitechapel Art Gallery, London (group)
Cat. *Inside the Visible: An Elliptical Traverse of Twentieth-century Art*, MIT Press, Cambridge, Massachusetts, texts Catherine de Zegher et al.

'Art of the Postwar 1960s Avant-Garde',
Kurashiki City Art Museum, Okayama (group)

'Yayoi Kusama: The 1950s and 1960s – Paintings, Sculpture, Works on Paper',
Paula Cooper Gallery, New York (solo)
Cat. *Yayoi Kusama: The 1950s and 1960s – Paintings, Sculpture, Works on Paper*, Paula Cooper Gallery, New York, texts Alexandra Munroe, et al.

'L'informe: Mode d'emploi',
Musée national d'art moderne, Centre Georges Pompidou, Paris (group)

Robert Miller Gallery, New York (solo)

1997
'All the Room's a Stage',
The Mattress Factory, Pittsburgh, Pennsylvania (group)

'De-Genderism',
Setagaya Art Museum, Tokyo (group)

草間彌生：自殺した私
—— 1950年代から現在までのペーパー・ワーク60点 ——
Yayoi Kusama: I who Committed Suicide
1995年7月1日出～8月5日出
July 1–August 5, 1995
オオタ ファイン アーツ
OTA FINE ARTS

Selected articles and interviews
1994-97

Friis-Hansen, Dana, 'Yayoi Kusama's Feminism',
art/text, No. 48, Sidney, September

1995

Itoi, Kay, 'Yayoi Kusama', *ARTnews*, New York,
November

1996

Clifford, Katie, 'Yayoi Kusama', *Art Papers*, Atlanta, Georgia, September–October
Duncan, Michael, 'Yayoi Kusama at Paula Cooper', *Art in America*, New York, October
Halle, Howard, 'From Here to Infinity', *Time Out*, New York, 15–22 May
Smith, Roberta, 'Yayoi Kusama: Paula Cooper Gallery', *New York Times*, 24 May

Moorman, Margaret, 'Yayoi Kusama', *ARTnews*, New York, November
Johnson, Ken, 'Yayoi Kusama at Robert Miller', *Art in America*, New York, December

1997
King, Elaine, 'All the Room's a Stage', *Sculpture*, Washington, DC, February
Raczka, Robert, 'Yayoi Kusama', *New Art Examiner*, New York, March
Solomon, Andrew, 'Dot Dot Dot (Yayoi Kusama)', *Artforum*, New York, February

Selected exhibitions and projects
1997-2000

Ota Fine Arts, Tokyo (solo)

'Floating Images of Woman in Art History',
Tochigi Prefectural Museum of Fine Art (group)

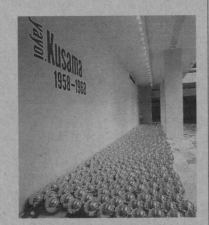

1998
'Out of Actions: Between Performance and the Object,
1949–1976',
Museum of Contemporary Art, Los Angeles, toured to
MAK, Museum of Applied, Vienna; **Museu d'Art
Contemporani**, Barcelona; **Museum of Contemporary
Art**, Tokyo; **National Museum of Art**, Osaka (group)
Cat. *Out of Actions: Between Performance and the
Object, 1949–1976*, Museum of Contemporary Art, Los
Angeles, texts Guy Brett, Hubert Klocker, Paul
Schimmel, Shinichiro Osaki, Kristine Stiles

'Love Forever: Yayoi Kusama, 1958–1968',
Los Angeles County Museum of Art, toured to **The
Museum of Modern Art**, New York; **Walker Art Center**,
Minneapolis; **Museum of Contemporary Art**, Tokyo
(solo)
Cat. *Love Forever: Yayoi Kusama, 1958–1968*, Los
Angeles County Museum of Art, texts Laura Hoptman,
Lynn Zelevansky, Akira Tatehata, Alexandra Munroe

Yayoi Kusama with Leo Castelli, The Museum of Modern Art,
New York

'Yayoi Kusama 1967–1970: Cage Painting Women',
Media of Modern Art Contemporary Gallery, Fukuoka
(solo)

'Yayoi Kusama Has Occupied Time',
Komagane Kogen Art Museum, Nagano (solo)

'Yayoi Kusama: Now',
Robert Miller Gallery, New York (solo)
Cat. *Yayoi Kusama: Now*, Robert Miller Gallery, New
York, texts Yayoi Kusama, Damien Hirst

The Mattress Factory, Pittsburgh, Pennsylvania (solo)

'Organic',
Palais des Arts, Ecole des Beaux Arts, Musée de
l'histoire de la Médecine, Toulouse (group)

1999
'Yayoi Kusama: Beyond My Illusion',
Media of Modern Art Contemporary Gallery, Fukuoka
(solo)

'In Full Bloom: Yayoi Kusama, Years in Japan',
exhibited in conjunction with 'Love Forever: Yayoi
Kusama, 1958–1968',
Museum of Contemporary Art, Tokyo (solo)
Cat. *In Full Bloom: Yayoi Kusama, Years in Japan*,
Museum of Contemporary Art, Tokyo, text Naoko Seki

2000
Serpentine Gallery, London (solo)

'Sydney Biennale'
(group)

Selected articles and interviews
1997-2000

Kultermann, Udo, 'Lucid Logic', *Sculpture*,
Washington, DC, January

1998

Camhi, Leslie, 'Dot's it', *ARTnews*, New York, September
Iannacone, Carmine, 'Yayoi Kusama at Los Angeles
County Museum of Art', *Art Issues*, New York, Summer
Koplos, Janet, 'The Phoenix Returns', *Art in America*,
New York, February
Lumpkin, Libby, 'Yayoi Kusama: LA County Museum of
Art', *Artforum*, New York, September
Naves, Mario, 'Love Forever: Yayoi Kusama, 1958–1968
at The Museum of Modern Art, New York', *New Criterion*,
New York, October

Bibliography

Abe, Nobuo, 'Exhibition Reviews: Yayoi Kusama', *BT*, Tokyo, February, 1981

Adams, Brookes, 'Proliferating Obsessions', *Art in America*, New York, April, 1990

Alexandra, Munroe, *Yayoi Kusama: A Retrospective*, Center for International Contemporary Arts, New York, 1989

Alexandra, Munroe, *Yayoi Kusama: The 1950s and 1960s – Paintings, Sculpture, Works on Paper*, Paula Cooper Gallery, New York, 1996

Alloway, lawrence, 'Arts in Escalation: the History of Happenings, a Question of Sources', *Arts Magazine*, New York, December–January, 1966

Amine, Patrick, 'Yayoi Kusama: L'obsession de la matière molle et du petit pois', *Art Press*, Paris, December, 1986

Ashton, Dore, 'Art Tenth Street Views', *New York Times*, 23 October, 1959

Ashton, Dore, 'New York Notes: Yayoi Kusama', *Art International*, Lugano, June–August, 1961

Ashton, Dore, 'New York Commentary: Resurrecting Some Recent Traditions', *Studio International*, London, March, 1964

Author unknown, 'Solo Exhibition of Yayoi Kusama', *Atelier*, Tokyo, May, 1954

Author unknown, 'Art World Discussed at a Gallery', *Geijutsu Shincho*, Tokyo, September, 1958

Author unknown, 'A Female Artist in New York', *Geijutsu Shincho*, Tokyo, March, 1961

Author unkown, 'Three Extraordinary Japanese Artists at the Whitney Museum', *Rafu shinpo*, Tokyo, 1 January, 1962

Author unknown, 'Gallery Previews: Kusama', *Art Voices*, New York, January, 1964

Author unknown, 'Ten Guest Tables', *Arts Voices*, New York, June, 1964

Author unknown, 'An Eccentric Exhibition of Yayoi Kusama', *Geijutsu seikatsu*, Tokyo, January, 1965

Author unknown, 'Erotiek in Orez: Practical jokes en kunst', *Het Vrije Volk*, The Hague, 21 May, 1965

Author unknown, 'Die Beatles sangen dazu: Kusama aus Japan erffnete gestern ihre Schau', *Gross Essen*, 30 April, 1966

Author unknown, 'In the Galleries: Kusama on Her Japanese Stroll through Central Park', *Arts Magazine*, New York, September–October, 1967

Author unknown, '"Bare Facts" Presented in a Political Protest', *New York Times*, 4 November, 1968

Author unknown, 'Four Nudes Protest the War in Vietnam', *New York Times*, 12 November, 1968

Author unknown, 'Four Nudes Turn Back on the War', *San Francisco Chronicle*, 12 November, 1968

Author unknown, 'But Is It Art?', *New York Daily News*, 25 August, 1969

Author unknown, 'Six Young Women and Two Men Led by Y. Kusama Cavort in Nude for 20 Minutes in "Grand Orgy to Awaken the Dead"', *New York Times*, 25 August, 1969

Author unknown, '"Queen of Happening" Returns: Yayoi Kusama's "Obsession" in First Solo Exhibition in Japan after 20 Years', *Shukan Posuto*, Tokyo, 22 February, 1975

Author unknown, 'The First Exhibition in Japan After 20 Years', *Mainici shinbun*, Tokyo, 20 December, 1975

Author unknown, 'Infinite Accumulation by Yayoi Kusama', *Geijutsu Shincho*, Tokyo, September, 1980

Author unknown, 'Obsessional Artist Yayoi Kusmam's Exhibition at the Fuji Television Gallery', *Zen Tokyo shinbun*, 31 March, 1982

Author unknown, 'The hallucinatory World of "Nothingness": Yayoi Kusama Retrospective', *Asashi shinbun*, Tokyo, 7 April, 1982

Author unknown, 'Galleries: Landscape Obliteration by Yayoi Kusama', *Geijutsu Shincho*, Tokyo, May, 1982

Author unknown, 'Art: "Blam! The Explosion of Pop, Minimalism and Performance, 1958–1964"', *Village Voice*, New York, 9 October, 1984

Author unknown, 'Soul Burning Flash: Yayoi Kusama Exhibiton', *Sankei shinbun*, Tokyo, 4 August, 1988

Author unknown, 'Soul Burning Flash: Yayoi Kusama Exhibiton', *Shin bijutsu*, Tokyo, 21 August, 1988

Author unknown, 'World Snap: Yayoi Kusama Decorates the Garden of Italian Pavilion at the Venice Biennale', *Geijutsu Shincho*, Tokyo, September, 1966

Benedikt, Michael, 'New York Letter:Sculpture in Plastic, Cloth, Electric Light, Chrome, Neon, and Bronze', *Art International*, Lugano, January, 1966

Benedikt, Michael, 'New York Letter: Light Sculpture and Sky Ecstasy', *Art International*, Lugano, September, 1966

Berkson, William, 'In the Galleries: Kusama', *Arts Magazine*, New York, May, 1966

Berkson, William, 'Yayoi Kusama: A Retrospective', *Artforum*, New York, Summer 1990

Bhupendra, Karia, *Yayoi Kusama: A Retrospective*, Center for International Contemporary Arts, New York, 1989

Boost, Rolf, 'Yayoi: Priesteres van het naakt', *Algemeen Dagblad*, Rotterdam, 21 November, 1967

Braun, Michael, 'Michael Braun Reports on the Venice Biennial', *Queen*, New York, July, 1966

Brown, Gordon, 'Obsessional Painting', *Art Voices*, New York, March, 1964

Brown, Gordon, 'The Imagination Critic: A Reply to the Proceeding Article', *Art Voices*, New York, Summer, 1965

Brown, Gordon, *Nul negentienhonderd viff en zestig*, Stedelijk Museum, Amsterdam, 1965

Brown, Gordon, *Yayoi Kusma*, Galleria d'Arte del Naviglio, Milan, 1966

Brown, Gordon, 'Yayoi Kusama', *d'Arts*, Milan, 10 April–20 October, 1966

Brown, Gordon, *Kusama Yayoi*, Fuji Television Gallery, Tokyo, 1982

Burrows, Carlyle, 'A Non-Objective Trend of Detail', *Herald Tribune*, New York, 5 May, 1961

Camhi, Leslie, 'Dot's it', *ARTnews*, New York, September, 1998

Carl, Alfred, 'Call Her Dotty', *New York Sunday News*, 13 August, 1967

Castile, Rand, 'Reviews and Previews: Kusama', *ARTnews*, New York, April, 1964

Clay, Jean, 'Art … Should Change man: Commentary from Stockholm', *Studio International*, London, March, 1966

Clifford, Katie, 'Yayoi Kusama', *Art Papers*, Atlanta, Georgia, September–October, 1996

Cooke, Lynne, 'Yayoi Kusama: A Retrospective', *Burlington Magazine*, London, February, 1990

Cremer, Jan, 'My Flower Bed (Painted Cloth) by Yayoi Kusama', *Art Voices*, New York, Fall, 1965

De Vecchi, Lerner, 'Paris: Kusama', *L'Oeil*, Lausanne, October, 1986

Duncan, Michael, 'Yayoi Kusama at Paula Cooper', *Art in America*, New York, October, 1996

Falkman, Sigrid, 'Three Japanese Woman: Isolation and Oppression', *Artes*, No. 4, Milan, 1984

Friedlander, Alberta, 'Another New Gallery: Gres Opens with Works by 10', *Chicago Daily News*, 2 December, 1961

Friis-Hansen, Dana, 'Yayoi Kusama: Bursting Galaxies', *Flash Art*, Milan, January–February, 1993

Friis-Hansen, Dana, 'Yayoi Kusama's Feminism', *art/text*, No. 48, Sidney, September, 1994

Fujimoto, Tokuji, 'A Panel Discussion with Yayoi Kusama: Part 1', *Shinshuorai*, Tokyo, October, 1978

Glueck, Grace, 'Art: Exploring Six Years of Pop, Minimalism, and Perfomance', *New York Times*, 28 September, 1984

Greenstein, M.A., 'Love Forever: Yayoi Kusama in Retrospective', *Art Asia Pacific*, No. 20, Sydney, September, 1998

Gray, Francine du Plessix, 'The House That Pop Art Built', *House & Garden*, New York, May, 1965

Gruen, John, 'Underground', *Vogue*, New York, 1 October, 1968

Guattari, Félix, *Infinity ∞ Explosion*, Fuji Television Gallery, Tokyo, 1986

Guattari, Félix, *Yayoi Kusama*, Musée des beaux-arts, Calais, 1986

Halle, Howard, 'From Here to Infinity', *Time Out*, New York, 15–22 May, 1996

Hirst, Damien, *Yayoi Kusama: Now*, Robert Miller Gallery, New York, 1998

Hoptman, Laura, *Love Forever: Yayoi Kusama, 1958–1968*, Los Angeles County Museum of Art, 1998

Hoptman, Laura, 'The Princess of the Polka Dot', *Harper's Bazaar*, New York, March, 1998

Iannacone, Carmine, 'Yayoi Kusama at Los Angeles County Museum of Art', *Art Issues*, New York, Summer, 1998

Ibe, Masataka, 'A Panel Discussion with Yayoi Kusama: Part 1', *Shinshuorai*, Tokyo, October, 1978

Itoi, Kay, 'Yayoi Kusama', *ARTnews*, New York, November, 1995

Jacobs, Jay, 'In the Galleries: Yayoi Kusama', *Arts Magazine*, New York, January, 1966

Johnson, Jill, 'Kusama's One Thousand Boat Show', *ARTnews*, New York, February, 1964

Johnson, Ken, 'Yayoi Kusama at Robert Miller', *Art in America*, New York, December, 1996

Judd, Donald, 'Reviews and Previews: New Names This Month – Yayoi Kusama', *ARTnews*, New York, October, 1959

Judd, Donald, 'Local History', *Arts Yearbook: New York – The New Art World*, Vol. 7, New York, 1963

Judd, Donald, 'In the Galleries: Yayoi Kusama', *Arts Magazine*, New York, September, 1964

Julien, François, 'Paris: Yayoi Kusama', *Beaux Arts*, Paris, October, 1986

Julien, François, *Yayoi Kusama*, Musée des beaux-arts, Calais, 1986

Junker, Howard, 'The Theater of the Nude', *Playboy*, New York, November, 1968

Kelly, Edward T., 'Neo Dada: A Critique of Pop Art', *Art Journal*, New York, Spring, 1964

King, Elaine, 'All the Room's a Stage', *Sculpture*, Washington, DC, February, 1996

Kiplinger, Suzanne, 'Art: 10th Street Views', *Village Voice*, New York, 28 October, 1959

Kitazawa, Kiyoji, 'Transforming Self into "Demon": About Miss Yayoi Kusama', *Shinshugeien*, Nagano, 1 January, 1963

Koplos, Janet, 'The Phoenix Returns', *Art in America*, New York, February, 1998

Kroll, Jack, 'Reviews and Previews: Yayoi Kusama', *ARTnews*, New York, May, 1961

Kultermann, Udo, *Monochrome Malerei*, Städtisches Museum, Leverkusen, Germany, 1960

Kultermann, Udo, *Yayoi Kusama*, Galerie M.E. Thelen, Essen, 1966

Kultermann, Udo, 'Die Sprache des Schweigens: Uber des Symbolmilieu der Farbe Weiss', *Quadrum*, No. 20, Brussels, 1966

Kultermann, Udo, 'Yayoi Kusama: Überreal', *Artis*, Stuttgart, June, 1966

Kultermann, Udo, *Kusama Yayoi*, Fuji Television Gallery, Tokyo, 1982

Kultermann, Udo, 'Lucid Logic', *Sculpture*, Washington, DC, January, 1997

Kusama, Yayoi, *Yayoi Kusama*, Galleria d'Arte del Naviglio, Milan, 1966

Kusama, Yayoi, New Works by *Yayoi Kusma: The Second Solo Exhibition*, First Community Centre, Matsumoto, 1952

Kusama, Yayoi, *Nul negentienhonderd viff en zestig*, Stedelijk Museum, Amsterdam, 1965

Kusama, Yayoi, *Yayoi Kusama*, Galleria d'Arte del Naviglio, Milan, 1966

Kusama, Yayoi, *Christopher Homosexual Brothel*, Kadokawa Shoten, Tokyo, 1984

Kusama, Yayoi, *Yayoi Kusama*, Musée des beaux-arts, Calais, 1986

Kusama, Yayoi, 'Odyssey of My Struggling Soul', *Geijutsu seikatsu*, Tokyo, November, 1975

Kusama, Yayoi, *Manhattan Suicide Addict*, Kosakusha, Tokyo, 1978

Kusama, Yayoi, 'A Panel Discussion with Yayoi Kusama: Part 1', *Shinshuorai*, Tokyo, October, 1978

Kusama, Yayoi, *The Burning of St. Marks Church*, Parco Shuppan, Tokyo, 1985

Kusama, Yayoi, *Yayoi Kusama ten*, Kitakyushu Municipal Museum of Art, Fukuoka, Japan, 1987

Kusama, Yayoi, *Between Heaven and Earth*, Jiritsu Shobo, Tokyo, 1988

Kusama, Yayoi, *Woodstock Phallus Cutter*, Atelier Peyotl, Tokyo, 1988

Kusama, Yayoi, *Yayoi Kusama: Soul Burning Flashes*, Fuji Television Gallery, Tokyo, 1988

Kusama, Yayoi, *Distress Like This*, Jiritsu Shobo, Tokyo, 1989

Kusama, Yayoi, *Double Suicide at Sakuragazuka*, Jiritsu Shobo, Tokyo, 1989

Kusama, Yayoi, *The Foxgloves of Central Park*, Jiritsu Shobo, Tokyo, 1991

Kusama, Yayoi, *Yayoi Kusama: Bursting Galaxies*, Sogetsu Museum of Art, Tokyo, 1992

Kusama, Yayoi, *Lost in Swampland*, Jiritsu Shobo, Tokyo, 1992

Kusama, Yayoi, *Yayoi Kusama*, Japan Foundation, Tokyo, 1993

Kusama, Yayoi, *New York Story*, Jiritsu Shobo, Tokyo, 1993

Kusama, Yayoi, *Hustlers Grotto: Three Novellas*, Wandering Mind Books, Berkeley, California, 1998

Kusama, Yayoi, *Violent Obsession*, Wandering Mind Books, Berkeley, California, 1998

Kusama, Yayoi, *Yayoi Kusama: Now*, Robert Miller Gallery, New York, 1998

Le Nouëne, Patrick, *Yayoi Kusama*, Musée des beaux-arts, Calais, 1986

Leveque, Jean-Jacques, 'La Sculpture Avant-Garde de l'Art', *La Galerie des Arts*, Paris, October, 1967

Levin, Kim, 'Yayoi Kusama', *Village Voice*, New York, 31 October, 1989

Lippard, Lucy R., 'New York Letter: Recent Sculpture As Escape', *Art International*, Lugano, February, 1966

Lippard, Lucy R., 'Eccentric Abstraction', *Art International*, Lugano, November, 1966

Lippard, Lucy R., 'The Silent Art', *Art in America*, New York, January–February, 1967

Lumpkin, Libby, 'Yayoi Kusama: LA County Museum of Art', *Artforum*, New York, September, 1998

Maeda, Atsuko, 'Objects: Material in Deviation', *BT*, Tokyo, July, 1987

Milani, Milena, 'Una biennale tutta sexy', *ABC*, Madrid, 3 July, 1966

Millet, Catherine, 'Radicalism of Our Dreams', *BT*, Tokyo, April, 1987

Minemura, Toshiaki, *My Manifesto for 1981*, Abe Studio, Tokyo, 1981

Minemura, Toshiaki, *Infinity ∞ Explosion*, Fuji Television Gallery, Tokyo, 1986

Minemura, Toshiaki, *Yayoi Kusama ten*, Kitakyushu Municipal Museum of Art, Fukuoka, Japan, 1987

Minoru, Ueda, 'Illuminant Scene 2, From Artist's Atelier: Ueda Minoru Interviews Yayoi Kusama', *Print Communication*, Tokyo, April, 1983

Miyajima, Hisao, 'Shift towards Post-Functionalism:"Design and Art of Modern Chairs"', *BT*, Tokyo, October, 1978

Mizutani, Takashi, 'Exhibition Reviews: Yayoi Kusama', *BT*, Tokyo, April, 1982

Moorman, Margaret, 'Yayoi Kusama', *ARTnews*, New York, November, 1996

Munroe, Alexandra, *Love Forever: Yayoi Kusama, 1958–1968*, Los Angeles County Museum of Art, 1998

Murata, Makoto, 'Art Today: Yayoi Kusama', *Ikebana Rysei*, Tokyo, August, 1988

Muto, Naoji, 'Patterns of Life and Death: Obsessional Art of Yayoi Kusama', *Re.jyowaiyo*, Tokyo, 20 December, 1976

Nakahara, Yusuke, *Message of Death from Hades*, Nishimura Gallery, Tokyo, 1975

Nakahara, Yusuke; Kusama, Yayoi, 'Yayoi Kusama', *BOX News*, No. 82, Box Gallery, Nagoya, January, 1982

Nakahara, Yusuke, *Kusama Yayoi*, Fuji Television Gallery, Tokyo, 1982

Nakajima, Jun.ichi, *Yayoi Kusama ten*, Kitakyushu Municipal Museum of Art, Fukuoka, Japan, 1987

Nakazawa, Shin.ichi, *Yayoi Kusama ten*, Kitakyushu Municipal Museum of Art, Fukuoka, Japan, 1987

Narotzky, Norman, 'The Venice Biennial: Pease Porridge in the Pot Nine Days Old', *Arts Magazine*, New York, September–October, 1966

Naves, Mario, 'Love Forever: Yayoi Kusama, 1958–1968, at The Museum of Modern Art, New York', *New Criterion*, New York, October, 1998

Ooka, Makoto, 'My Impressions of the Exhibition "Japon des Avant-Garde" in Paris', *Geijutsu Shincho*, Tokyo, February, 1987

O'Doherty, Brian, 'Exhibitions Playing a Wide Field: International Selection of Painting and Sculpture in Local Galleries', *New York Times*, 29 December, 1963

O'Doherty, Brian, 'Kusama Explores a New Area', *New York Times*, 25 April, 1964

Oguchi, Yoshio, 'A Female Artist in New York: Yayoi Kusama', *Ato/Art*, Tokyo, March, 1966

Okada, Takahiko, 'Recent Work by Yayoi Kusama: Overcoming the Fear of Repetition', *Hanga geijutsu*, Tokyo, Winter, 1984

Okamoto, Kenjiro, 'New Faces: Yayoi Kusama', *Geijutsu Shincho*, Tokyo, May, 1955

Peeters, Henk, '0=Nul: De niewe tendenzen', *Museumjournaal voor moderne kunst*, Amsterdam, April, 1964

Preston, Stuart, 'Twentieth Century Sense and Sensibility', *New York Times*, 7 May, 1961

Raczka, Robert, 'Yayoi Kusama', *New Art Examiner*, New York, March, 1996

Read, Herbert, *Yayoi Kusma*, Galleria d'Arte del Naviglio, Milan, 1966

Restany, Pierre, 'Le Japon a rejoint l'art moderne en prolongeant ses traditions', *La Galeries des Arts*, Paris, November, 1963

Restany, Pierre, *Yayoi Kusama*, Musée des beaux-arts, Calais, 1986

Rose, Barbara, 'New York Letter: Green Gallery', *Art International*, Lugano, 5 December, 1963

Sandler, Irving, 'In the Galleries: Kusama', *New York Post*, 5 January, 1964

Sasaki, Mieko, 'Going Dotty over Dot Infinities', *Daily Yomiuri*, Tokyo, 25 March, 1982

Schjeldahl, Peter, 'Reviews and Previews: Kusama', *ARTnews*, New York, May, 1966

Seki, Naoko, *In Full Bloom: Yayoi Kusama, Years in Japan*, Museum of Contemporary Art, Tokyo, 1999

Sello, Gottfried, 'Kunstkalender: Kusama's Driving Image Show', *Die Zeit*, Hamburg, 27 May, 1966

Shiraishi, Kazuko, 'Yayoi Kusama: Breathing and Accumulating Nets', *BT*, Tokyo, June, 1982

Singleton, Donald, 'Find Bodies in East Side Park: Covered All Over with Strange Spots', *New York Sunday News*, 16 July, 1967

Smith, Roberta, 'Intense Personal Visions of a Fragile Japanese Artist', *New York Times*, 20 October, 1989

Smith, Roberta, 'Yayoi Kusama: Paula Cooper Gallery', *New York Times*, 24 May, 1996

Solomon, Andrew, 'Dot Dot Dot (Yayoi Kusama)', *Artforum*, New York, February, 1996

Sommer, Ed, 'Letter from Germany: Yayoi Kusama at the Galerie M.E. Thelen', *Art International*, Lugano, October, 1966

Stange, John, 'Kookie Kusama: Fun City's New Nude Goddess of Free Love', *Ace*, New York, March, 1969

Tamaki, Masatoshi, 'Yayoi Kusama', *d'Arts*, Milan, December, 1977

Tamaki, Masatoshi, *Yayoi Kusama*, Galleria d'Arte del Naviglio, Milan, 1982

Tatehata, Akira, *Yayoi Kusama*, Japan Foundation, Tokyo, 1993

Tatehata, Akira, *Love Forever: Yayoi Kusama, 1958–1968*, Los Angeles County Museum of Art, 1998

Taylor, Richard, 'Events in Art', *Boston Sunday Herald*, 6 December, 1959

Tillim, Sidney, 'In the Galleries: Yayoi Kusama', *Arts Magazine*, New York, October, 1959

Tillim, Sidney, 'In the Galleries: Yayoi Kusama', *Arts Magazine*, New York, May–June, 1961

Tillim, Sidney, 'In the Galleries: Yayoi Kusama', *Arts Magazine*, New York, February, 1964

Tokuda, Yoshihito, 'Centering around Artaud', *Yuriika*, Tokyo, February, 1988

Tsuruoka, Masao, 'Solo Exhibition of Yayoi Kusama', *Mizue*, Tokyo, Date unknown, 1954

Turner, Grandy, 'Yayoi Kusama', *Bomb*, No. 66, New York, Winter, 1999

Uno, Kuni.ichi, 'Castration and Cosmos: Yayoi Kusama Exhibition', *BT*, Tokyo, September, 1988

Van garrel, Betty, 'Kusama's obsessies in zilver en goud', *HRC Handelsblad*, Rotterdam, 28 June, 1983

Van Keuren, Jan, 'Nul=0 Nul', *De Groene Amsterdammer*, Amsterdam, 24 March, 1962

Van Starrex, Allan, 'Kusama and Her "Naked Happenings"', *Mr*, New York, August, 1968

Van Starrex, Allan, 'Bonnie and Clyde in the Nude: As Directed by Kusama, High Priestess of Self-Obliteration', *Man to Man*, New York, May, 1969

Von Hennenberg, Josephine, 'Teamwork versus Individualism: Will the New group Movement Revolutionize Design?', *Art Voices*, New York, Winter, 1965

Weaver, Neal, 'The Polka Dot Girl Strikes Again, or Kusama's Infamous Spectacular', *After Dark*, New York, May, 1968

Wetzsteon, Ross, 'The Way of All Flesh: Stripping for Inaction', *Village Voice*, New York, 15 February, 1968

Willard, Charlotte, 'In the Art Galleries', *New York Post*, 14 November, 1965

Wiznitzer, Louis, 'Young Japanese Female Has Conquered Manhattan', *Revista do Globo*, Porto Alegre, 24 June–7 July, 1961

Wyatt, Hugh, 'Find Bodies in East Side Park: Covered All Over with Strange Spots', *New York Sunday News*, 16 July, 1967

Wyatt, Hugh, '4 Eves and an Adam Burn Commie Flag', *New York Daily News*, 9 September, 1968

Wye, Pamela, 'Yayoi Kusama: A Retrospective', *Arts Magazine*, New York, December, 1989

Yalkut, Jud, 'The Polka Dot Way of Life (Conversation with Yayoi Kusama)', *New York Free Press*, 15 February, 1968

Yoshida, Yoshie, 'Obsession: Interview with Yayoi Kusama', *Ato bijon*, Tokyo, June, 1982

Zelevansky, Lynn, *Love Forever: Yayoi Kusama, 1958–1968*, Los Angeles County Museum of Art, 1998